s book

dear friend

NBLUM

6

orge

GILBERT & GEORGE

Tate Publishing

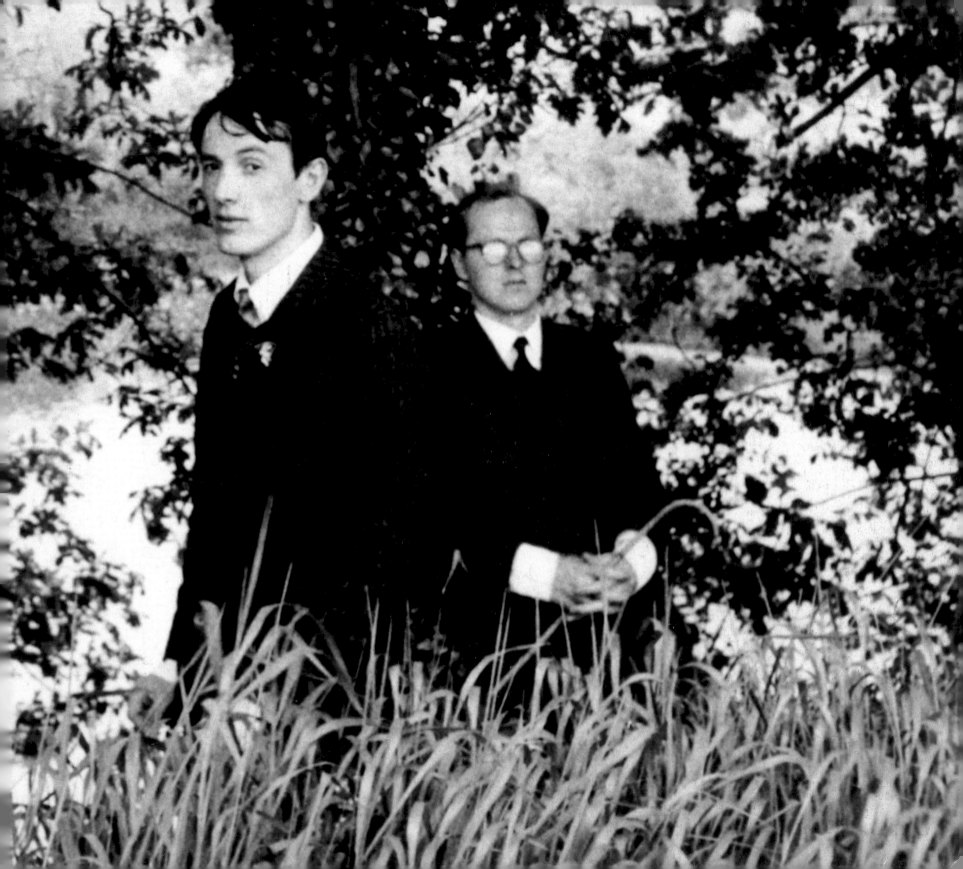

GILBERT & GEORGE

Tate Modern, London
2007

Haus der Kunst, Munich
2007

Castello di Rivoli, Rivoli-Turin
2007–2008

de Young Museum, San Francisco
2008

Milwaukee Art Museum
2008

Brooklyn Museum, New York
2008–2009

First published 2007 by order of the Tate Trustees by Tate Publishing, a division of Tate Enterprises Ltd, Millbank, London SW1P 4RG
www.tate.org.uk/publishing

© Tate 2007

On the occasion of the exhibition
Gilbert & George: Major Exhibition

Tate Modern, London
15 February – 6 May 2007

Exhibition sponsored by
TATE MEMBERS

From the Heart (pp.12–25) © Marco Livingstone

British Library Cataloguing in Publication Data
A catalogue record for this book is available from the British Library

ISBN 978-185437-666-4

Distributed in the United States and Canada by Harry N. Abrams, Inc., New York

Library of Congress Cataloging in Publication Data
Library of Congress Control Number: 2006938009

Designed by Rose, London
Cover by Gilbert & George
Printed by Beacon Press, UK

Front cover and back covers: details from ISHMAEL 2004
Frontispiece (fig.1): Gilbert & George, 1971

Gilbert & George Quotations
p.47: Interview with Wolf Jahn, 1995, first published in *Gilbert & George 1986–1997*, Valencia 1999, p.220.
p.60: *Gilbert & George: Intimate Conversations with François Jonquet*, London 2004, p.89.
p.64: Jahn 1999, p.250.
p.72: Interview with Gordon Burn, 1981, reprinted in *The Words of Gilbert & George*, London 1997, p.131.
p.133: Jahn 1999, p.262.
p.150: Jonquet 2004, p.251.
p.159: Jonquet 2004, p.271.
p.162: Interview with students from ENS-LSH in *Gilbert & George: E1*, Paris 2003, p.74.

Copyright Credits
All pictures by Gilbert & George © Gilbert & George
Fig.21: reproduced courtesy of ITV PLC (GRANADA INT'L)/LFI

Photographic Credits
Many thanks to Gilbert & George for supplying us with images of all their art, and to Yu Yi-Gang at the artists' studio. Thanks also to Samuel Drake, Rod Tidnam, and Dave Lambert for their photography for the *Early Art* section.

CONTENTS

Tate Members are delighted to support *Gilbert & George* – their first major UK retrospective in more than twenty-five years. Addressing the broad spectrum of human existence Gilbert & George's art has been consistently prescient and influential across a span of almost forty years. Subversive, incisive and arresting, the focus and inspiration of their art is firmly rooted in the fabric of western urban life.

The charity Tate Members was founded in 1958 to support the work of Tate and is now one of the most successful schemes of its kind. Last financial year Members gave nearly £3 million in direct funding to Tate. This included £250,000 to the Collections endowment, the second instalment of an overall commitment of £1 million to develop the Collection of British and International Modern Art.

Tate Members are central to the success of all four galleries. They help build and care for the Collection and extend exhibition, educational and outreach programmes. Members support Tate's vision helping to increase public knowledge, understanding and enjoyment of art. We hope that many of you who view the exhibition and read this catalogue will want to join us.

Francine Stock
Chair, Tate Members

SPONSOR'S FOREWORD

For almost four decades Gilbert & George have been making some of the most remarkable and influential art of our times. Tate is very proud to have worked so closely with the artists on this exhibition, the first retrospective of their pictures in Britain for over twenty years. The pictures are at the core of their practice and contain powerful messages that speak of the moment of their creation with rarely matched acuity. This becomes even more pronounced with the benefit of hindsight as the furore subsides and the pictures reveal depths of emotion: tenderness, violence, shame, pleasure and fear. The striking originality of their images is another great achievement: pictures by Gilbert & George bear little resemblance to anything from the modern world but pictures by Gilbert & George. The artists are instantly recognisable, always formal but open and generous. Often described as the quintessential London artists, it is certainly true that their subject matter is linked to their immediate environment, the liminal border between The City and the East End. The fusions and tensions of the area, between local and global, privilege and exclusion, migrant populations and cultural traditions, are at the heart of their art. Gilbert & George represent the condition, or contradiction, of the metropolis: it is precisely these local textures that give their work such an international quality.

Very early on the artists realised that every aspect of their lives contributed to their art and immediately set themselves exacting terms to which they have maintained an unerring commitment. The totality of their integration of art and life is reflected in the installation. It is the first time an exhibition devoted to living artists will extend across both sets of galleries and also into the public spaces of Level 4. The concourse, bookshop and café spaces become part of the installation, creating an immersive world by breaking down barriers between these usually segregated areas.

I would like to thank the exhibition's curators Jan Debbaut and Ben Borthwick for realising such an extraordinary exhibition. When Jan Debbaut joined Tate as Director, Collections, it was natural to invite him to be curator of the exhibition and tour. Over twenty-five years, he has worked on numerous exhibitions with Gilbert & George including their first retrospective and tour in 1980, and since leaving Tate he has continued as external curator. Ben Borthwick, Assistant Curator at Tate Modern, has worked closely with the artists and led the organisation of the exhibition.

Gilbert & George's prolific output on a domestic and grand scale means there are substantial holdings in both institutional and private collections. An exhibition of such scale, followed by a five venue European and American tour, is rare and makes great demands on the lenders without whose support such an undertaking would not be possible. This is particularly true of Massimo Martino and Massimo Valsecchi whose holdings of the artists' pictures from all periods form the backbone of the exhibition. The support of the artists' galleries has been crucial: in New York, Sonnabend (who have represented the artists since 1971) and Lehmann Maupin, Bernier/Eliades in Athens, Thaddaeus Ropac in Paris and Salzburg, and White Cube in London. We are also grateful to Anthony d'Offay who represented Gilbert & George for many years. Following Tate Modern, the exhibition will tour in its entirety to Haus der Kunst, Munich, then a distilled version will go on to Castello di Rivoli before travelling to the de Young Museum in San Francisco, Milwaukee Art Museum and Brooklyn Museum of Art during 2008. We are delighted to work with colleagues at these institutions.

The catalogue will make a valuable contribution to existing scholarship with excellent essays by Michael Bracewell, Marco Livingstone and the curators who all take very different approaches to the art. It has been elegantly designed by Rose Design, and I am grateful to Rebecca Fortey and the team at Tate Publishing for skilful editing and production.

At Tate I would like to thank Sheena Wagstaff, Chief Curator and her department colleagues: Stephen Mellor, Coordinator: Exhibitions & Displays; Stephen Dunn and Clare Simpson, Registrars; Art Installation Manager Phil Monk and the art handling team; in Conservation, Piers Townshend and Matthew Flintham, and Jane Burton's team in Interpretation. The exhibition is supported by Tate Members and we are grateful for their generosity which has enabled us to fulfil the artists' maxim 'Art for All' by presenting one third of the exhibition free to all of Tate Modern's visitors.

Finally, I would like to thank the artists. Their singular vision has been unwavering and enabled us to undertake such an ambitious project in which the installation is unmistakably theirs. Without their tireless commitment, support, good humour and generosity, this vision of the exhibition would never have been realised.

Vicente Todolí
Director, Tate Modern

FOREWORD

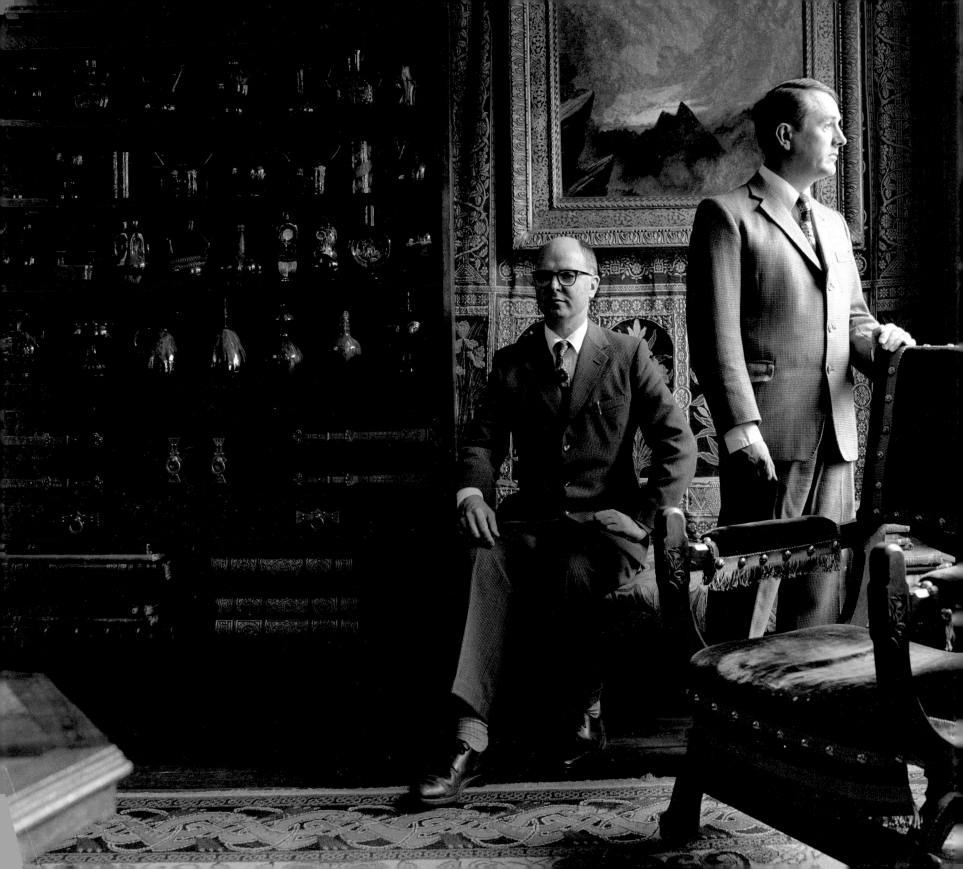

Q: And are you still living sculptures today?
A: We believe so. In our opinion it's our greatest invention.[1]

In accordance with the first of their *Laws of Sculptors* (published in 1969) Gilbert & George were 'always smartly dressed, well groomed, relaxed, friendly, polite and in complete control' during the meetings we had with Tate's Director Nicholas Serota in order to discuss a major exhibition of their art in London. Well, perhaps they were not always entirely relaxed, but certainly well prepared, since obviously, for them, a retrospective exhibition in their home-town was long overdue and already fully anticipated.

Immediately after the invitation was finally made, I received four faxes, confronting me in a gentle but decisive way with the full scale of the undertaking. The first fax listed a total of 938 *Pictures* made between 1971 and 2003. The second described thirteen huge *Charcoal on Paper Sculptures* executed from 1970 to 1974 (some of them consisting of as many as twenty-three panels). The third inventoried 440 *Postcard Sculptures* and *Post-Card Pieces* made between 1972 and 1989. The final fax reminded me that they had also created eleven *Postal Sculptures*, six *Magazine Sculptures*, twelve *Works in Edition*, four *Video Sculptures* and five *Films,* adding that they had a large archive of photographs and film footage of their exhibitions around the world. This last fax ended with the reassuring promise that 'We also will create new pictures between 2004 to 2007!'

Rarely have artists of our time been so productive in such a variety of forms and built such an impressive and complex oeuvre. The art of Gilbert & George spans a period of more than forty years. It goes all the way back to a forgotten time when their pictures were manually developed in a dark room and the maximum size of available print paper was 50 x 60 cm. It was a time when the function of photography in the visual arts could still be re-invented, and so this is what they did. Because they met at St Martin's School of Art in London in the sixties they are unavoidably associated with the iconoclastic wave of Conceptual Art of that period. And yet to me their art is very different in nature, embedded in a long-standing pictorial tradition. It is very much concerned with visual languages, formal aspects of representation, even craftsmanship.

At St Martin's, Gilbert & George were trained as sculptors, so initially 'everything was sculpture'. They wanted to go beyond the usual and therefore had to invent their own language. Nobody did photo-pieces in a non-documentary way at the time. They even – as they happily recall – had to reinvent the use of the word 'picture', because their artworks were neither paintings nor photographs. It took them five years to find the right form (losing the gap between the framed panels), but the result was productive; a new and active format, like journalism. It enabled them to use the whole world as subject matter: everybody, everything, everywhere. A visual language anyone can understand and identify with – empathy with an iconic quality.

First there were all kinds of adventurous experiments (living sculptures, singing sculptures, etc). Then there was the form which would become so influential. And finally they developed their cyclical working methods:

Step one is collecting the raw material. This is like harvesting – working in the field and getting in the crop – and like any harvesting, it is done without too much thought. It is carried out through conventional studio sessions with their sitters or exploring their daily environment – the

'WELL THEN, LET'S MAKE THE WORLD OUR GALLERY!'
JAN DEBBAUT

FIG 2
Gilbert & George
in their London
home, 1987.
Photo: Derry Moore

1
*Gilbert & George:
Intimate Conversations
with François Jonquet,*
London 2004, p.79.

spicy and colourful streets of London – by roaming the crowded multicultural boiling pot of Commercial Street and Brick Lane, with its Jack the Ripper stories, narrow smelly passages, its Huguenot and Jewish roots and Bangladeshi markets.

Step two is organising that material, creating a system that makes it possible to use it. It means devising their own visual dictionary; with categories, typologies and indexes. This is the learning process. While organising the material they see exactly what it is that they have harvested.

Step three could be called 'the incubation period'. Pinning countless contact-sheets and hand-written indexes on the wall of the studio, living with them, staring at them, discussing them and seeking their moral dimension, while the raw material slowly sinks in and its potential becomes clear.

Step four might come as a surprise. Gilbert & George study the architecture of the (future) exhibition space for which the new pictures are planned and draw up blank pictures for the lay-out *before* they decide on the formats and the number of pictures they need for the exhibition.

Step five is the actual design of the pictures, ranging from fast first sketches to the final design. During this process – they tell me – everybody has to leave the studio. They must be on their own, fully concentrated, as if in a trance, sometimes for weeks in a row. For Gilbert & George the actual making of the pictures is like an eruption that comes about without too much thinking. The artists switch to a subconscious mode – their own unique *ecriture automatique* – that

spontaneous process of improvised and associative action. They might put the process on hold – and they might sometimes even escape the studio – but they never reject works once they are done. They accept whatever comes out.

Each new group of pictures is first exhibited in the gallery it was created for and is conceived as a consistent and coherent body built around one theme or motif, as well as published in a standard oblong format, again designed by the artists. Researching, conceiving, designing, exhibiting, publishing, discussing, documenting and archiving are all part of one and the same integrated and consistent practice, or more accurately 'existence', since their art so much equals their lives and vice versa.

After all these years Gilbert & George are still as interested in talking to an audience as wandering the streets of London for subject matter or exploring the technical possibilities offered by the newest digital image-processing. They are in control, take the decisions, and that is part of the way they work: 'We are arrogant in pretending to know what pictures the world requires, which pictures are needed' they say, 'but we do not work for the in-crowd.'

With artists so complete and all-encompassing as Gilbert & George, there is not much left for a curator to do other than offer a helping hand and be the caretaker of the artists' vulnerability. Because vulnerable they are. At certain moments – and especially in their own country – Gilbert & George can come under heavy media attack, mainly because of their subject matter. It makes them feel fundamentally misunderstood and has taken their work repeatedly into an unwanted sensationalist perspective. To believe that Gilbert & George deliberately aim to provoke is to

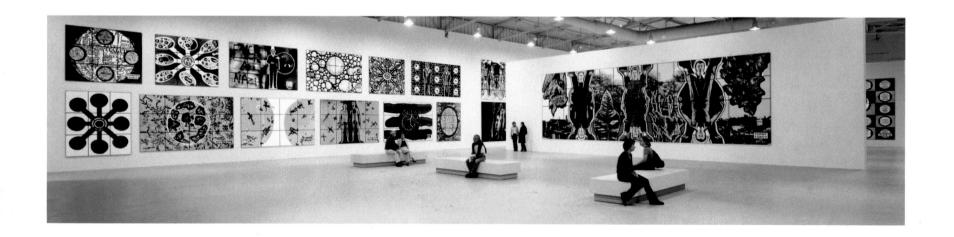

misunderstand them. 'Shocking is a media idea', they say, 'it is not an artist idea. Our pictures are not attacking or confronting, but exploring.'

Over the years, the art of Gilbert & George has explored the human condition – *our* human condition – in all its aspects. As artists they are enhanced observers with an eye for the detail that tells a story. And however confrontational or disturbing that story might be, their artistic integrity claims the freedom of speech to tell it without compromise. It is this moral quality that can make some people uncomfortable while looking at their pictures. Gilbert & George continue the role of the court jester at a time when freedom of speech and frankness are no longer fully respected or protected.

Unless otherwise indicated, all quotes were compiled by Jan Debbaut in preparatory exhibition meetings with Gilbert & George.

We met in London last year

We began to dream of a world of beauty and happiness of great riches and pleasures new of joy and laughter of children and sweets of the music of colour and the sweetness of shape, a world of feeling and meaning a newer better world, a world of delicious disasters of heartrending sorrow, of loathing and dread a world complete, all the world an art gallery.

THE LAWS OF SCULPTORS

1 Always be smartly dressed, well groomed relaxed friendly polite and in complete control

2 Make the world to believe in you and to pay heavily for this privilege

3 Never worry assess discuss or criticize but remain quiet respectful and calm

4 The lord chissels still, so dont leave your bench for long

FIG 3
View of a major exhibition at
Athens School of Fine Arts,
2001

FIG 4
THE LAWS OF SCULPTORS
1969

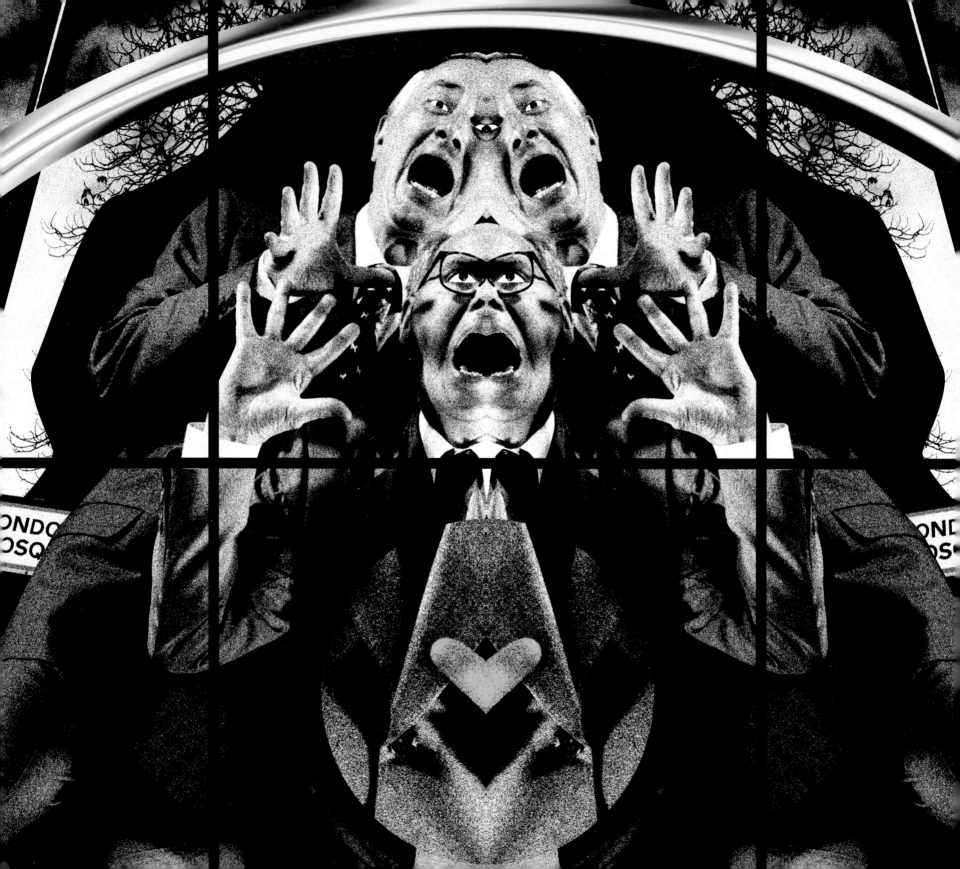

Trust yourself when you look at Gilbert & George's pictures. Don't listen to what others have to say. Put aside your prejudices. Bypass an intellectual response, if need be by force of will. Succumb to your gut reaction, even if it awakens unsavoury thoughts. Dare to think the unthinkable, as the artists themselves do when they create their art in a 'dead-headed' state, filtering out nothing, resisting the temptation to edit their ideas or the images that emerge from them. Give in to this parallel world unreservedly, if only in the spirit of experiment, and see what you will also learn in the process about yourself, stripped of pretence, in all the complicated, contradictory truth of what it is that makes you the person you are. Accept yourself not just for your capacity for goodness or love, for your appreciation of beauty, for your pleasure in the body and the mind, and for your ability to celebrate both the wonder of nature and human achievements, but also for your anger, your despondency, your irrational anxieties, your bad habits, obsessions and addictions, your more brutal sexual urges and your demons, however disturbing these may be even to yourself.

By all means behave in ways that make life easier for everybody – as Gilbert & George so conspicuously do through their celebrated politeness, ritualised re-enactments of social conventions and immaculate way of presenting themselves – but have the courage to follow their example also in stripping yourself naked, metaphorically and emotionally, until you truly know yourself. The journey through art and life that these two men have undertaken together since joining forces to become one artist, soon after meeting as students in 1967, has above all been a voyage into self-understanding. To look at their art, therefore, simply as a spectacle or even as a prolonged investigation of the human comedy would be to miss the full force of its moral purpose.

Perhaps the most valuable part of a prolonged encounter with Gilbert & George's art is to learn from their fearlessness in mercilessly exposing themselves, even to the extent of ridicule and self-humiliation. They did this right from the beginning, when they cheerfully presented themselves in 1969 as *George the Cunt and Gilbert the Shit* in their 'magazine sculpture' of that name, first published in black and white and with the offending words censored in the May 1970 issue of *Studio International* as a way of arming themselves to deal with every obstacle that life could possibly put in their way (see fig.6).

Viewed in this manner, without preconceptions and even without worries about what constitutes artistic value, Gilbert & George's pictures have a genuine and sometimes frightening potential to shake us out of the sleepwalking that all too often we mistake for living. These pictures, especially when hung close together in exhibitions to fill our field of vision, flash by as images and imprint themselves on our minds like a succession of passing thoughts. They prompt and dare us in turn to smile, to feel awe, to succumb to despair, to yearn for escape, to enjoy moments of infantile silliness, to become sexually aroused, to feel tenderness, to experience shame, to be horrified or disgusted, to laugh at ourselves, to think about the inevitability of death and the uncontrollable speed with which our youth (and with it some of our hopes and aspirations) slips away.

In short, by refusing to insist on its privileged status as art, the work of Gilbert & George frees us all, if we allow it, to take life as it is in all its messy and imperfect glory. In the end, its message – and the artists are characteristically immune to fashion in insisting above all on the importance of their art's message, rather than its form – is an optimistic one, leading as it does to an acceptance of the diversity of human experience and of the vagaries of our brief existence. Most of us have

FROM THE HEART
MARCO LIVINGSTONE

FIG 5
HEART
2004
(Detail from pl.172)

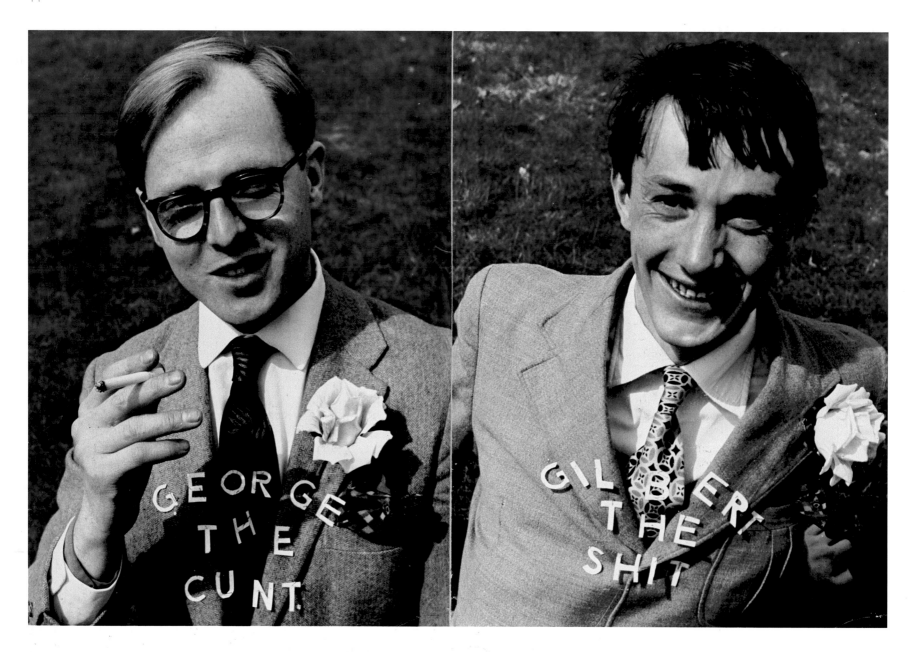

FIG 6
GEORGE THE CUNT
AND GILBERT THE SHIT
1969
38 x 64 cm
A censored version of this magazine
sculpture appeared in *Studio
International* the following year.

a capacity to be spiritual and compassionate, but also to act on our baser natures. No judgement needs to be passed on matters that apply to everyone, even if social convention has dictated that certain things be deemed improper for public discussion, like the body functions that Gilbert & George have brought controversially (and to some unpalatably) to the surface of their later pictures. These are all just facts of life. This extraordinary pair have subjected themselves to an unremitting self-exploration and self-exposure, not out of self-importance or vanity – quite the contrary, when one considers the brutal honesty with which they have presented their emotions, their appearance and even the fluids coursing through their bodies – but as an example to others of the necessity for a fully examined life.

From the moment that they began working together self-consciously as a unit, Gilbert & George have proceeded with an almost frighteningly focused sense of purpose. Having made the momentous decision to present themselves as the object and subject of their art, notably in a living sculpture (as they termed their performances) first presented in 1969, *Underneath the Arches* (fig.24, p.32), they conceived of the artefacts they produced as concrete realisations of their thoughts, moods and experience of life at any given time. The form, in a sense, was immaterial. That they have employed photography as their prime, if not exclusive, medium since 1971 speaks not of any devotion to that process for its own sake, or even as a way of asserting their modernity, but as a purely pragmatic solution to producing large-scale pictures with maximum impact and to translating the images in their minds as quickly as if they had been beamed telepathically from their brains to the surface of the paper. Working with the camera also had a built-in advantage for artists who wished to deflect attention from the 'how' to the 'what' of their pictures, from the process to the subject matter, so

that the viewer experiences each picture fully formed and with the force of a thunderbolt, not as a series of traces made over a period of time. Though their pictures are actually arrived at through an elaborate and convoluted procedure – involving the shooting of huge numbers of negatives, the sketching out of the compositions in small drawings (never exhibited), the printing of the separate components on the largest commercially available sheets of photographic paper and the selective hand-colouring of these panels – they cover their tracks in order to convey the impression that they have been created almost effortlessly.

There is, of course, another way in which photography proved the perfect vehicle for two artists working together who wished to present a united front. By removing any obvious sign of the handmade, they effectively thwarted the possibility of the viewer being able to differentiate one person's input from the other's, with potentially divisive consequences. From 1970 to 1974, just as they were making their first photo-pieces, they did, in fact, also produce an extended group of very large and extremely affecting drawings under the title *The General Jungle* (which they termed 'charcoal on paper sculptures') and a group of similarly ambitious canvases entitled *The Paintings (with Us in the Nature)* (fig.7). In both these cases they sought to subvert the associations of either medium with individual creativity – the notion of 'touch' or style – and to employ instead as inert and depersonalised a method as possible, as if the pictures could have been executed by anybody. However, all these handmade works were produced at great speed from their own photographs by the two of them working together. Had they had the financial and technical resources to present these images photographically on the scale they wanted, they would have had no hesitation in doing so. Paradoxically, given their utter and final rejection of their individual identities, they played in all these works on their singularity as an artistic enterprise

FIG 7
Triptych number three from
THE PAINTINGS
(with Us in the Nature)
1971
An oil on canvas painting sculpture
230 x 680 cm

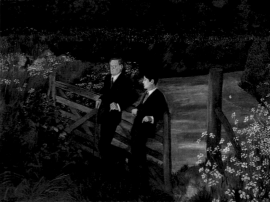

by reference to nineteenth-century Romantic notions of the artist as a lonely, friendless and solitary being, isolated at the margins of society, communing with nature or (in the case of *The Bar No. 1* and *The Bar No. 2* 1972, pl.2) losing himself in the oblivion of drink. Revealingly, it is only in the first of the drawings, in diptych format, *All My Life I Give You Nothing and Still You Ask for More* 1970 (pl.1), that they reveal their separate artistic handwriting: one panel is signed 'Gilbert by George', the other 'George by Gilbert'. Never again did they lay bare their separate manual abilities in this way.

The rigorous grid system that Gilbert and George have employed since the *Cherry Blossom* works of 1974, the graphic clarity of their art from that time onwards, the decision to limit themselves to a particular range of imagery or restricted set of colours in any given group, all contribute to a sense of the artists being in complete control of their language and proceeding in an orderly fashion. This sense of rigorous logic and even of a certain professional ethos (a notion that they would in some ways find abhorrent) is declared also by a rather astonishing point of fact: that every one of these pictures has been made as part of a larger group destined for a gallery or museum show. That is to say that not once in their lives have they made a one-off picture because an idea had occurred to them that had to be made then and there. In fact, just as they have made all their art as a couple, so too they prefer to see sequences of their pictures displayed together in mutually supportive fashion, so that the whole is always greater than the sum of the parts. They despair of seeing their works displayed individually in the permanent collections of museums, their power diminished by isolation. It would be difficult to think of any other contemporary artist for whom the exhibition is more essential as the preferred format or medium.

The sense of purpose remarked upon earlier, the compulsive work ethic that has resulted in an almost industrial productivity, and the unswerving reliance for more than three decades on the strict rectilinear grid of standard-sized elements, might well contribute to the notion that Gilbert & George proceed purely methodically, setting themselves a particular task and then knocking out enough variations to fill whatever space in which they are destined to be displayed. While it is certainly true that with practice they have become clearer and consequently more efficient about what will work, all the while adding to the enormous bank of images from which they can draw at any time, it would be misleading and unhelpful to assume from the confidence exuded by their pictures that they have been arrived at easily or even through a logical process. A necessary corrective to the artists' highly organised mindset has been their consistent willingness to trust their intuitions, to make spontaneous decisions, even to base entire groups of pictures on propositions that seemed even to them to be preposterous, verging on lunacy. (It is not for nothing that they used the term *Mental*, with its double meaning, as the title for an important group of pictures in 1976.) Always aware of the complementary forces at work in all our lives, they appear to relish being at once totally in command and completely out of control.

This duality, and proof (if needed) of their essential trust in irrationality as a creative force, is powerfully in evidence in the 'drinking pieces' of 1972 and 1973 (pls.13–22) that are among the first works in which they made use of photography, a large number of which were presented in 1973 under the self-deprecating title of *New Decorative Works*. Like the even earlier *Nature Pieces* of 1971 (also known as *Photo-Pieces,* pls.11 and 12), each consists of numerous separately framed fragmentary images, the small dimensions of the components

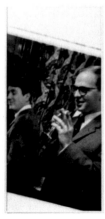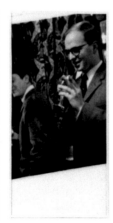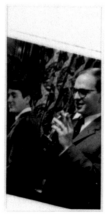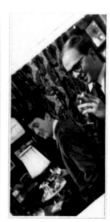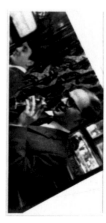

accumulating through numbers into an eccentrically shaped whole that makes its physical presence powerfully felt. There is no set format to any of these works, making evident how gradual a process it was for them to settle eventually on the conventional rectangle; resistant though they were to being influenced by the work of their contemporaries at St Martins or further afield, the random configurations they favoured in their first experiments suggest a sympathy, at the very least, with the 'anti-form' tendencies of the time. Arranging the separate frames in their final configuration only when first hanging them for exhibition, they tried out a variety of methods, scattering them on the wall in a frenzied vortex suggestive of the dizzying effects of excessive consumption of alcohol, as in *Falling* or *Smashed* of 1972 (fig.9); laying the panels almost edge to edge, just out of alignment, as in *Tipsying* 1972; pooling them together into ragged geometric shapes, such as the oval of *Balls* 1972 (pl.13) or the tilting rectangle of *Head over Heels* 1973 (pl.18); or even laying them out, as in *True Man* 1973, so as to suggest a standing figure. The individual elements, though based on crisply defined negatives taken in bars, are in many cases manipulated in the studio/darkroom, distorted or printed deliberately out of focus, so as to communicate the state of intoxication and blurred vision appropriate to the subject. These key formative pictures are to some extent a classic case of 'emotion recollected in tranquility', made as they are with a clarity of purpose though hot-wired from the artists' actual experiences of becoming uncharacteristically inebriated as they came to terms with the expectations to socialise placed upon them as newly successful artists.

A taste for eccentric shapes as part of their urge to break the boundaries of convention is manifested in an even more extreme way in the *Modern Rubbish* series of 1973. These pieces take on the

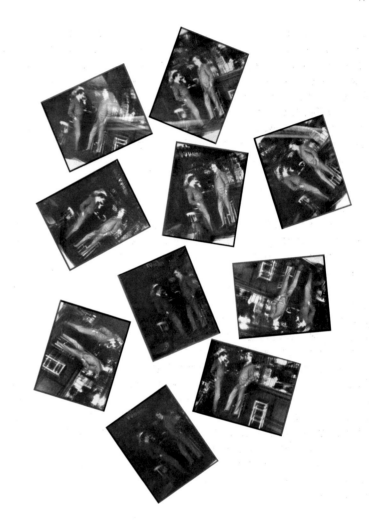

FIG 8
A TOAST
1973
51 x 193 cm

FIG 9
SMASHED
1972
190 x 132 cm

appearance of mathematical formulas ('*To Her Majesty*', pl.19) or of rudimentary writing (as with the three Xs of *The Secret Drinker* 1973 (fig.10), or the emblematic *G and G* 1973), while *Inca Pisco A.* and *Inca Pisco B.*, both from 1974 (pls.23 and 24), take the head-shaped bottles of a highly potent South American spirit as a cue for a male and female figure respectively, dancing wildly with arms outstretched. As with so much of Gilbert & George's art, the energy of the work results not just from an imaginative (and in this case witty) pictorial solution, but in the fact that the subject is rooted in their lives and true to their experience. Both dancing and drinking figured heavily in their end-of-day routine at that time, as it did for many of their equally young artist friends. Rather than returning to the studio the morning after to engage in some cerebral activity totally disconnected from the night before, they made the very honest decision to convey – even in the torpor or haze of a hangover – the reality of their existence as they spiralled out of control.

At every stage, in every new group of pictures, Gilbert & George have continued to speak unreservedly of the condition of their lives and their state of mind. Working pointedly within a society that prizes reticence to the point of hypocrisy, this naked and almost unmediated self-exposure has been their extraordinary gift to anyone confronted by their art. It constitutes an affecting avowal of our shared, and highly imperfect, humanity. In the *Human Bondage* series that followed in 1974 (pl.25), where the layout begins to approach a more regular grid of equal-sized elements, and in the *Dark Shadow* pictures of the same year (pls.26–8), which recomplicate the sizes of the constituent parts but within a completely contained rectangular structure, the shift to a stricter format carries within itself the same openness of possibility as that found in the more random configurations they had employed during the previous three years.

As the elegance, simplicity and austerity of their formal solutions increased, so the content became correspondingly darker and more enervated. Increasingly celebrated as artists, they experienced a greater intensity of despair, anxiety and desperation than before, locking themselves away as much as possible while simultaneously making their art and renovating the early eighteenth-century house in the Spitalfields district in which they had first rented rooms as students and which by this time they finally owned. Undertaking the daunting task of bringing the 'dead boards' of this wood-panelled house back to life, living in rooms bare except for the sawdust they raised with their tools, they confronted their mortality far more deeply and troublingly than would normally be the case for those still in their early thirties. The swastika or inverted swastika that appears in some of the *Human Bondage* pictures, interpreted by some as a flirtation with Fascism, is relayed (like the Christian cross) as evidence of the torments we inflict upon ourselves and each other, and of the imprisonment we experience through the mere fact of acting on our desires. All life is suffering, according to Buddhist thought. The *Dark Shadow* pictures, in spite of their kaleidoscopic light effects and geometries, are similarly shot through with melancholy. The artists appear occasionally on the same panel, double exposed, but more usually apart and contained within separate frames, each as if imprisoned in his own world – fundamentally alone, like all of us, in spite of their shared enterprise.

Some viewers may find aspects of these pictures sad or even depressing, as they might find later works violent or sordid. That is a perfectly legitimate response. We are all free, in any case, to seek solace in art made in a more optimistic and celebratory state of mind, or even to abandon all contact with reality and attempt to see everything in a rosy glow. But escapism, however well intentioned, is not part of

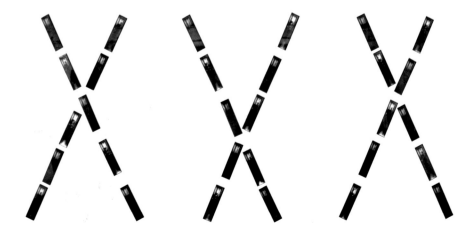

FIG 10
THE SECRET
DRINKER
1973
287 x 608 cm

Gilbert & George's lifelong project. Many who lived through that dreary, grey period of English life in the mid- to late 1970s will feel at least a twinge of recognition concerning the pervasive mood of hopelessness at that time, the very atmosphere of aggression and violence that is embodied by the *Cherry Blossom* pictures of 1974 (pls.29–33, fig.11) and *Bloody Life* pictures of 1975 (pls.36–40), with their ritualised Kung Fu gestures and sudden infusions of blood red. The same negativity was expressed independently (but in response to those very conditions) with equal vehemence in the music and attitude of punk.

Gilbert & George seem to have an uncannily sensitive radar to social changes – in spite of their professed isolation, and notwithstanding their avoidance of other people's art, music or literature. They repeatedly anticipate seismic upheavals in the fabric of life, including the onset of AIDS in the early 1980s and the more recent development of Britain into a multicultural society. They have done so, more remarkably, entirely within the compass of their home in the East End of London. Every single negative they have taken for use in their art has been shot within walking distance of their studio. Yet within this apparently severely restricted geography they have somehow addressed themselves to the whole world. It is not just luck that brought them to one of the most cosmopolitan neighbourhoods on the planet, with its constantly shifting communities and conflicting ideologies. It is a question also of their extreme attentiveness even to apparent trivialities and minutiae – right down to the blobs of spat-out chewing gum trodden underfoot on city streets – that speak of universal human experience and more particularly of modern urban existence.

Even by Gilbert & George's standards, the *Dirty Words Pictures* of 1977 (pls.65–71), first exhibited under the mischievously bland title of *New*

Photo-Pieces, packed a violent punch whose aftershocks continue to be felt to this day. Earlier in 1977, having concentrated during the previous five years on internal matters – their moods and thoughts circumscribed by the rooms in which they lived, worked or drank or made concrete by reference to nature – they had begun in the *Red Morning* pieces (pls.61–4) to turn their attention outwards to the urban landscape on their doorstep. The cityscape they picture of faceless, anonymous, alienating office blocks and residential high-rises communicates an almost totalitarian disregard for the individual, with an attendant bleakness. The Romantic image of the solitary poet in nature is now transformed into that of the loner in the modern city. In *The Dirty Words* they take this experience of despair, disenfranchisement and isolation further still by identifying themselves not just with tramps and vagrants (as they had in *Underneath the Arches*) but with the angry, aimless youths among whom they walked on the city's grimy streets.

For the first time in their art, there is a sense of direct political engagement, but one destined to unravel in response to any attempt at analysis. Does *Communism* (pl.71) betray the artists' own stance, or even reveal unambiguously that of the person who spray-painted the word on the wall, or should we assume that *Smash the Reds* (fig.12) is more indicative of their opinion? Is there any reason to detect, as the artists' detractors were to do during the 1980s, traces of National Front sympathies just because some working-class East End youths are associated with extreme right-wing views? Many of the men pictured in these works – and presented sympathetically as fellow suffering human beings with whom they feel a strong kinship – are, after all, black or Asian. It is therefore difficult to understand on what basis accusations of racism were made against the artists other than from a simplistic reading based on the occurrence of words such as 'PAKI', used by

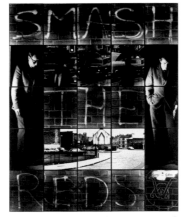

FIG 11
CHERRY BLOSSOM
NO.3
1974
211 x 251 cm

FIG 12
SMASH THE REDS
1977
300 x 250 cm

some as a term of abuse but here presented more neutrally. These pictures, made during the 'Winter of Discontent' in the last days of a Labour government prior to Margaret Thatcher's long reign as prime minister, might more convincingly be taken as proof of the Conservatism that the artists (and George in particular) were later to proclaim in defiance of the Leftist, liberal views held as a badge of honour by most artists. Yet even this observation would be difficult to defend in view of the undoubted empathy the art expresses with those struggling at the margins of society: the poor, the unemployed and others left feeling powerless and utterly without hope. Whatever the artists themselves may say, these works are closer in spirit to the Sex Pistols' 'Anarchy in the UK' – then ringing in the air as a rallying call to disaffected youth – than to the Tory party manifesto.

The graffiti that supplied the 'dirty words' for these pictures is largely of a defiantly vulgar sexual nature, terms of abuse or simply of frustration and desire (fig.13). By taking these often desperate unsigned scrawls the artists give voice to those driven to assert themselves – because of their own sense of impotence – to making their marks on the streets occupied by us all. Those words of provocation, which sully and desecrate the environment, dare society at large to take notice of them. In recording these abusive remarks, Gilbert & George not only dignify them with attention but immortalise the unnamed people who made them, accepting them, in a sense, as fellow artists – as they were again to do in pictures such as *The Penis* 1978 (pl.76), the four lower panels of which present an enlargement of a crudely drawn picture of a head of indeterminate sex eagerly holding out its tongue to catch a flow of semen spouting from a hilariously oversized male member. The gesture of solidarity with such works of the imagination is an especially generous one considering that the artists have so steadfastly refused to allow themselves the luxury of their own handmade marks.

The formal strategies by which Gilbert & George have constructed their pictures have remained essentially the same from that moment in the late 1970s. Though they have constantly elaborated their visual language – most obviously in the complications they introduced through a much wider spectrum of colour in the 1980s – they saw no reason to alter a format that offered them such flexibility in terms of imagery, scale, pictorial space and composition, not to mention of mood or subject matter. Pictures could be made in this format even without a camera, as with the playful, emblematic motifs festooned on pictures of the early 1980s such as *Speaking Youth* 1981 (fig.14), each of which was 'drawn' in the studio by cutting out shapes to be used as masks or stencils and then selectively coloured with vivid dyes. The technique constituted a survival of their drawing instincts, in spite of themselves, though subsumed into photograms.

Having discovered a new way of constructing a picture, they reserved the right to return to such methods when it suited them. In the case of these photograms, they revisited the idea in 1982 in a group of particularly sexual pictures such as *Sperm Eaters*, *Thirst* and *Hunger* (pls.93–5), their outrageousness excused by their comical formulation. An exchange of body substances is portrayed as a sacramental act, one that transcends disgust, as it does in the sexual act itself. Through such imagery they create a metaphor for the very act of looking in which we are all engaged as an equivalent interchange of intimacies between the artist and ourselves. One of these photograms, *Holy Cock* 1982, echoes in its title some lines from the footnote to *Howl* by American Beat poet Allen Ginsberg, published in 1955: 'The world is holy! The soul is holy! The skin is holy! The nose is holy! The tongue and cock and hand and asshole holy!/ Everything is holy! everybody's holy! everywhere is holy! everyday is in eternity! Everyman's an angel!'

FIG 13
BOLLOCKS
WE'RE ALL ANGRY
1977
242 x 202 cm

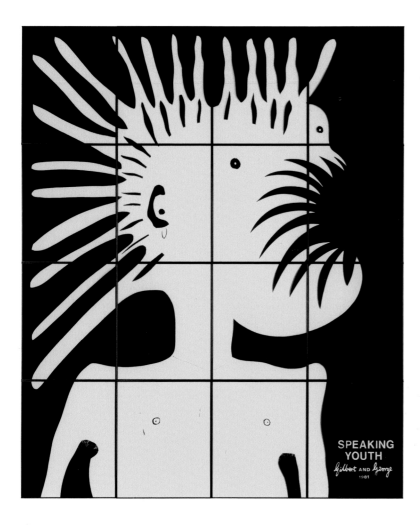

SPEAKING
YOUTH
Gilbert AND George
1981

Although every feature, every component of Gilbert & George's pictures exists on that thin surface of photographic paper, the lack of conventional surface interest – the kind of mark or materiality to which one would normally be attracted when looking at handmade paintings or drawings – succeeds in somehow making invisible both that surface and the framing grid that contains it, so that one has the sensation of looking through a transparent plane into an endlessly shifting and surprising world of images. The effect is particularly pronounced when one is confronted by closely hung banks of their pictures in exhibitions. It is like swimming in a sea of the imagination. One never knows quite what is going to float by one's field of vision next.

So it is that each group of pictures represents an unpredictable shift of tone, mood and pictorial structure. Among my favourite Gilbert & George works are those of 1980 and 1981, some of which were exhibited as *Modern Fears* (pls.78 and 84–92), which are very close in their range of imagery and visual elegance and simplicity to the feature-length film masterpiece they released just at that time, *The World of Gilbert & George*. These remain among their most poetic, tender, life-affirming, graceful and frankly beautiful works. There is a strong erotic charge to many of these pictures, and not just those of attractive young men displaying themselves seductively that might appeal to a gay man like me. The close-ups of flowers with their petals unfolding, as in *Rose Hole* 1980 (pl.90), are as blatantly sexual as the images of young men offering themselves up for an appreciative, lingering look, in works such as *Four Feelings* 1980 (fig.15). The pictures featuring slim young men, naked or clothed – the first group to feature models posing for them in the studio, rather than on the street or glimpsed from afar – are among those that caused Gilbert & George's later art to be routinely labelled 'homoerotic'. It is a term that they have

FIG 14
SPEAKING YOUTH
1981
242 x 202 cm

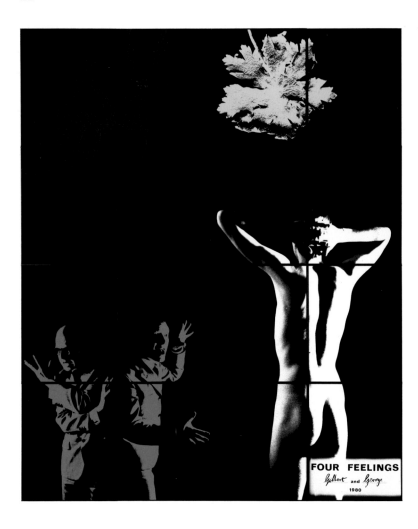

steadfastly rejected, asserting that the simpler 'erotic' will do, admitting as it does the possible response of women (all too often excluded from art-historical discussions surrounding the nude) and the basic fact of sexuality as a force within us all. These adolescents are also, of course, stand-ins for the artists themselves, which is one of the prime reasons that they never use females in their pictures, a factor that has led to another common misapprehension of their art as misogynistic. That both artists were by then approaching forty helps account for the wistful, elegiac tone of these pictures, which touch so powerfully and movingly on those moments of life reaching perfection before the inevitable decay, decline and death. These are bittersweet pictures, at once among their most celebratory and their saddest.

During the 1980s Gilbert & George elaborated their pictures with complex conjunctions of images and clashes of colour in far greater variety, seeking to present not just a concentrated emotion or visual sign at maximum intensity – at which they were by now so proficient, as a work such as *Deatho Knocko* 1982 (pl.99) attests – but a sequence of separate and even contradictory sensations and moods. They did so most spectacularly on works created on a panoramic scale, such as *Life Without End* 1982 (pl.103, arranged over 154 panels). I say 'panoramic' rather than 'monumental' because the urge is not so much to impress or overwhelm the spectator as to invite him or her to enter fully into the world they have created. The intention is to achieve a greater intimacy, not a greater distance (as would be implied by notions of the monumental). This development reaches a peak in 1984 with *Death Hope Life Fear* (pl.119), in which they address themselves to the primal emotions and facts of existence. In its profusion of sumptuously coloured images, in its totemic qualities and in the suggestion of the artists repeatedly giving birth to themselves through their imagination

FIG 15
FOUR FEELINGS
1980
242 x 202 cm

and in their art, they give form – however exaggeratedly – to the same ambitions and anxieties, and re-enact the same cycle of life and death, to which all of us are subject.

All the big themes tackled by Gilbert & George recur in their art, as do particular motifs, sometimes making an isolated and surprising first appearance only to return years later as a major concern in its own right. Issues of faith and religion dealt with in the *Believing World* pictures of 1983 (pls.111 and 113–17), for instance, resurfaced in far more perturbing form over two decades later in the *SonofaGod Pictures* of 2005 (pls.189–93), this time played against the background of fundamentalism, superstition and terrorism. What seemed like a (possibly distasteful) oddity within the *Believing World*, a picture called *Shitted* (pl.112) that represents our two suited friends with human-sized turds falling in on them, was to prove a polite rehearsal for an entire group in 1994, *The Naked Shit Pictures* (pl.153 and fig.16). These showed the now vulnerably naked and ageing protagonists baring all and risking total self-debasement as a form of humility – much as they had done twenty-five years earlier in portraying themselves as *George the Cunt and Gilbert the Shit*.

The city, and specifically London, as the focus of modern life also rooted in history had been a strong presence in Gilbert & George's art long before they began picturing its streets in the mapped backgrounds to the *Rudimentary Pictures* of 1998, such as *Gum City* (pl.159) or presenting the street signs in the *Twenty London East One Pictures* of 2003 (pls.169–71). A work from the latter series entitled *Twenty-Three Haunts*, and several from the *Thirteen Hooligan Pictures* that followed in 2004, prominently feature 'tags' – the stylised signatures by which street artists mark their territory on street walls and facades – an update

of the graffiti motifs that they had employed so effectively and with such brutal force nearly thirty years earlier in the *Dirty Words Pictures*.

The emergence of AIDS as a pandemic around 1984 gave haunting new meaning to the pictures they had made in 1980–1, with their sense of life cut off in its prime. This became a conscious theme in its own right with the *For AIDS Pictures* of 1988, the entire proceeds of which were donated to the AIDS charity Crusaid. With their massively magnified drops of blood as a carrier of both life and death, these pictures in turn introduced the imagery of body fluids, including semen, tears and urine, that were to be foregrounded as motifs in the *Fundamental Pictures* of 1996 (pls.154–6), *New Testamental Pictures* such as *Spit Law* 1997, *Our Spunk* and *Spunk on Sweat* 1997 (pls.157 and 158, and fig.17) and some of the *Rudimentary Pictures* of 1998. It was a way of entering even more deeply, and literally, inside the artists and consequently inside our selves. The tragic sense of AIDS-related loss that worms its way insidiously through their work, haunting even the most apparently benign motifs, can also be deduced from the gradual disappearance by the early 1990s of the images of young men that had been such striking presences in their art a decade earlier. Having witnessed the deaths of so many of their friends from this devastating disease, they lost not only some of their models but also some of their will to invite others into their studio, and they retreated, wounded, inside themselves. The *New Horny Pictures* of 2001, such as *Named* (pl.160) and *Twelve* (fig.18), marked a particularly sombre return to this theme. The contact ads for male escorts that they had collected for years are here reprinted, without comment, as stand-ins for sexy, vital men now likely to be dead or at least grown old: they read like grave-markers and tombstones, prolonging their memories and celebrating the life force within them by offering them the dignity of being immortalised in art.

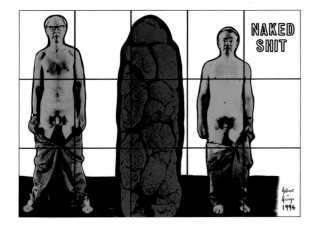

FIG 16
NAKED SHIT
1994
253 x 355 cm

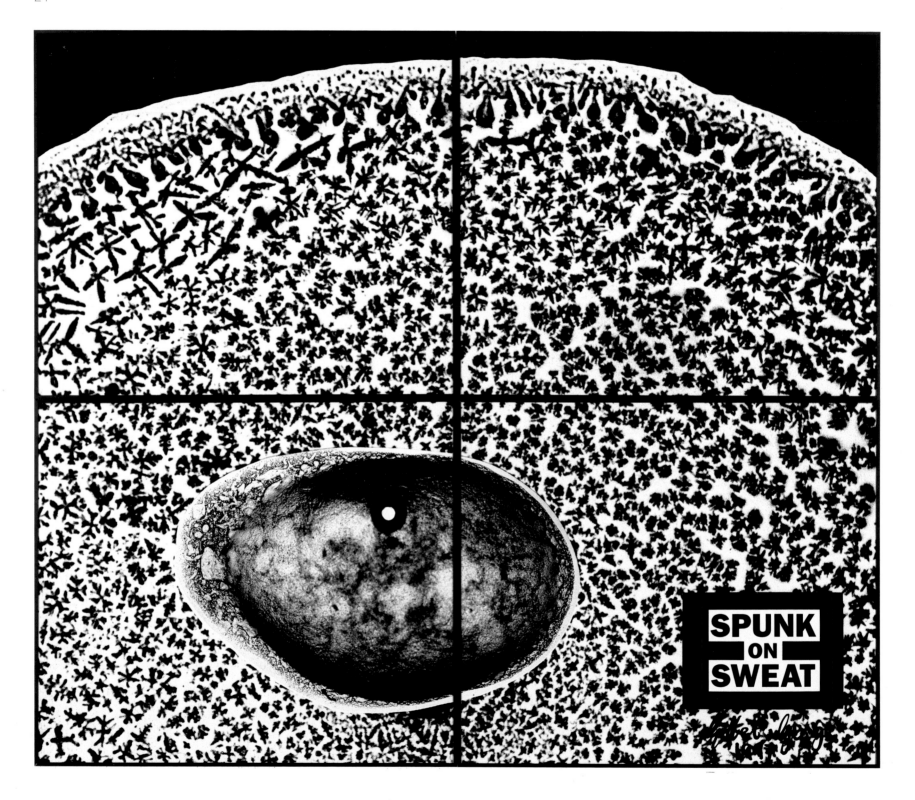

SPUNK
ON
SWEAT

Laid out chronologically, the pictures of Gilbert & George invite the spectator to share in the adventure of their lives together in art, their thoughts and emotions made concrete, their observations of the world around them and of the changes in their society turned into visual metaphors of stunning and memorable concision. Now that they have both passed the age of sixty, Gilbert & George naturally have begun ruthlessly confronting the reality of their own ageing and the daunting proximity – hopefully still a few decades away – of their own demise. They have chosen to do so just as they reinvent their technical procedures for making art, no longer manipulating the negatives in the darkroom or hand-colouring them. Now, as befits two men who produce art that has always been of its time, they carry out everything apart from the initial imagery on computers, using powerful software adapted to their very particular needs. As the pictures continue to be conceived on the same principles and to be printed out on photographic paper of the same size as before, arranged as always in the grid of frames, the change of procedure is not apparent except in the far greater flexibility it gives them in combining and manipulating their still-growing dictionary of images. The mirroring they employ in many of these recent works from the *Thirteen Hooligan Pictures* or the *Perversive Pictures* of 2004 (pls.172–82) results in terrifying, distorted, distended, grotesque representations of themselves. Turning their faces into far older and more decrepit versions of the way they are now, they imagine themselves further along the line towards certain death. They do this fearlessly, in the same way they have faced every other reality of existence as a fact that cannot be avoided, and with their habitual honesty, as can be judged from the trauma, despair and outright panic conveyed by works such as *Heart* and *Crystal* 2004 (pl.172 and fig.19). How could it be otherwise, for artists who over a period of thirty-five years have produced over a thousand pictures from the heart?

Let's all laugh in the face of death. Treat yourself. Release yourself. Be unafraid. You will not get too many chances like this, certainly not in an art exhibition. Tomorrow it will again be business as usual, with much worthy art being produced and consumed in a spirit of well-intentioned professionalism – 'career' art – rather than driven, as Gilbert & George's work is, by the forces that define our personalities and animate our daily experience.

FIG 17
SPUNK ON SWEAT
1997
127 x 151 cm

FIG 18
TWELVE
2001
213 x 338 cm

FIG 19
CRYSTAL
2004
142 x 169 cm

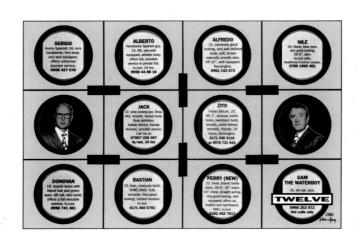

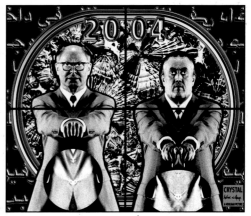

'You may be certain that this drama is neither fiction nor romance. All is true, so true that everyone can recognize the elements of the tragedy in his own household, in his own heart perhaps.' [1]

Streets, strangers, leaves, crosses, money, blood, doorways, flowers, maps, rain, graffiti, trees, shit, amulets, tracts, gum, semen, traffic, buildings, sweat, signs, flies, teenagers, litter, graves, piss, tramps, statues, Gilbert, George. Gazing, gesturing, screaming, shouting, resting, collapsing, running, singing, pointing, dancing, watching, witnessing, walking.

Since first meeting at St Martin's School of Art, London, in 1967, Gilbert & George have worked without pause to make an art that conveys, at the most visceral level, the stark experience of being alive in the modern world. In this endeavour, they are concerned with the common denominators of the human condition: with the emotions, physiology, beliefs, economies and truths that apply to everyone. Hence their declaration, as early as 1969, of their ambition for an: 'ART FOR ALL'.

In the art of Gilbert & George, the universal is made eloquent by the local, and the profound, epic vision is discovered in the simple quotidian detail. From religious propaganda to wild flowers, phenomena and feelings that might occur in any modern city on Earth have been recorded by Gilbert & George in the streets immediately around their home in Fournier Street, east London. The title of a work from their *Rudimentary Pictures* of 1998, in which we see enlargements of details from the street map of east London, could be said to summarise this equation: *Fournier World* (fig.20).

In the forty years during which they have been making their art, Gilbert & George have always been concerned with communicating feelings and passions, rather than intellectual propositions or emotionally weightless ideas. Their art presents an entire cosmology of the human experience, and has been based upon the absolute truths of their own lives. Thus, those phenomena that they have not recorded in the streets around their home, for subsequent placement and expression in their art, Gilbert & George have taken from within their own bodies – locating scripts and symbols, maps and patterns, a destiny encoded within the massively magnified substances of their own blood, sweat, urine and tears. It is as though the artists have undertaken their own pilgrim's progress – a lifetime's journey upon which, against all odds, they have continued to create intensely felt, richly detailed, utterly lucid, and at times dramatically vertiginous, accounts of our social, moral and emotional existence.

But how was such a vast project conceived, by two young artists who knew themselves to be almost completely at odds with the system of art-making into which they had been educated? One answer must lie in the courteous but immoveable manner in which Gilbert & George began by setting themselves apart – apart from other artists of their generation, apart from the fashions and prevailing trends of their times, and apart from any creed or ideology other than the one that they were both determined and inspired to create for themselves – word by word, picture by picture, action by action, inch by inch.

This is not to say that Gilbert & George retreated to the Ivory Tower of popular imagination – to some hall of mirrors created by the private intensity of their own relationship. Rather, the complete opposite is true. The two young artists took themselves to those very places where

'FOURNIER WORLD' THE ART OF GILBERT & GEORGE 1967–2007
MICHAEL BRACEWELL

1
Honore de Balzac, Le Pere Goriot, Paris 1834.

neither their art nor their personal relationship (the two being indissoluble) would be likely to be understood or tolerated, let alone applauded.

They went east – to that area of London that had been defined on sociological maps (the districts colour-coded to denote their social climate) right up until the 1930s, as one of utter moral dereliction; a place of thieves, whores, beggars and addicts, into which no 'decent' person – let alone an inhabitant of the fashionable art world – would either care or dare to set foot.

On the one hand, this move was demanded by necessity – the east of the city was cheaper than the west. But there was also the sense that Gilbert & George could never have made their home – and they have subsequently said that their home is in many ways a part of their art – amidst what in the late 1960s were the more fashionably bohemian squares and terraces of, say, Notting Hill Gate or West Kensington. ('We would die if we had to live in west London', George once told me.) What was required was a place where life flowed around the young artists without interference from the tempering values of culture; a place where art itself would have to be made and tested against the keen edges of an often aggressive or indifferent society. The district immediately around Fournier Street would supply this need, presenting Gilbert & George with a universe in microcosm – the systems and values of which, even in the 1960s, were evolved from and dictated by a daily struggle for survival. At the same time, these streets were encoded with centuries of human activity – that same human journey between the forceps and the stone that Gilbert & George would set about trying to express in every gesture that they made as artists.

Determinedly and constantly modern, Gilbert & George possess a sensibility descended in part from that of the great European naturalistic novelists of the nineteenth century – from Honore de Balzac, Charles Dickens, Emile Zola, Gustave Flaubert or Leo Tolstoy. As alert to nature as they were to the city, and seeing these two states as mirrors of one another, these writers were concerned with a realist vision of the (then newly) modern world; above all, they made eloquent those truths that were as undeniable for the poorest and least fortunate as they were for the wealthiest and most fashionable.

The term used by Balzac for his series of novels concerning the totality of modern experience was *La Comedie Humaine* (The Human Comedy); for Flaubert, there was 'nothing more noble than the contemplation of mankind'; in his *Anna Karenina*, Tolstoy spared the reader no detail of a man's death from consumption, nor of the conflicting, unpredictable, mercilessly ungovernable reactions of his brother, who attends him. But it is perhaps in the acuity of Charles Dickens, one of the greatest anatomists in prose of London life, that we find the closest spiritual precedent for the mission on which, nearly a hundred years after the author's death in 1870, Gilbert & George would first embark. Like Dickens, Gilbert & George would explore the vastness of London as much through its smallest details, lonely outcasts and covert, secret worlds, as through its civic grandeur, social tides and institutional pomp. They would then transpose their experience of the city into a vision as filled with romanticism – an intense poetic strangeness – as it was based upon the vulnerable lucidity of unyielding realism.

Also worthy of note is the fondness and admiration that Gilbert & George have maintained for the early film adaptations of the novels of Dickens:

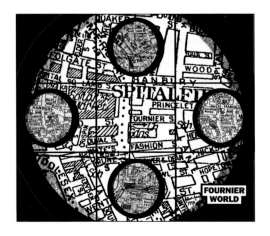

FIG 20
FOURNIER WORLD
(detail on page 26)
1998
190 x 226 cm

the shadowy, portentous, richly atmospheric interpretations of *The Old Curiosity Shop*, *Oliver Twist* and *Great Expectations* made by Thomas Bentley and David Lean between 1935 and 1948 (fig.21). In these films, holding a steady course between melodrama and an intensely imaginative recreation of Victorian London, we see the city as a broiling, volatile, virtually elemental site – a ceaseless configuration of event and emotion, dictated by sudden swerves of fate.

One can identify a similar effect in the art of Gilbert & George throughout their career, from the stillness and profound emotional claustrophobia of series such as *Dark Shadow, Cherry Blossom* and *Bloody Life*, made between 1973 and 1975 (with their relentless articulation of near unbearable lucidity, abandonment and collapse, pls.26–40), through to the *Nine Dark Pictures* of 2001, or the *Twenty London East One Pictures* of 2003 – in which Gilbert & George appear to have become ghostly presences or spiritual imprints upon the very streets of the city (pls.162–71).

In the closing years of the 1960s, the area between Spitalfields Market, Brick Lane and Commercial Street, through the heart of which runs Fournier Street, could not have been more distant from the world of fashionable London that existed to the west of St Martin's School of Art, on the Charing Cross Road. For the East End was a community of market porters, lorry drivers, itinerant workers, furriers, traders, artisan craftsmen, squatters and drunks – the temper of which, at that time, can be judged by the dogged eagerness with which the neo-fascist agents of the National Front sought to elect its interest and support. Once again, this was all a world away from the pot, agitprop and anti-Vietnam protests that were then a popular and vital feature of student life in England. In choosing to live in east London, Gilbert & George

were affirming their view of reality: that as artists they must engage firstly with the world outside the institutions of culture – with the people and places for whom the elasticity of concept and political ideology, as proclaimed by much of the art world, was of little relevance.

Despite a very brief dalliance with the venues and audiences offered by the pop world of the late 1960s, Gilbert & George rejected both the cultural dogma and the rhetoric of permissiveness that was fashionable amongst the artistic and counter-cultural community of the time. They have never been concerned with the political meanderings of sub-culture, fashion or popular taste. Their ultra-modernity has always been resolute: tinged with a heady mixture of neo-Gothicism and science fiction – as though they can depict the innards of our present reality by revealing the relationship between the future and the past. And in this, they convey both the constancy of youth and the inevitability of old age and death – a forceful sense of time passing, unravelling spools of existence, at once urgent and fluid, snagging on boredom or accelerated by exhilaration.

Feelings, as opposed to ideas, consumed them. Power surges in individual or social behaviour; the crazed futurology and shifts in cultural camouflage that admit to no single named author; freakish information storms created by the density and economy of urban life; the worn-out thoroughfares of the streets, home to banality as much as psychotic extremism: these were the qualities that Gilbert & George would increasingly recognise as being the common feelings that they wanted to express in their art – as undeniable and unavoidable as the blood, sweat, shit, tears and piss that accompany birth and death, or the sudden drops into fear and wonder, despair or reflectiveness that happen to us all.

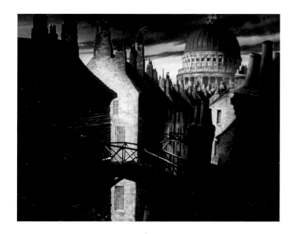

FIG 21
An atmospheric recreation of Victorian London from David Lean's film OLIVER TWIST (1948).

Just prior to meeting Gilbert at St Martin's, George – whose initial employment in the capital had included working at Selfridges department store, and more enjoyably as a barman at an old-time music hall near Villiers Street – had first moved to east London and rented a studio in Wilkes Street for sixteen pounds a month. A photograph taken in 1968 shows 'A corner of the Old Studio in Wilkes Street', and has all the resonance of a scene in a short story: an open fire is blazing on a bare brick hearth; a sign advertising the popular soft drink Tizer is fastened to the wall to one side; a stainless-steel teapot glints in the firelight before an old wooden cupboard. Another photograph taken the same year, 'Posing with *Object-Sculptures* on the roof of St Martin's School of Art, London' (fig.22), shows Gilbert & George against a bone-white London sky, with the Post Office tower directly behind them. The sense of sparsity and lack is palpable.

Subsequent to their life-defining meeting, and initial move to their house in Fournier Street (then a derelict, partially squatted wreck), Gilbert & George took their place within a district of London that was beginning to appear simultaneously ancient and modern. The juxtaposition of dark, Georgian or neo-Gothic antiquity and stark, hard-edged futurism would be a vital component of their art. On the one hand, there were the tall sombre houses of Fournier Street, built in 1724 to house Huegenot weavers; on the other, just a few streets away, the blank, brutalist office buildings that were then being built in the City itself, with their raised and railinged concrete walkways around London Wall and Moorgate.

A television documentary made in 1967, based upon Geoffrey Fletcher's book, *The London Nobody Knows*, would find the urbane and gentlemanly actor, James Mason, serving as our guide to the very street in which Gilbert & George would acquire their home. In his elegant tweed cap and sports jacket, Mason has the air of a patrician but sympathetic tourist, politely impressed as a housewife shows him the spot where, in a backyard in neighbouring Hanbury Street, the horribly mutilated body of one of Jack The Ripper's female victims was discovered.

For Gilbert & George, residence in Fournier Street would be fundamental to the development of their art. You could say that the district was both their palette and their canvas, their subject and their marble, and they immediately set about the business of preparing for their journey through the world that its shabby streets – tense, volatile, poetic, profound – would open up on their very doorstep. 'Gilbert and George, the sculptors, are walking along a new road', the artists would write in their postal sculpture of 1970, *A Message from the Sculptors Gilbert & George*; 'They left their little studio with all the tools and brushes, taking with them only some music, gentle smiles on their faces and the most serious intentions in the world.'

Gilbert & George had also set themselves apart by their appearance, and the seriousness of their intent, therefore, was additionally suggested by their clothes. Their chosen form of dress was nothing more or less than the conventional male attire of the modern urban world – hard-wearing business suits of a plain, unostentatious cut, designed for work and anonymity (fig.23). In this, Gilbert & George could not have been more radical. As young students during the closing years of the 1960s (a decade that John Lennon would retrospectively define as being a time during which 'we all dressed up') they rejected both the conformity and the implicit ideology of youth fashions, preferring what was perceived as the audacious or questionable conservatism of their own neat appearance.

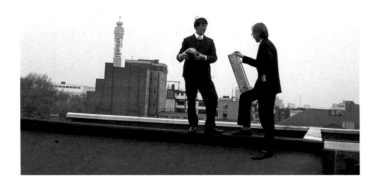

FIG 22
Posing with
OBJECT-
SCULPTURES
on the roof of
St Martin's School of
Art, London, 1968

It is highly ironic that Gilbert & George – in company, polite, besuited, reserved – would be regarded in some quarters as appearing archaic and reactionary, because of their chosen mode of dress and deportment. For it was these very qualities of restraint and formality that were also enabling Gilbert & George to live and work directly on the bedlamite front line of their emotional response to modern urban existence. Although appearing like ordinary citizen workers, beyond the grasp of the latest sophism, Gilbert & George were intent on maintaining the vital tension between absolute control and complete mental abandonment that was demanded by their art. Within the anonymity of their formal and unchanging style, they had obtained the unboundaried agency and independence that they immediately declared in their art. The paradox that accompanied this transaction had been well rehearsed, coincidentally, by the nineteenth-century French novelist, Gustave Flaubert, in his maxim: 'You must be regular and natural in your habits, like a bourgeois, that you might be violent and original in your art.'

While quiet sartorial correctitude was one of the founding tenets of Dandyism, as a cult of personal appearance established during the early years of the nineteenth century, for Gilbert & George the formality of their appearance would always be a pledge to both their independence and the cruelly demanding rigours of their work ethic. In their sonorous, mesmeric text piece written in autumn, 1971, *A Day In The Life of Gilbert & George*, the artists describe their attire as, 'the responsibility-suits of our art' – continuing, 'We put on our shoes for the coming walk'. And so another 'sculpture-day' begins.

Gilbert & George are often seen as artists who have expressed the reality of the city and the urban condition above all; but some of their earliest works were drawn from a specific encounter with nature and the countryside. In one of these, their 'three panel charcoal on paper sculpture', *To Be With Art Is All We Ask* 1970, the artists are depicted 'Frozen into a gazing for you Art'. As Gilbert & George have taken their place in so many of their pictures over the last forty years, there is always a sense in which they have never ceased this position of being 'frozen into a gazing', even though their countenance and expressions are simultaneously pledged to the viewer who is regarding them, making of each picture a visual love letter.

Having declared their independence and pledged themselves to their lives as artists, Gilbert & George had immediately begun a body of work in which their communion with, and dedication to, art as the guiding purpose of their lives was the principal subject. And it is the unwavering intensity of this early process of communion (which would also include *The Meal*, a sculpture in the form of a dinner with David Hockney, made in Bromley, Kent, in 1969) that seems to serve as the deep foundation from which they would subsequently build the epic structure of their art.

In their 'living sculptures' and, most famously, their *Singing Sculpture* and *Underneath The Arches* (all made between 1969 and 1971), Gilbert & George underwent a definitive act of transubstantiation – publicly changing from artists into art itself, and in so doing renewing their commitment to their calling. Looking at photographs taken in 1969 of the 'Anniversary' creation of the sculpture *Underneath The Arches*, made in Railway Arch No.8, Cable Street, London E1, you are immediately aware of how extreme, isolated and determined Gilbert & George had become in order to pursue their commitment to their art. The location of the sculpture – a damp, dank, public space, more frequented by vagrants

FIG 23
'ON COBBLESTONES
THEY LAY ...'
1971

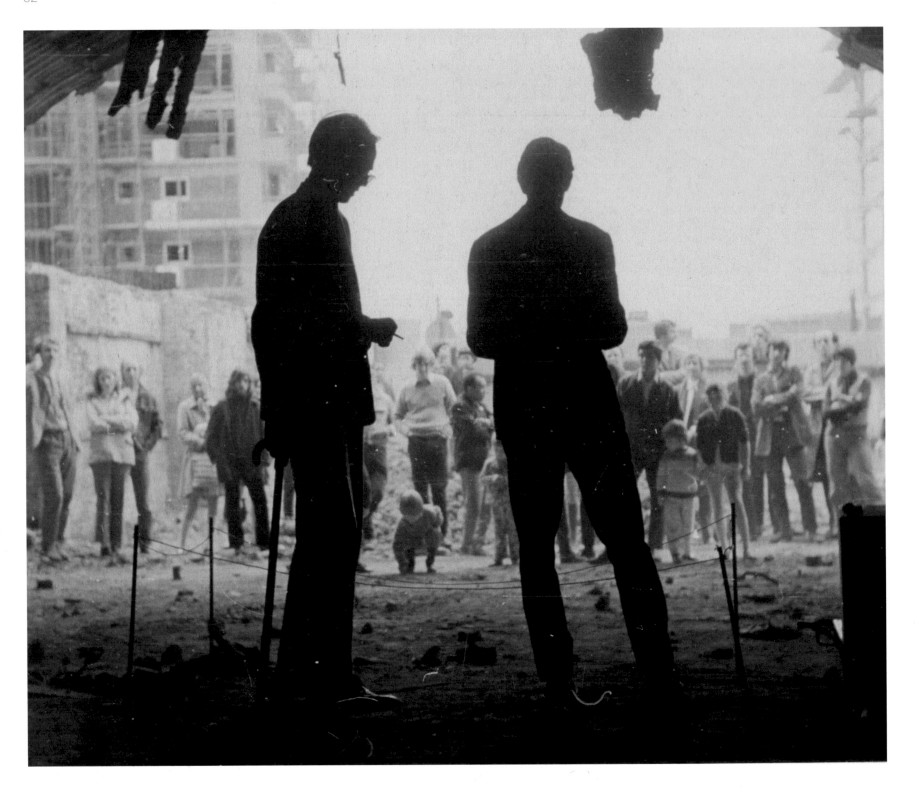

than art lovers – was both determined by necessity and a vital aspect of the work. In singing 'Underneath The Arches' – the music hall song made famous by Flanagan & Allen, in which two tramps recount the pleasures of their freedom – Gilbert & George were reciting a hymn to their chosen creed as perpetual outcasts, for whom the consolations of art were found within the very suffering, loneliness and discomfort of their situation (fig.24).

It is a historical coincidence, but eloquent nonetheless, that during the mid-Victorian period the railway arches of the south London train lines would serve as public meeting places for non-conformist religious sects. Philip Hoare, in his book *England's Lost Eden* gives detailed accounts of such occasions, with specific reference to those held by Mrs Girling's 'Shaker' followers. Believing that in their public dancing they would enter first a trance, then a death-like coma – to be reborn immortal as a follower of Mrs Girling – these Victorian ecstatics possessed as much dedication to supernatural religion as Gilbert & George possessed to their developing art. Linked by choice of location, to say nothing of the utter bemusement of their initial audiences, these two examples of public ritual – separated by a hundred years – have a similarity that is founded in their adherence to a separatist, dramatically heightened expression of feeling. To their early audiences, would Gilbert & George have seemed like artists, madmen, buskers, comedians or hoaxers? All five, perhaps. What was undeniable – and swiftly spread its power to a sizeable international audience – was the poise and pathos of this important early sculpture. In these 'living sculptures', it seems as though a sudden acceleration has occurred in the artists' awareness of their capacity to create. Their actions, intentions, appearance and identity – their fomality, their devotion to their calling, their chosen 'outsiderdom' – are all resolved into a seamless, apparently effortless art.

And yet to achieve this, the artists have had to hand themselves over, entirely and irredeemably, to the process of its creation. (To borrow from WH Auden's poem 'The Novelist', they must 'become the whole of boredom', and 'suffer dully all the wrongs of man'.) It is as though a transaction has been made, and that henceforth the lives of Gilbert & George will serve only to enable their art – in a routine of work as demanding and ceaseless as any devotional practice. In their own words (from their text 'The Laws of Sculptors' 1969): '2. Make the world to believe in you and to pay heavily for this privilege.'

Gilbert & George discovered their 'signature' as artists from almost the moment when they first worked together. Rapidly increased by the growing recognition of what the critic Robert Rosenblum has described as 'the singularity of their duality', the international fascination with the art of Gilbert & George would immediately place them in a cultural category of their own – regarded by some as seers, by others as a new form of rock star, and by all as artists who seemed to have achieved a position from which they could observe the human condition, in all of its passion, dread and absurdity, as simultaneously witnesses, participants and victims. In this they were indeed like postmodernist extensions of Dickensian characters, achieving during the latter half of the 1970s, in series such as *Dusty Corners* 1975, *Dead Boards* 1976 and *Red Morning* 1977, a sense of place and mood that was all the more intense – more open to the darkling nuances of destiny – for its seeming simplicity and austerity (fig.25, pls.41–52 and 61–4).

These pictures present both freshness and vulnerability – a vivid sense of the ways in which our internal feelings and our external surroundings can fall into a strange harmony with each other, at once disquieting and filled with quietude. In the *Red Morning* series, Gilbert & George appear

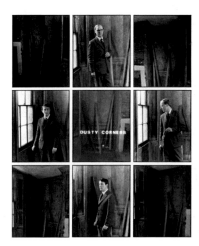

FIG 24
UNDERNEATH THE ARCHES
Living sculpture presentation
at Cable Street, London
1970

FIG 25
DUSTY CORNERS
NO.1
1975
187 x 157 cm

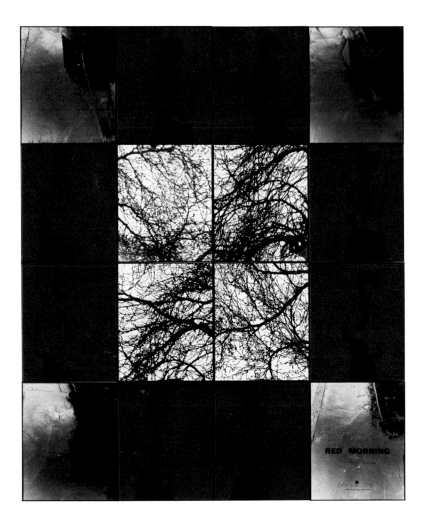

calm and patient, isolated yet serene, alongside images that convey the simple, unending procession of commonplace days – buildings, leaves, reflections in puddles. But then there are the unexpected, jarring titles: *Red Morning Hell*, *Red Morning Hate*, *Red Morning Scandal*, *Red Morning Blood*. What had seemed at first to be images open to the light of new mornings, suddenly become evidence of misery and dread (fig.26).

The violence of feeling in the art of Gilbert & George is a constant throughout their work. The city streets, whether shown in monochrome or lurid colour, in their figurative state or as up-ended, re-configured versions of themselves, seem to present a world in which the pageantry of human existence is seldom joyous, and often filled with aggression, indifference, decay and madness. In the *Dirty Words Pictures* of 1977, Gilbert & George would commence some of their most deeply felt images of urban aggression (pls.65–71). A mood of violence, dereliction and nocturnal witness dominates – the sense of a world on the brink of collapse, in step with the proposal implicit in the ritual negativity of punk that modernity itself had reached critical mass, and that henceforth we would inhabit a society self-destructing on the chaos and neurasthenia brought about by its own wanton consumerism, boredom and mad lusts. (It is a society that the poet Alexander Pope had also predicted as early as 1729, in his vexed and despairing review of modern life, *The Dunciad*, concluding, in a pronouncement of absolute finality that Gilbert & George, paradoxically, would most probably contest: 'and universal darkness buries all!')

But just as the primarily monochromatic pictures of the latter half of the 1970s seemed to foretell recession, social unrest and despair, so the exuberant colour that Gilbert & George began to employ in the 1980s

FIG 26
RED MORNING: SCANDAL
1977
242 x 202 cm

appears to mark a premonition of dizzying socio-cultural change. New sensations of primitivism, blatancy and orgiastic excess, depicted in toxic, chemical colours, seem to scream their ravenous desires through these pictures. If pop music, media and fashion had exchanged the cerebral, anxious, black and grey mood of post-punk for what was memorably described by one record company as 'the sound of a bright new Britain', then the art of Gilbert & George was using colour and scale to declare monolithic visions of febrile sexuality, the new threat of AIDS, and a world in which power, conflict and consumption were matched by alienation, obliteration and a form of emotional vertigo.

As though Richard Dadd had tutored with Disney, in one of their greatest pictures, *Drunk With God* 1983, Gilbert & George created a vast, multi-faceted, ominous, comedic, epic vision of the world (fig.27). The city becomes ornate and worthless, real and fantastical, peopled with marching youths and simultaneously lonely and deserted. It is as though the viewer accompanies Gilbert & George on a shamanic journey through the cosmology of their own creation, in which the artists are both watchers and creators, clowns and demi-gods, chased and chasing through a dream. Increasingly, Gilbert & George would appear to trasmute into a mythic version of themselves – a process of reincarnation that began, in fact, with their first commitment to their lives as artists. In some of their pictures from the 1980s, the artists appear like travellers within cosmic, magic-realist visions, fables and dreams. They seem both ceremonial and participatory, enquiring, involved, responsive to the relaxed, waiting, sentinel-like youths who populate the pictures.

And after such voyages, where else was there for the artists to go, other than within themselves? Having presented the world around them as a map to the human condition, Gilbert & George now reversed the process – making the physical constitution of the human body a chart of Earthly values, prejudices and theologies. 'Fournier World' was thus internalised; the pioneer artists explored the substances within themselves – their shit, blood, sweat, tears, semen and urine – identifying what appeared, under intense magnification, to be contour maps of strange new countries, patternings of script and symbol, or maps of destiny. As they had always been concerned with truth and realism above all (at college, George had once suggested that the reflection in a sculpture of the world outside the studio window was its greatest strength), so in their new pictures – notably the *New Testamental Pictures* – Gilbert & George related the reality of their corporeal selves to both their individual presences and to Biblical writings on personal conduct and morality (pls.157–8).

These pictures were defiant statements regarding not just the social perception of bodily functions, but also the capacity of art to convey the fundamental realities of existence. And the *New Testamental Pictures* took these notions further still: as Gilbert & George had aged before their viewers, appearing in many of their pictures, always with the same intentions, so now they took their place besuited or naked, impassive or collapsed, dignified or defiant, but throughout with a sense of renewed vulnerability. They made public the wonder, awkwardness and fallibility of the body, in turn revealing its heroism and sanctity, its ability to maintain or extinguish life.

The effect was electrifying – as though Gilbert & George were presenting not just new images of themselves, but images that possessed the accumulated emotional resonance of all the times that they had ever appeared in their art. With titles like those of punk novellas – *Spit Heads*,

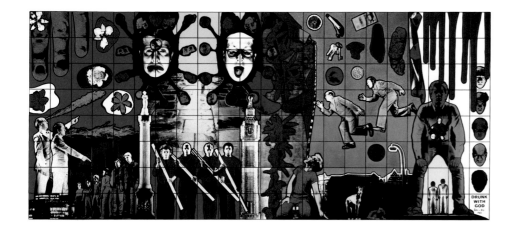

FIG 27
DRUNK WITH GOD
1983
484 x 1111 cm

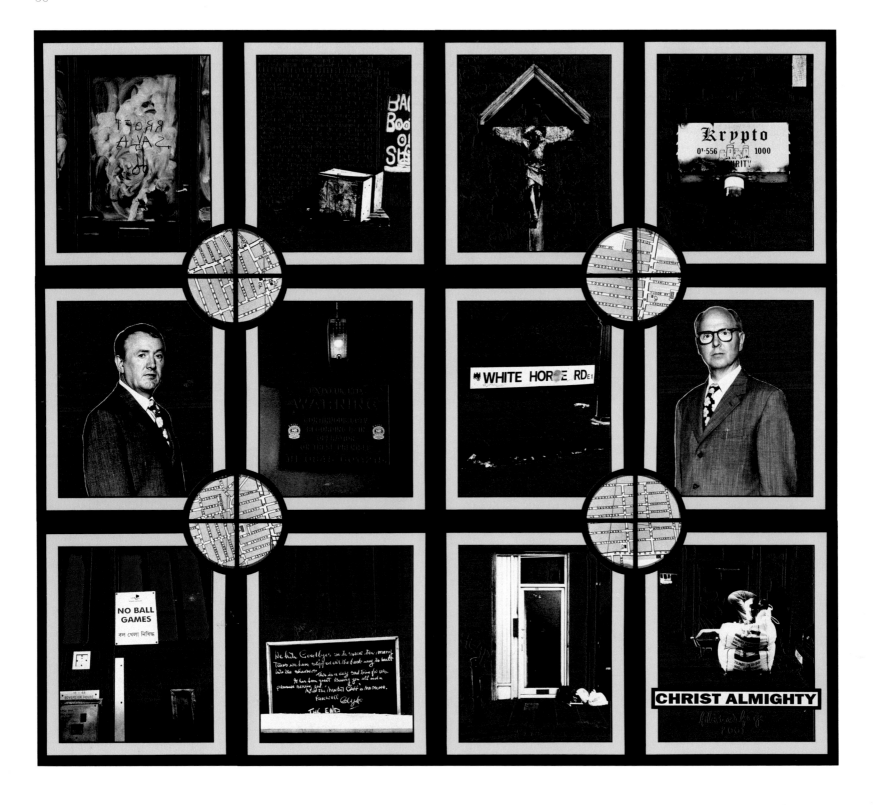

In The Piss, *Spunkland* – these new pictures continued that vital aspect of Gilbert & George's art, which is to cause a certain amount of mischief – to play with puns and double-entendres, to deliver insight from within the Trojan horse of comic nuance, vulgarity or insolence.

The tension between absolute seriousness and poised, comic inflection has always been a feature within the art of Gilbert & George – at times as though they are adapting the humour of a 'Carry On' film to a moral X-ray of the modern world. (On the envelopes of one of their early postal sculptures, Gilbert & George had once printed the words, 'Carrying On Sculpting'.) Within this tension, they sustain the depth of feeling that distinguishes even their darkest and most poetic works. Humour, as much as tears, is posited as a vital component of the human situation – recalling Balzac's *La Comedie Humaine*.

One could argue that the *Nine Dark Pictures* of 2001 constituted one of the most intense and pivotal expressions of Fournier World that Gilbert & George would ever create. Figurative, elegiac, sepulchral, the works appeared to be pervaded by an almost unbearable sadness, filled with images of closure, farewell, sleep, abandonment and death. Indeed, this was the first time that we would see the images of Gilbert & George themselves begin to recede into darkened, unsmiling poses. It was as though, after all the years during which we had 'known' them through their art, they were somehow taking leave of us – just as their beloved Clyde and Phyllis, the proprietors of the old Market Café on Fournier Street, had slipped away themselves, leaving a hand-written message of farewell in the window (as detailed in the picture *Christ Almighty*) in order to 'spare too many tears' (fig.28).

These *Nine Dark Pictures* marked the transition of Gilbert & George, as they appeared in their work, from one state of being – that of ordinary mortality – into a form that owed more to the ceremonial depiction of deities, poltergeists, comic-book super villains or warrior gods. In some of their most recent art – the *Hooligan Pictures* and *Perversive Pictures* of 2004, for example – we see Gilbert & George as newly recreated versions of themselves – bifurcated, mutated, grotesque, co-joined, at once terrifying and terrified, vacant and possessed (fig.29).

These new pictures find Gilbert & George encased within a tracery of graffiti, ornamental script and extravagant adornment, against backdrops of city streets engulfed in fundamentalism, the linguistic cross-hatching of multi-culturalism, and a futuristic fusion of religious dogma and anonymous street scrawl. 'Fournier World' – the modern condition – has become a maelstrom of volatile ideological and social aggression, its cultural rhetoric expressed through a kind of bling alloy – alien, unknowable, yet targeted.

De-humanised, watchful, agonised, restless, contorted within golden tessellations of ginkgo leaves or amidst accumulations of debased religious insignia, these latest incarnations of Gilbert & George have a sense about them of existing within a spirit world – a place on the other side of a transparent membrane that separates the inhabitants of the modern city from their theistic consciousness and moral shadow.

FIG 28
CHRIST ALMIGHTY
2001
226 x 254 cm

FIG 29
OVER
2004
254 x 226 cm

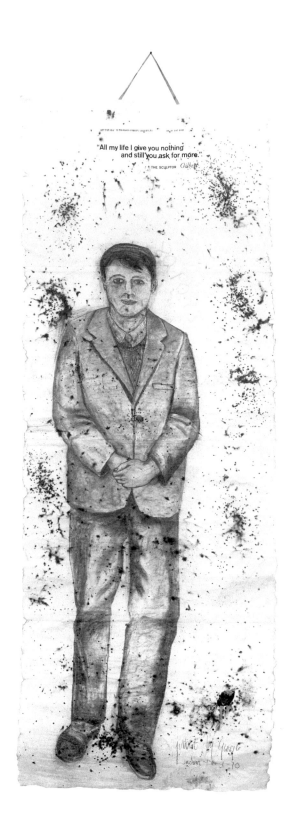

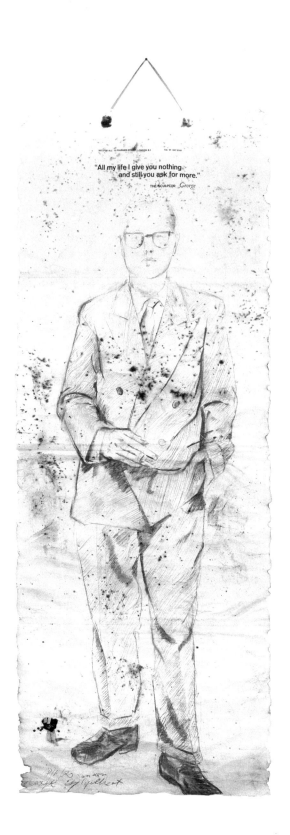

1
ALL MY LIFE I GIVE YOU NOTHING
AND STILL YOU ASK FOR MORE
1970
A charcoal on paper sculpture
Each part 193 x 75 cm

(Opposite page)
2
THE BAR NO.2
1972
A nine-part charcoal on paper sculpture
Exhibited here at Anthony d'Offay Gallery,
London, 1972

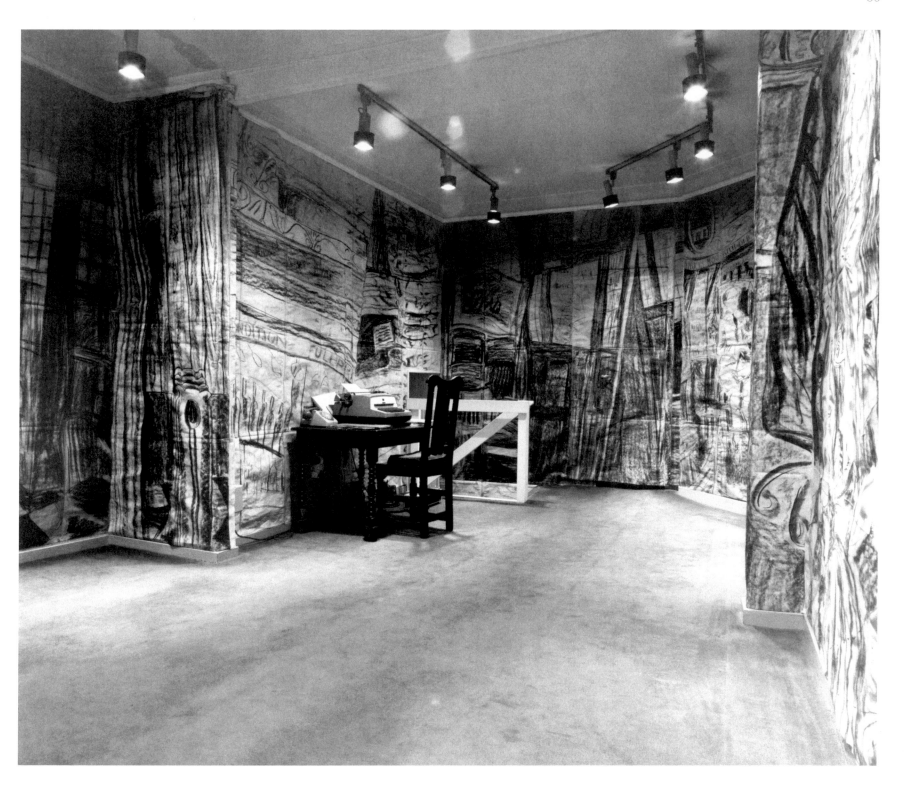

3
THE NATURE OF OUR LOOKING
1970
A five-part charcoal on paper sculpture
Left to right: 348 x 236 cm; 263 x 118 cm;
278 x 362 cm; 263 x 90 cm; 385 x 270 cm

FOREVER WE WILL SEARCH AND GIVE OUR THOUGHT TO THE PICTURE WE HAVE IN OUR MIND.
WE ARE WALKING ROUND NOW AS SAD AS CAN BE

THE NATURE OF OUR LOOKING.

WE BELIEVE THAT LOVE is the PATH for a Better WORLD of

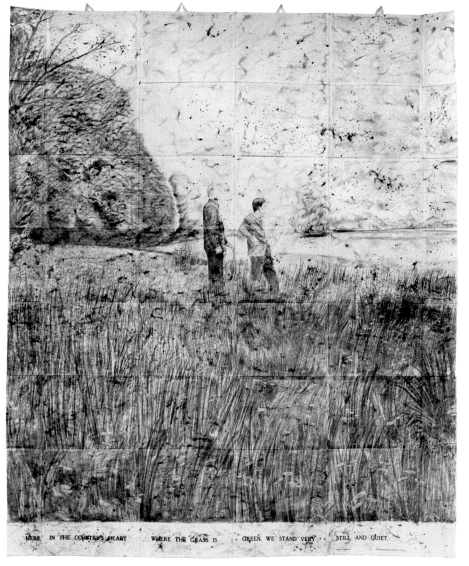

GOOD & BAD GIVE WAY for GILBERT and GEORGE TO BE

THE NATURE OF OUR LOOKING.

HERE IN THE COUNTRY'S HEART WHERE THE GRASS IS GREEN WE STAND VERY STILL AND QUIET

4
THERE WERE
TWO YOUNG MEN
WHO DID LAUGH
1971
240 x 240 cm

(Opposite page,
clockwise from top left)
5
THERE WERE
TWO YOUNG MEN
WHO WERE TIRED
1971
240 x 240 cm

6
THERE WERE
TWO YOUNG MEN
FROM AFAR
1971
270 x 200 cm

7
THERE WERE
TWO YOUNG MEN
SO POLITE
1971
270 x 200 cm

8
THERE WERE
TWO YOUNG MEN
WITH NO HEART
AND NO PEACE
1971
240 x 400 cm

9
THERE WERE
TWO YOUNG MEN
WHO WERE
COVERED IN BLOOD
1971
240 x 400 cm

A six-part charcoal
on paper sculpture

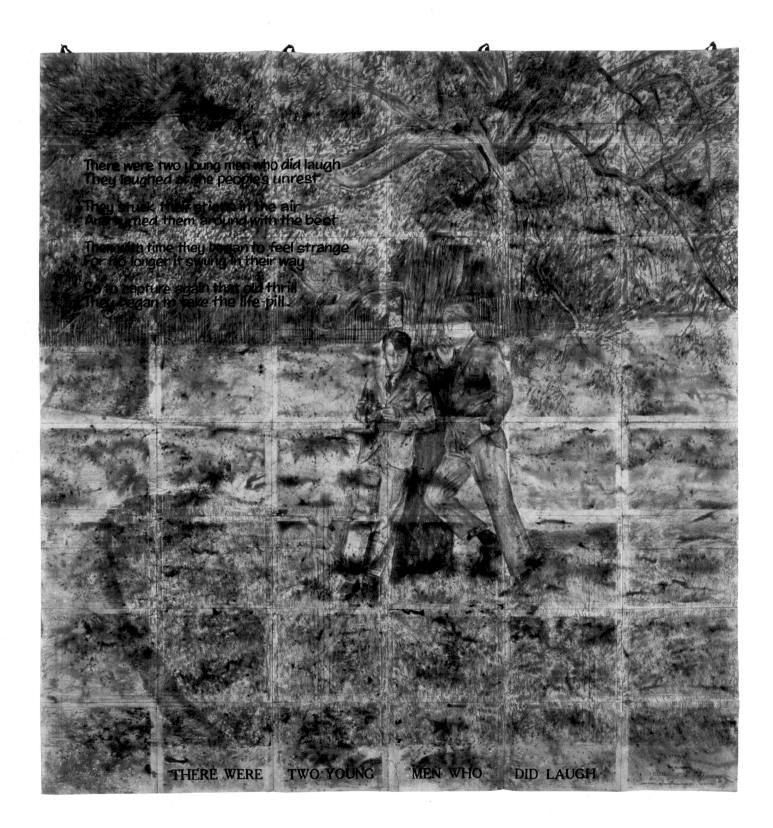

There were two young men who did laugh
They laughed at the people's unrest

They struck their sticks in the air
And turned them around with the beat

Though in time they began to feel strange
For no longer it swung in their way

So to capture again that old thrill
They began to take the life-pill

THERE WERE TWO YOUNG MEN WHO DID LAUGH

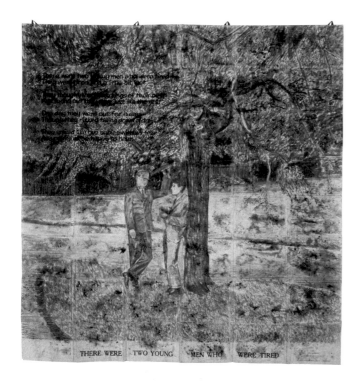

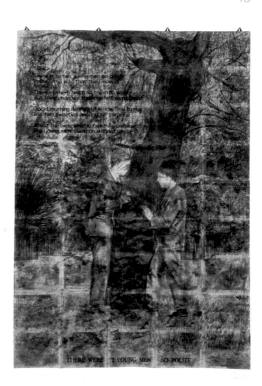

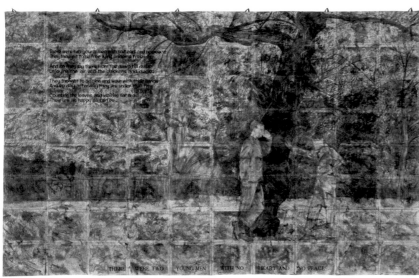

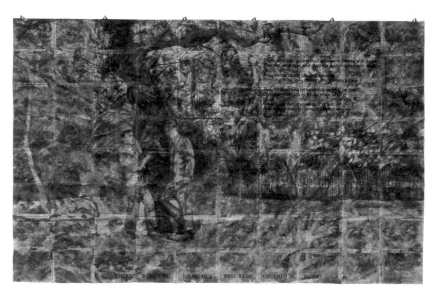

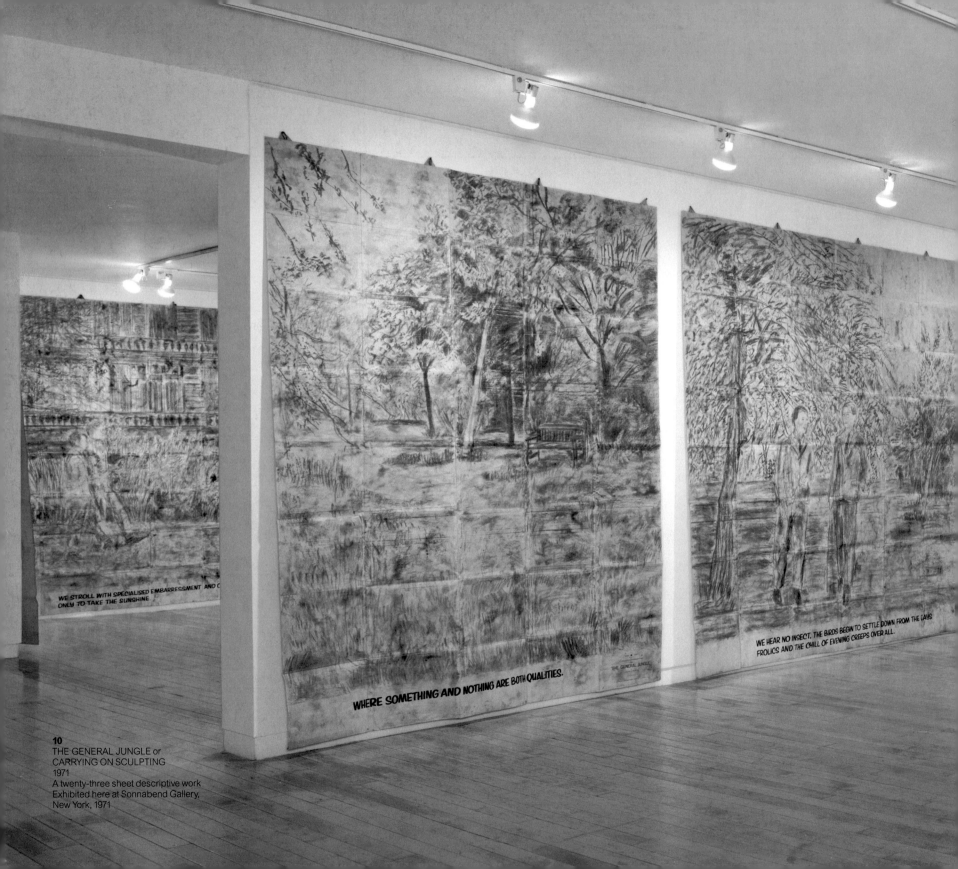

WE STROLL WITH SPECIALISED EMBARRESSMENT AND ONLY TO TAKE THE SUNSHINE

WHERE SOMETHING AND NOTHING ARE BOTH QUALITIES.

THE GENERAL JUNGLE.

WE HEAR NO INSECT. THE BIRDS BEGIN TO SETTLE DOWN FROM THE DAYS FROLICS AND THE CHILL OF EVENING CREEPS OVER ALL.

10
THE GENERAL JUNGLE or
CARRYING ON SCULPTING
1971
A twenty-three sheet descriptive work
Exhibited here at Sonnabend Gallery,
New York, 1971

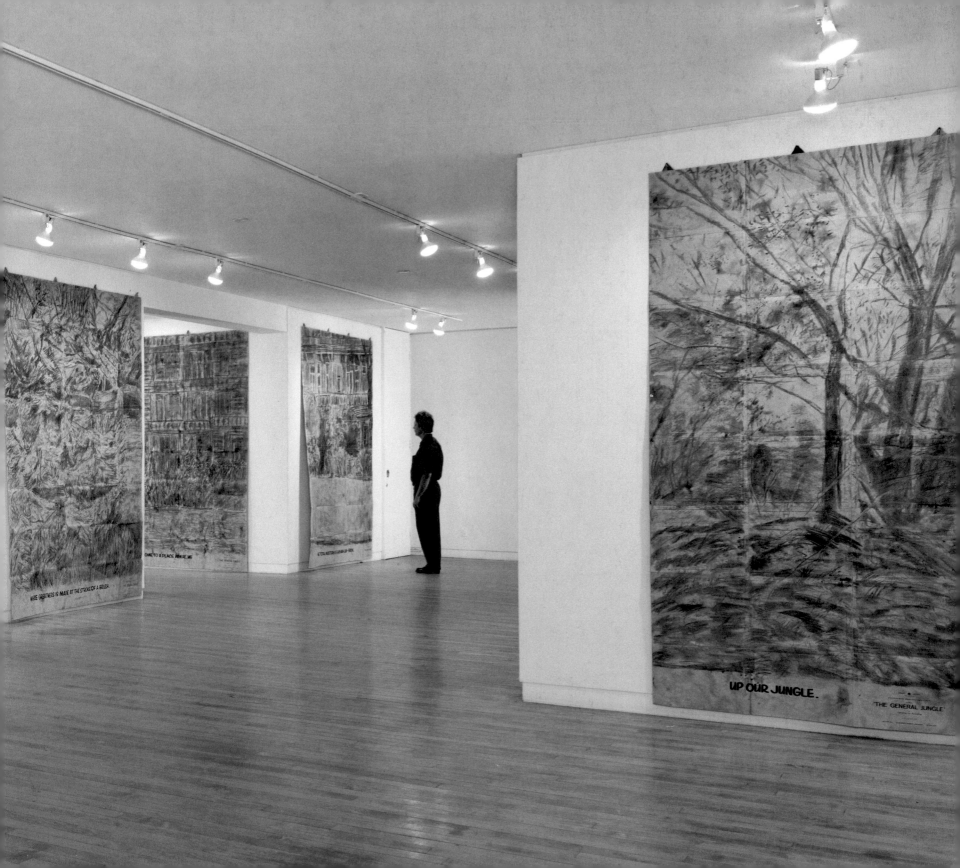

WHERE GREATNESS IS MADE AT THE STROKE OF A BRUSH.

...OME TO A PLACE WHERE WE

A TOTAL WESTERN SCENARIO UP THERE.

UP OUR JUNGLE.

THE GENERAL JUNGLE

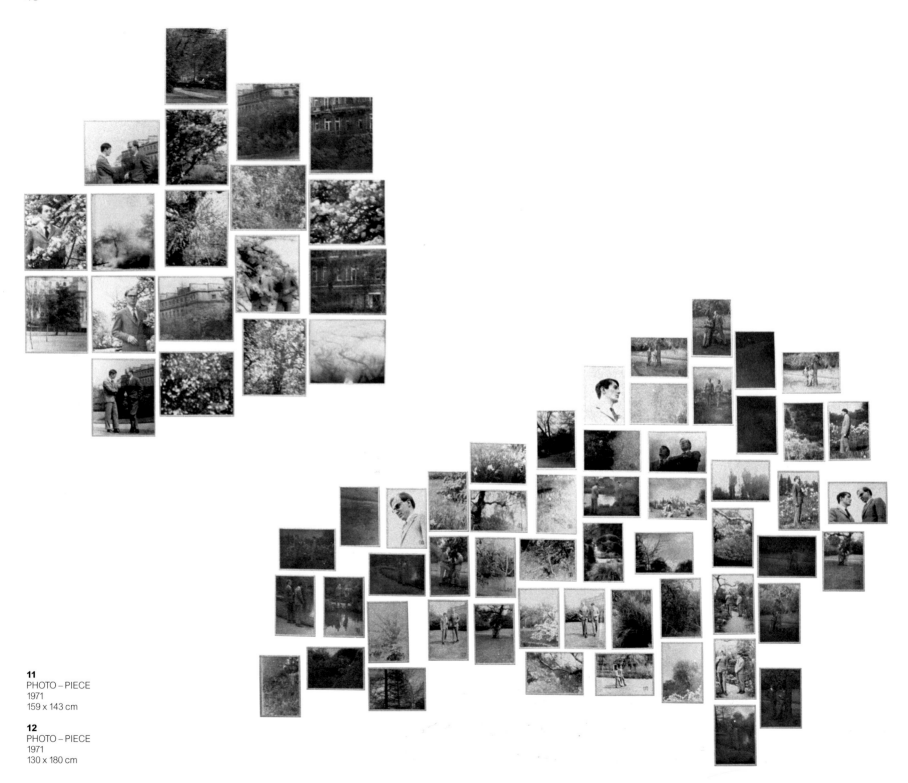

11
PHOTO – PIECE
1971
159 x 143 cm

12
PHOTO – PIECE
1971
130 x 180 cm

13
BALLS or THE EVENING BEFORE
THE MORNING AFTER
1972
211 x 437 cm

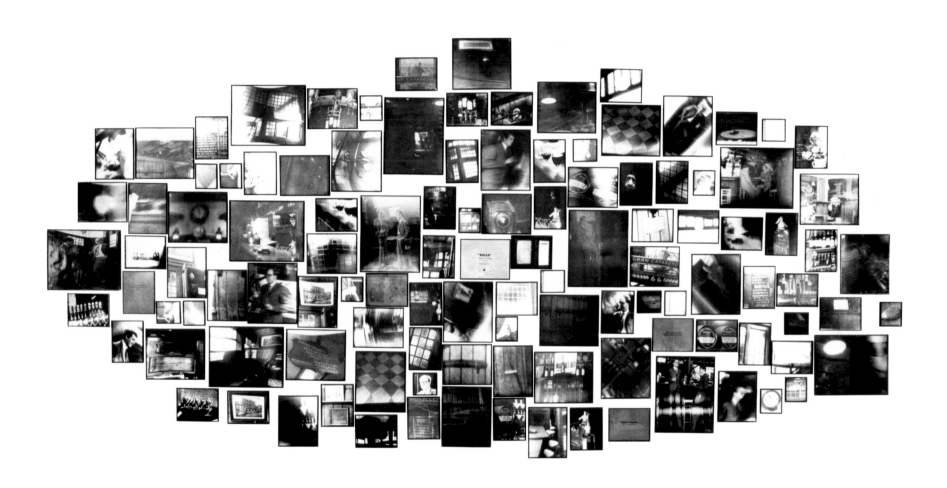

'We look at nature for comparisons with human states: fruiting, flowering, death, the skeleton, they're all human states'

14
THE EFFECT
formerly known as
A DRINKING PIECE
1973
173 x 82 cm

15
TWO A.M.
1973
122 x 89 cm

16
THE GLASS 2
1973
130 x 85 cm

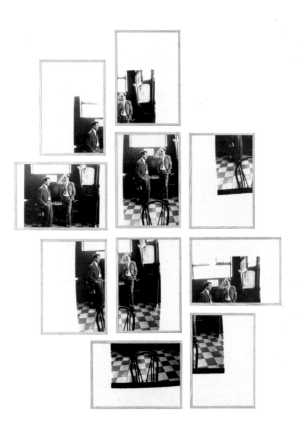

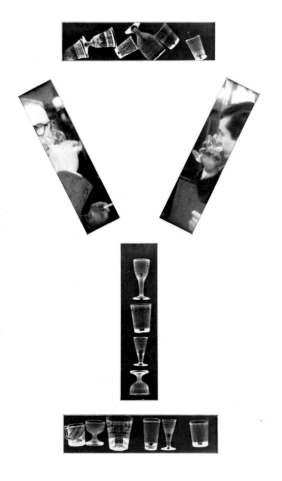

17
BLACK STARE
1973
116 x 108 cm

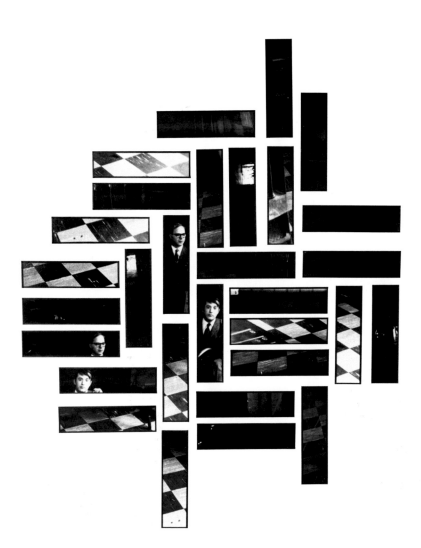

18
HEAD OVER
HEELS
1973
277 x 64 cm

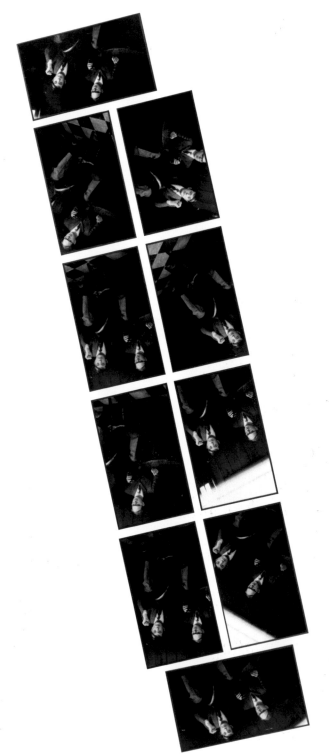

19
'TO HER MAJESTY'
1973
145 x 350 cm

20
RATHER SPORTY
1973
15 x 96 cm

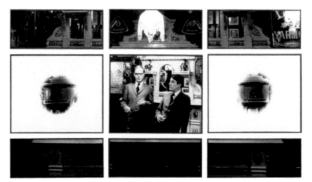

21
AXE BAR
1973
129 x 109 cm

22
GIN AND TONIC
1973
71 x 42 cm

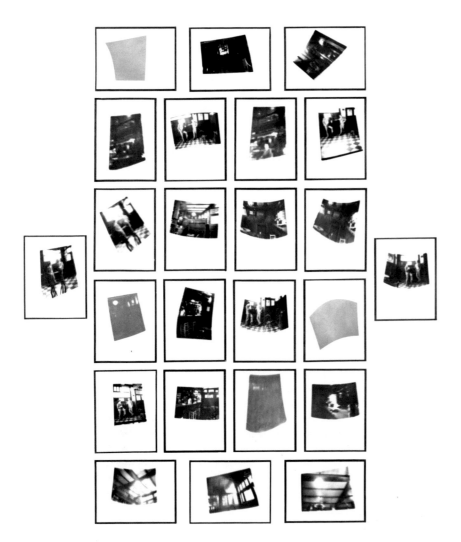

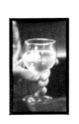 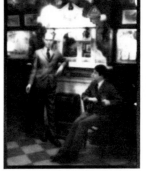

23
INCA PISCO A
1974
353 x 426 cm

24
INCA PISCO B
1974
305 x 410 cm

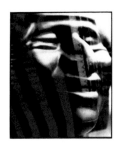

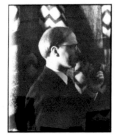

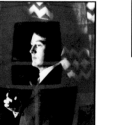

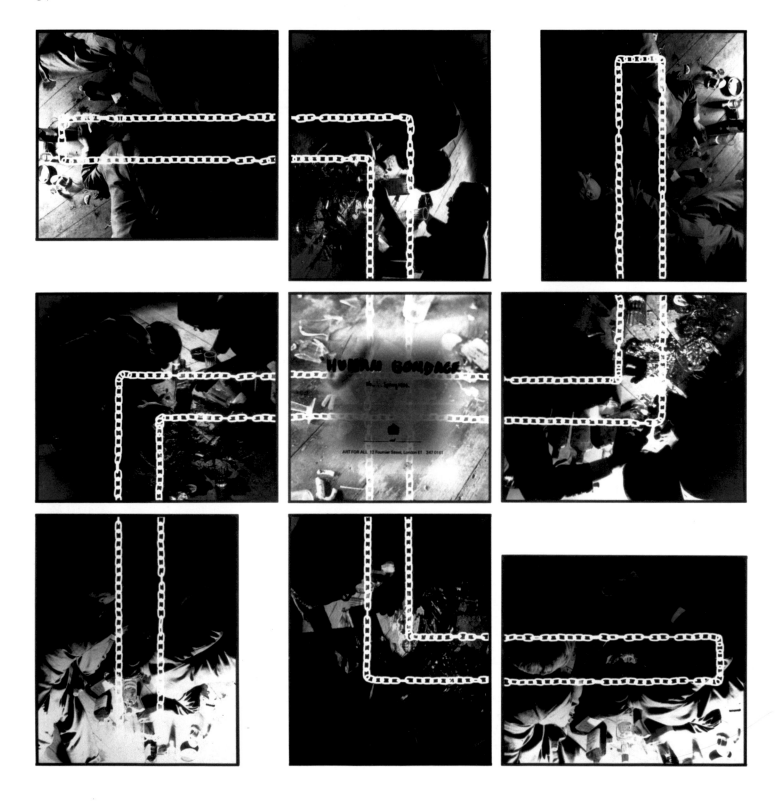

25
HUMAN BONDAGE NO.5
1974
175 x 175 cm

26
DARK SHADOW NO.4
1974
211 x 156 cm

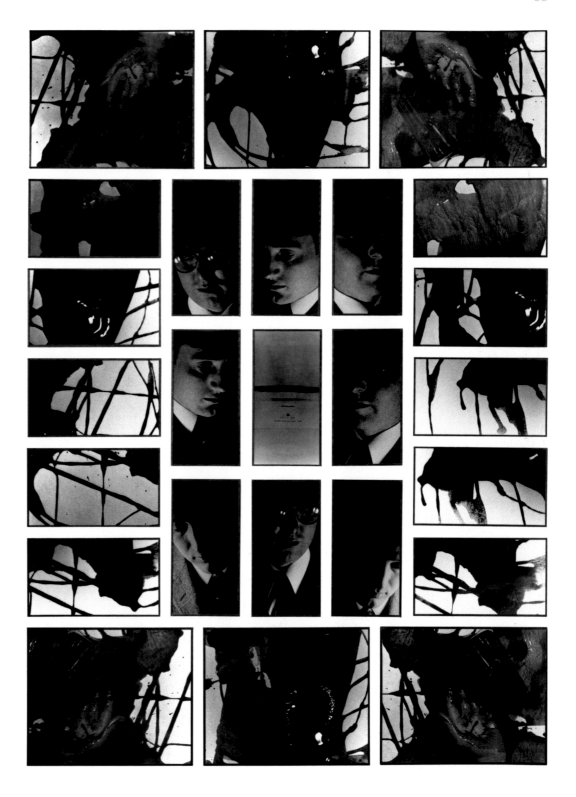

27
DARK SHADOW NO.6
1974
151 x 206 cm

28
DARK SHADOW NO.8
1974
151 x 206 cm

29
CHERRY BLOSSOM NO.1
1974
251 x 211 cm

30
CHERRY BLOSSOM NO.11
1974
187 x 157 cm

31
CHERRY BLOSSOM NO.2
1974
251 x 211 cm

32
CHERRY BLOSSOM NO.5
1974
251 x 211 cm

33
CHERRY BLOSSOM NO.7
1974
251 x 211 cm

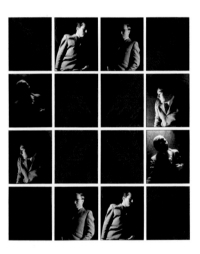

34
COMING
1975
187 x 157 cm

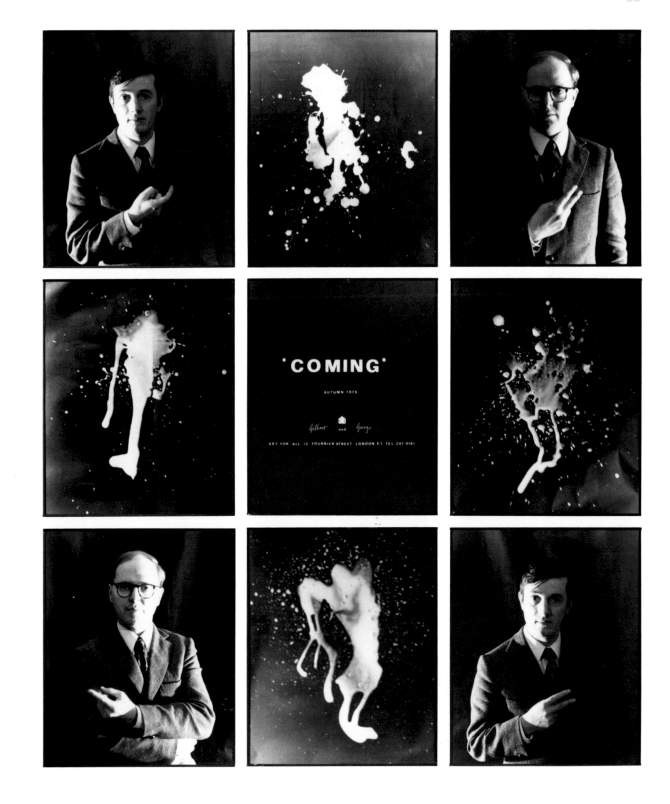

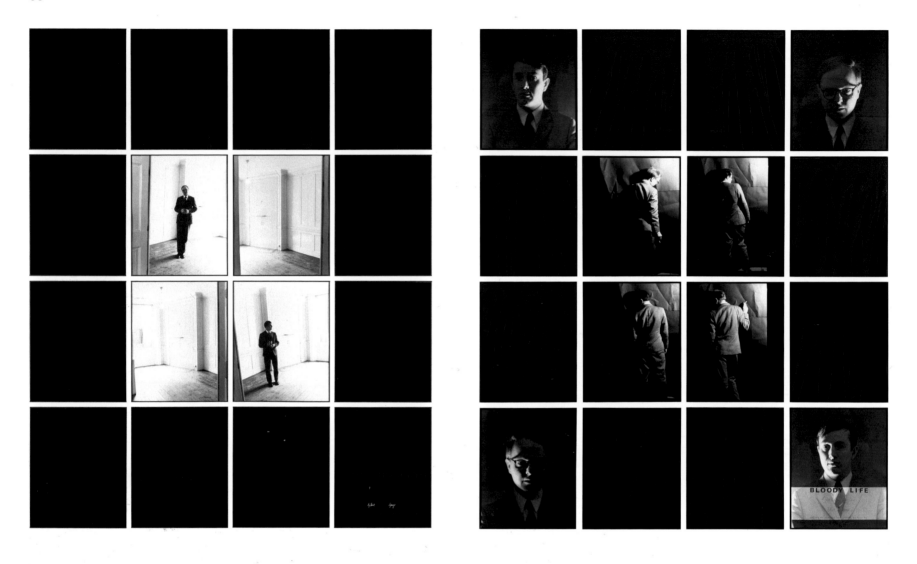

35
BAD THOUGHTS NO.7
1975
251 x 211 cm

36
BLOODY LIFE NO.1
1975
251 x 211 cm

'For years we saw only red in front of our eyes ...
Red in political terms ... Misery'

37
BLOODY LIFE NO.7
1975
187 x 157 cm

38
BLOODY LIFE NO.16
1975
251 x 211 cm

39
BLOODY LIFE NO.3
1975
251 x 211 cm

40
BLOODY LIFE NO.4
1975
251 x 211 cm

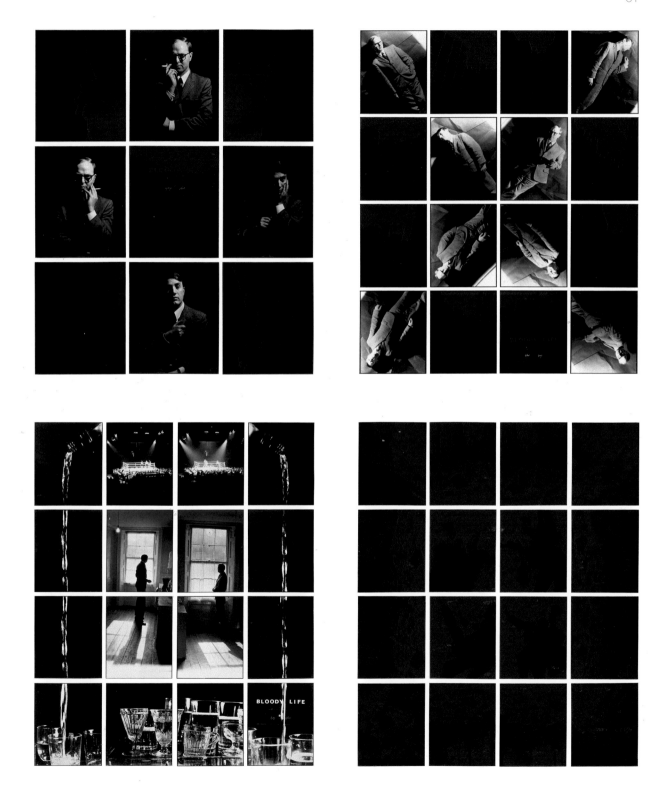

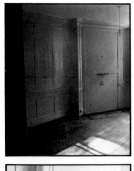

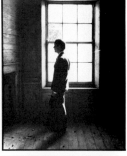

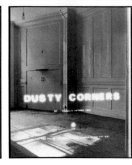
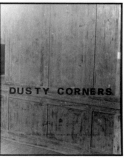
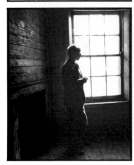

41
DUSTY CORNERS NO.6
1975
124 x 104 cm

42
DUSTY CORNERS NO.15
1975
124 x 104 cm

43
DUSTY CORNERS NO.16
1975
124 x 104

44
DUSTY CORNERS NO.21
1975
124 x 104 cm

45
DUSTY CORNERS NO.2
1975
187 x 157 cm

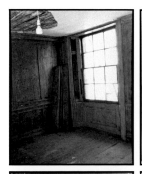

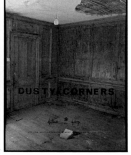
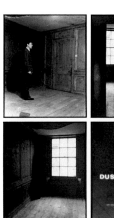
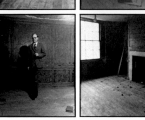
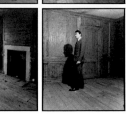
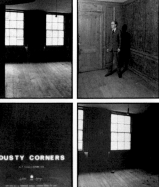

46
DUSTY CORNERS NO.13
1975
251 x 211 cm

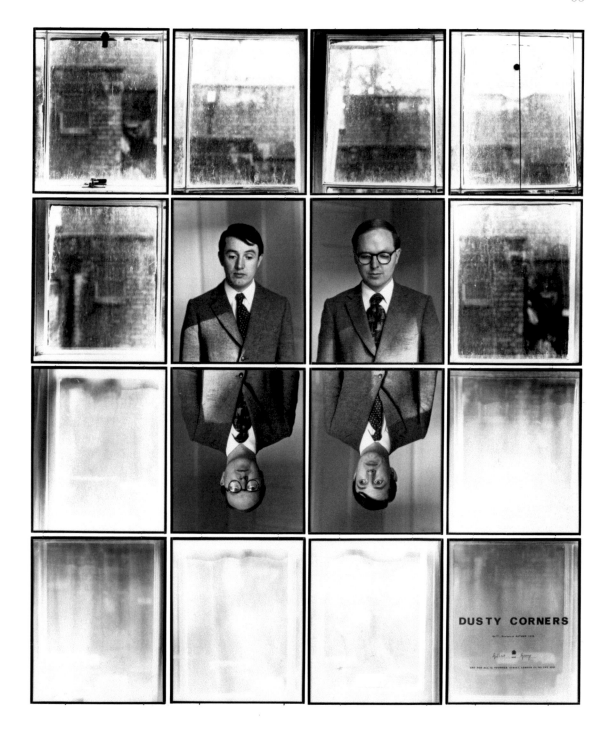

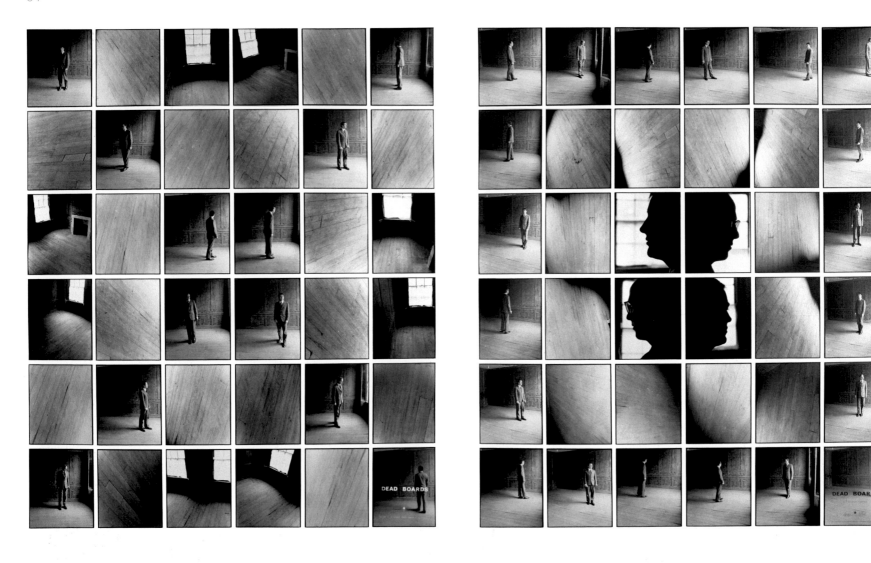

47
DEAD BOARDS NO.2
1976
378 x 318 cm

48
DEAD BOARDS NO.4
1976
378 x 318 cm

'We were trying to do something that was absolutely hopeless, dead, grey, lost'

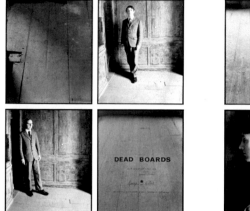

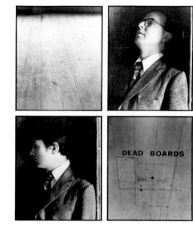

49
DEAD BOARDS
NO.16
1976
124 x 104 cm

50
DEAD BOARDS
NO.17
1976
124 x 104 cm

51
DEAD BOARDS
NO.7
1976
251 x 211 cm

52
DEAD BOARDS
NO.9
1976
251 x 211 cm

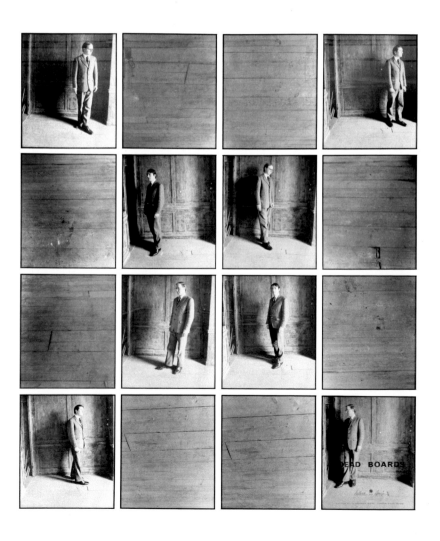

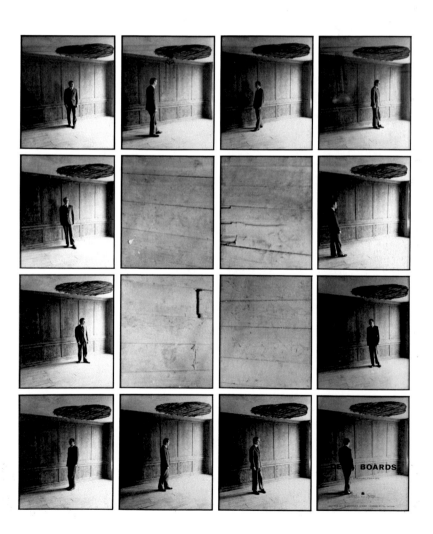

53
MENTAL NO.3
1976
314 x 264 cm

54
MENTAL NO.2
1976
314 x 264 cm

55
MENTAL NO.10
1976
187 x 157 cm

56
MENTAL NO.5
1976
251 x 211 cm

57
MENTAL NO.8
1976
187 x 157 cm

58
MENTAL NO.11
1976
124 x 104 cm

59
MENTAL NO.4
1976
251 x 211 cm

60
MENTAL NO.12
1976
124 x 104 cm

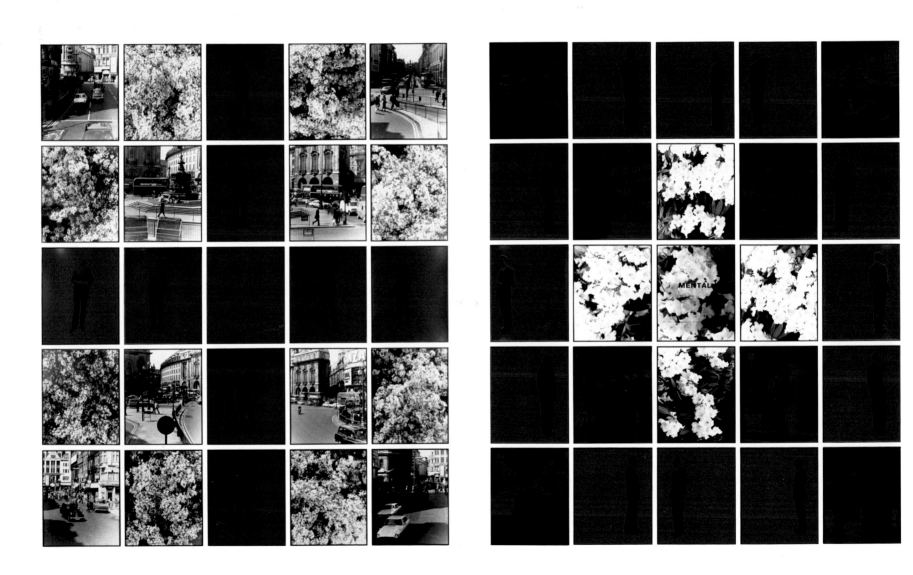

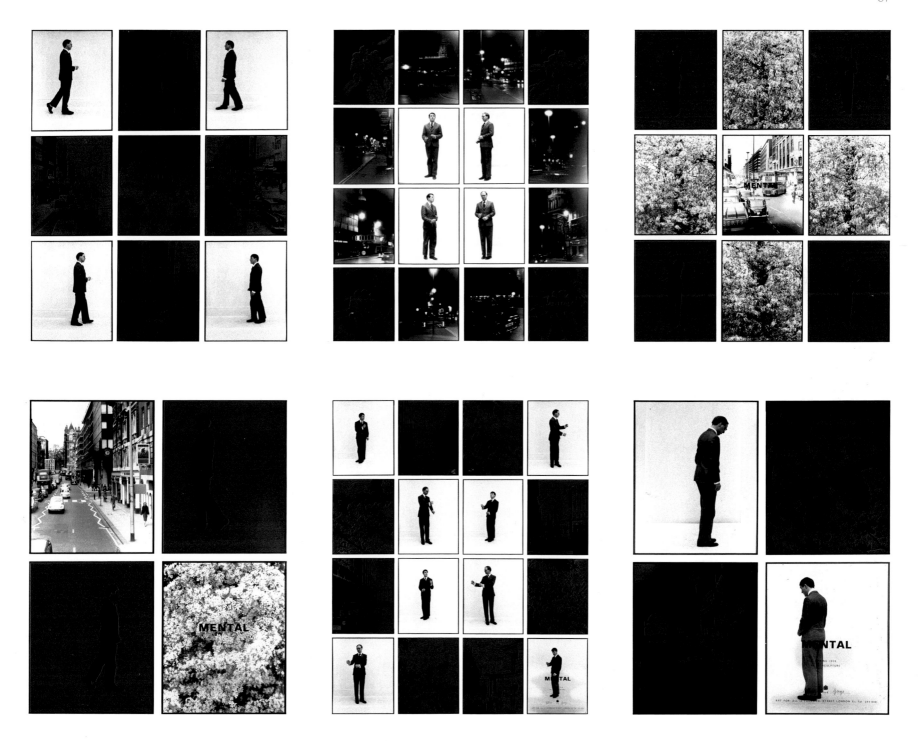

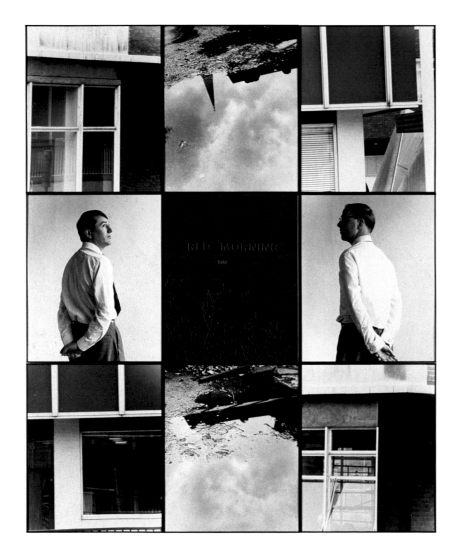

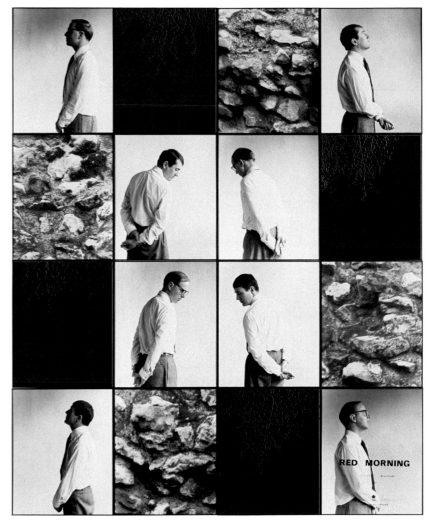

61
RED MORNING: DIRT
1977
181 x 151 cm

62
RED MORNING: VIOLENCE
1977
242 x 202 cm

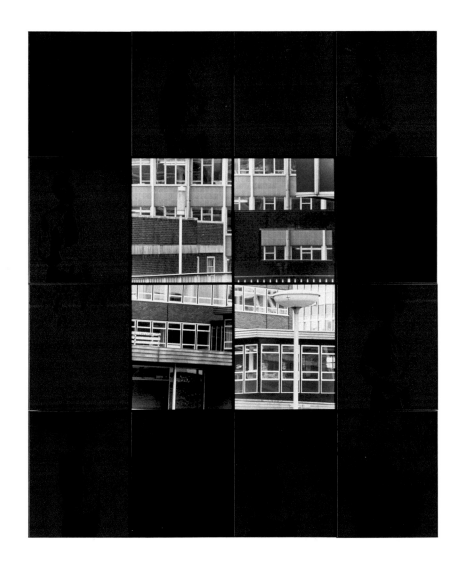

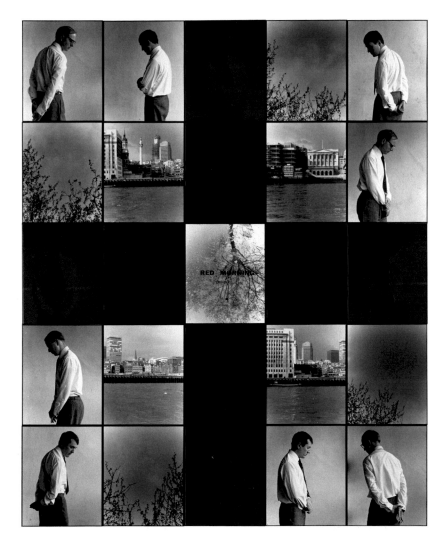

63
RED MORNING: HATE
1977
242 x 202 cm

64
RED MORNING: TROUBLE
1977
302 x 252 cm

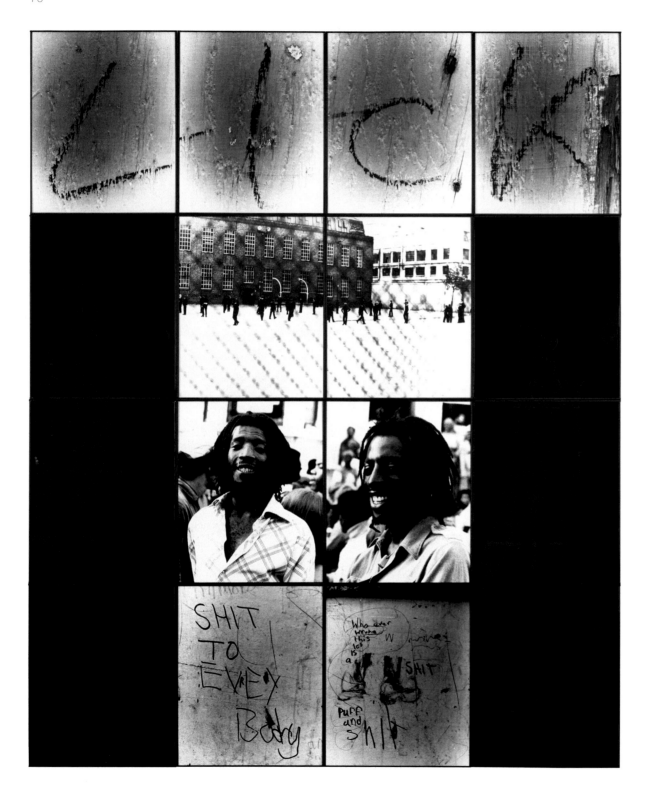

65
LICK
1977
242 x 202 cm

66
ARE YOU ANGRY OR
ARE YOU BORING?
1977
242 x 202 cm

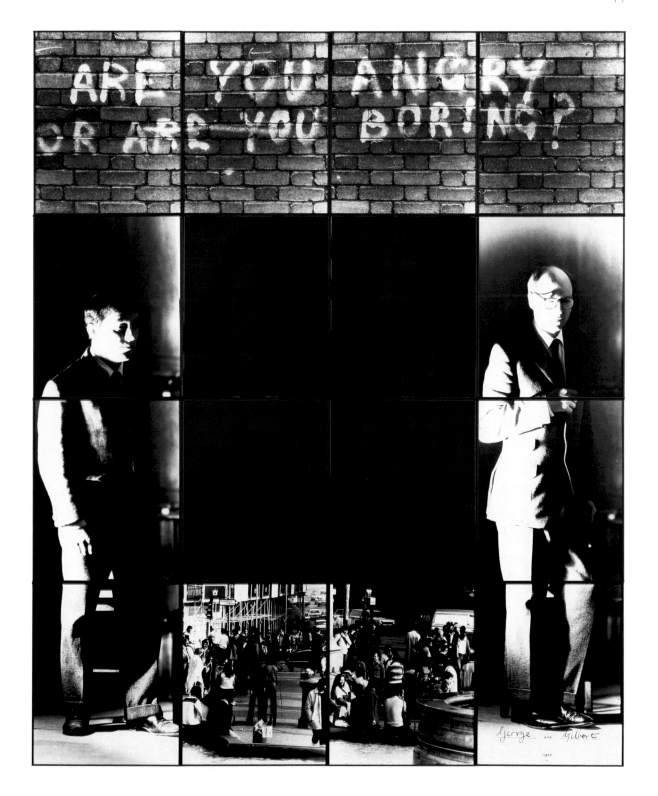

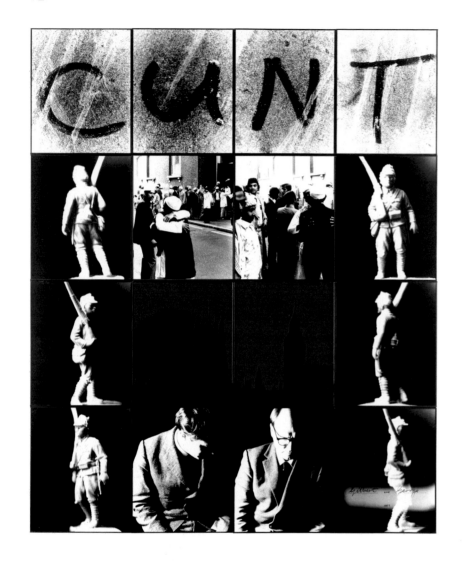

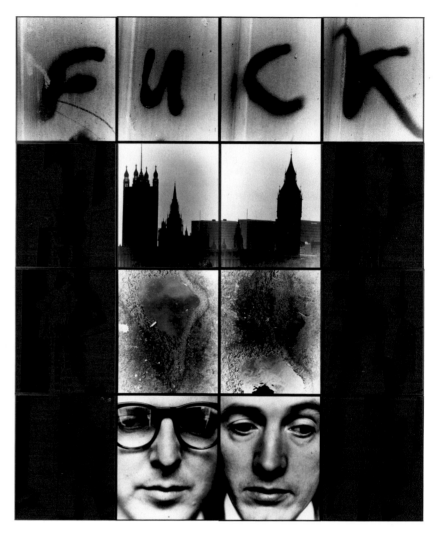

**'We want to be completely outside
with – whatyoucall – hooligans and tramps'**

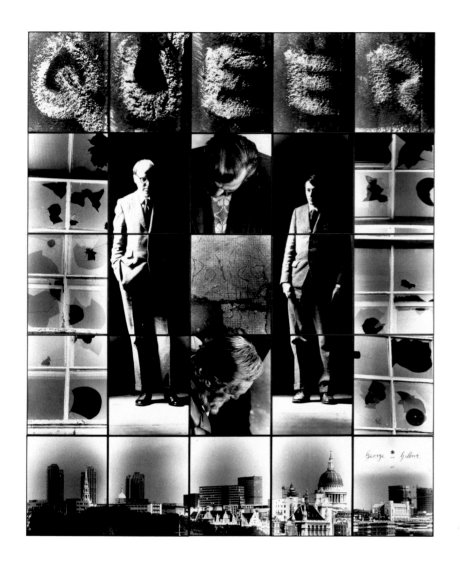

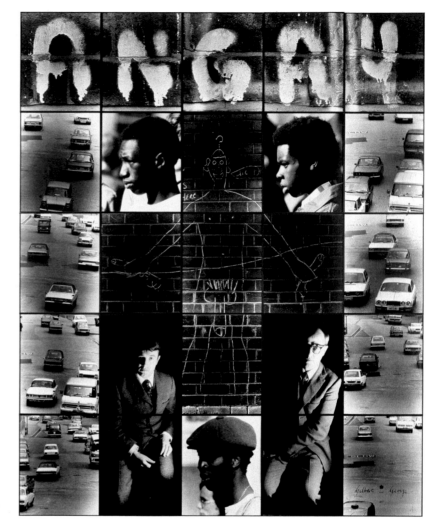

67
CUNT
1977
242 x 202 cm

68
FUCK
1977
242 x 202 cm

69
QUEER
1977
302 x 252 cm

70
ANGRY
1977
302 x 252 cm

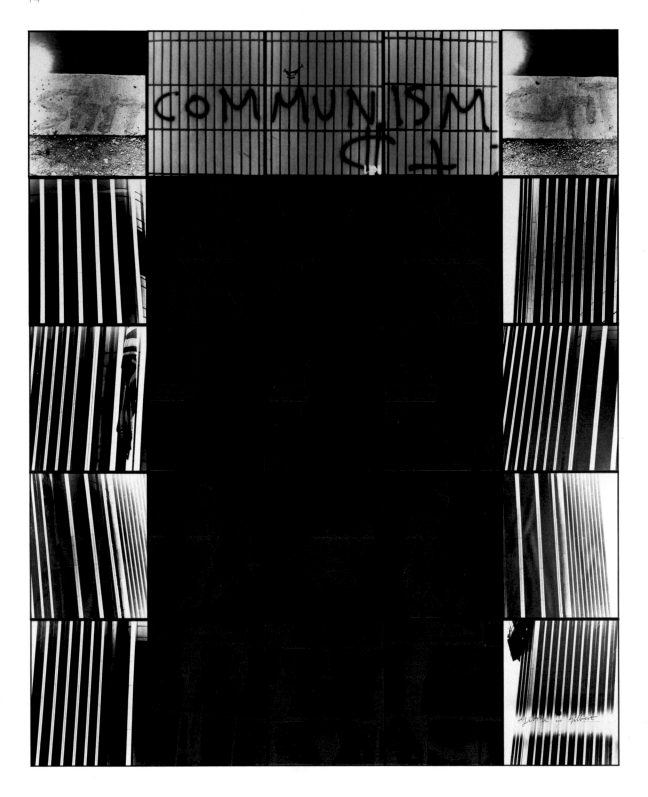

71
COMMUNISM
1977
302 x 252 cm

72
THE QUEUE
1978
242 x 202 cm

73
MORNING
1978
151 x 121 cm

76
THE PENIS
1978
242 x 202 cm

74
THE BRANCH
1978
242 x 202 cm

75
THE ALCOHOLIC
1978
242 x 202 cm

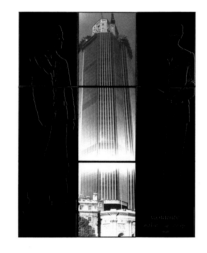

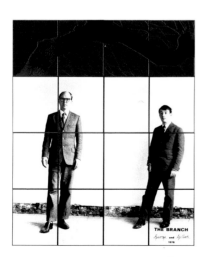

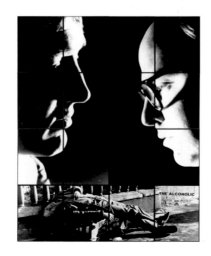

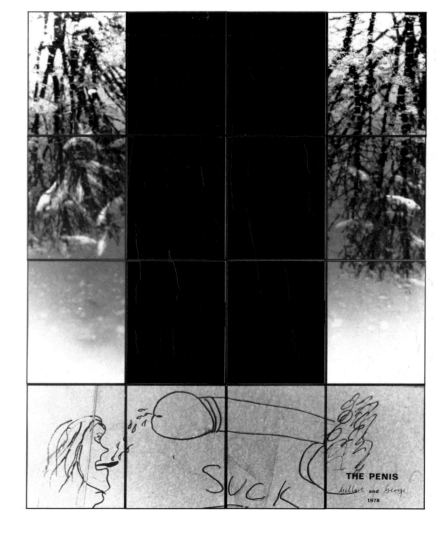

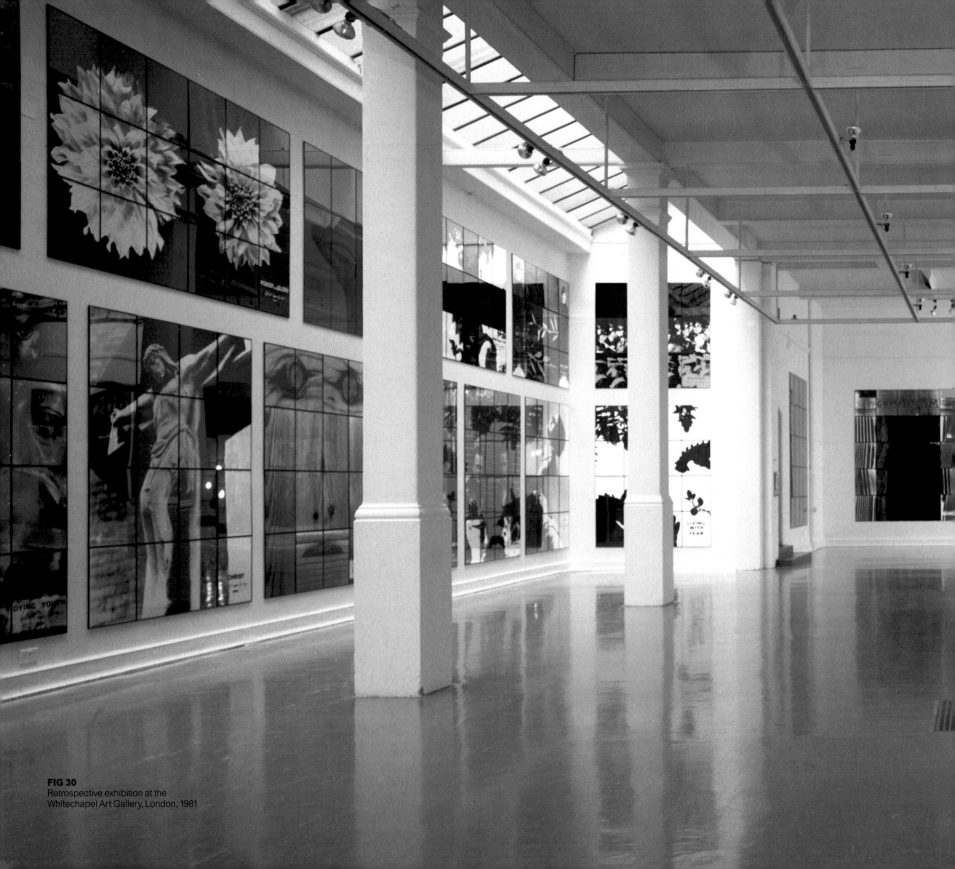

FIG 30
Retrospective exhibition at the
Whitechapel Art Gallery, London, 1981

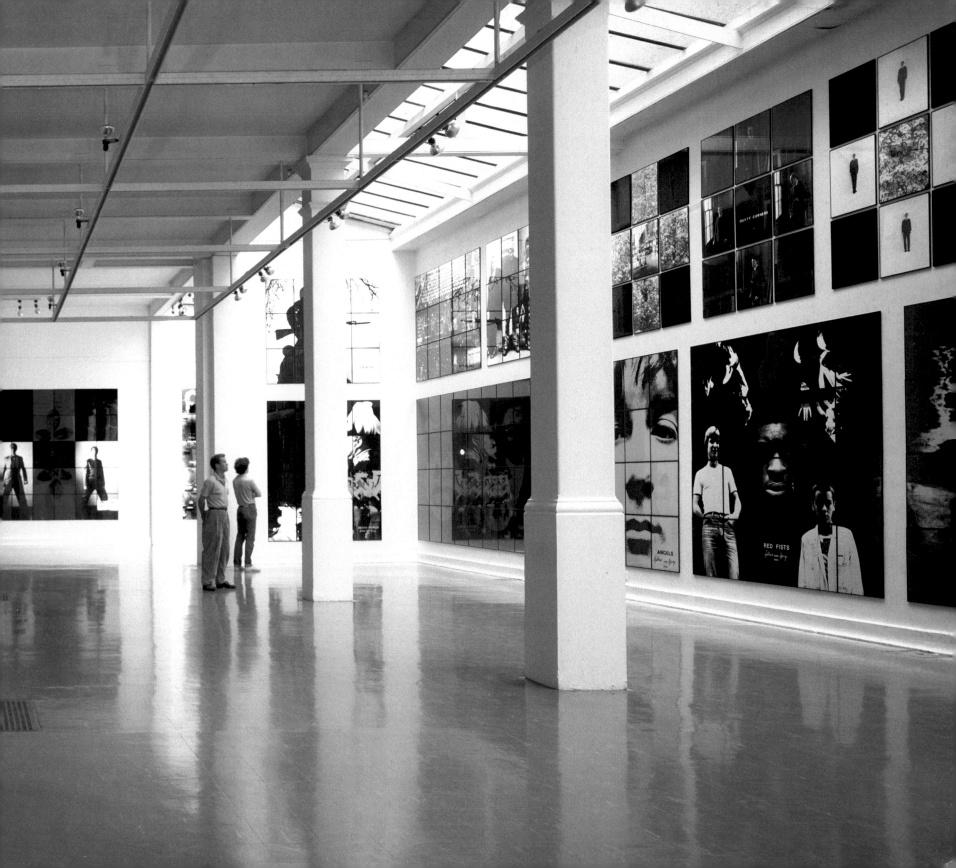

77
BLACK JESUS
1980
181 x 252 cm

FOURNIER STREET

78
FOURNIER STREET
1980
181 x 252 cm

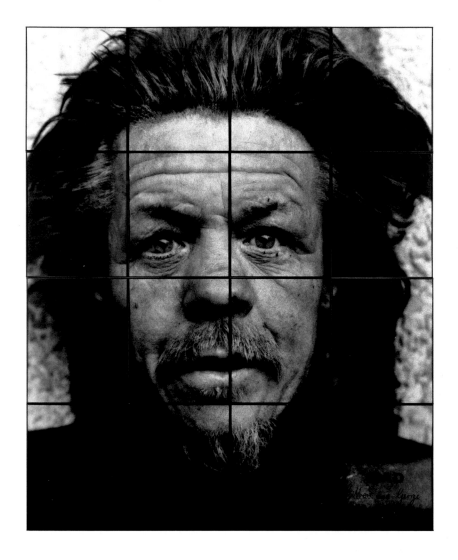

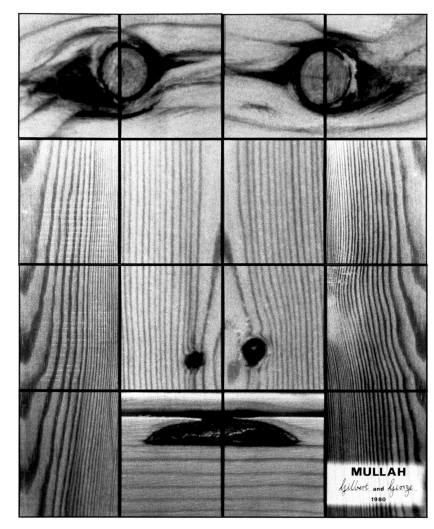

79
MAD
1980
242 x 202 cm

80
MULLAH
1980
242 x 202 cm

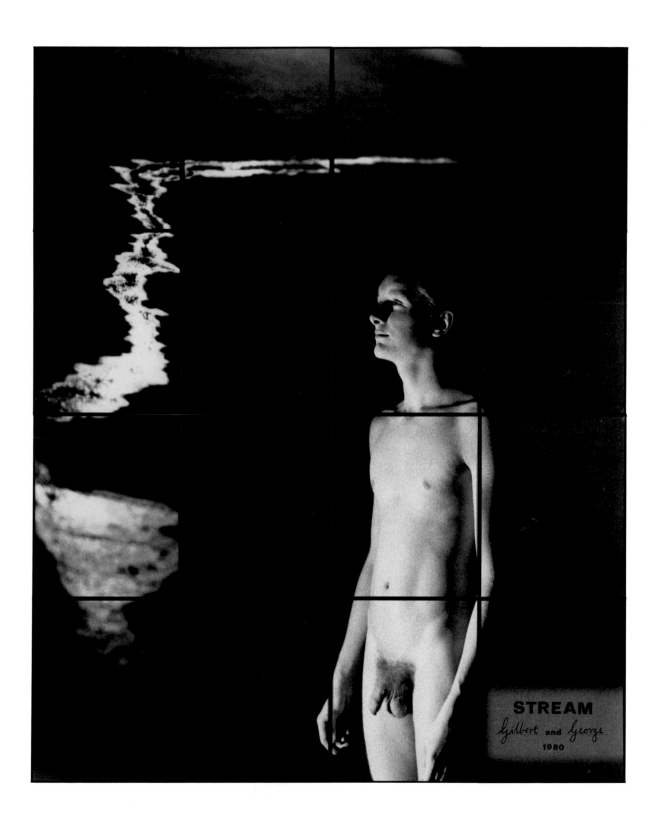

81
STREAM
1980
242 x 202 cm

82
PATRIOTS
1980
181 x 303 cm

83
HELLISH
1980
242 x 303 cm

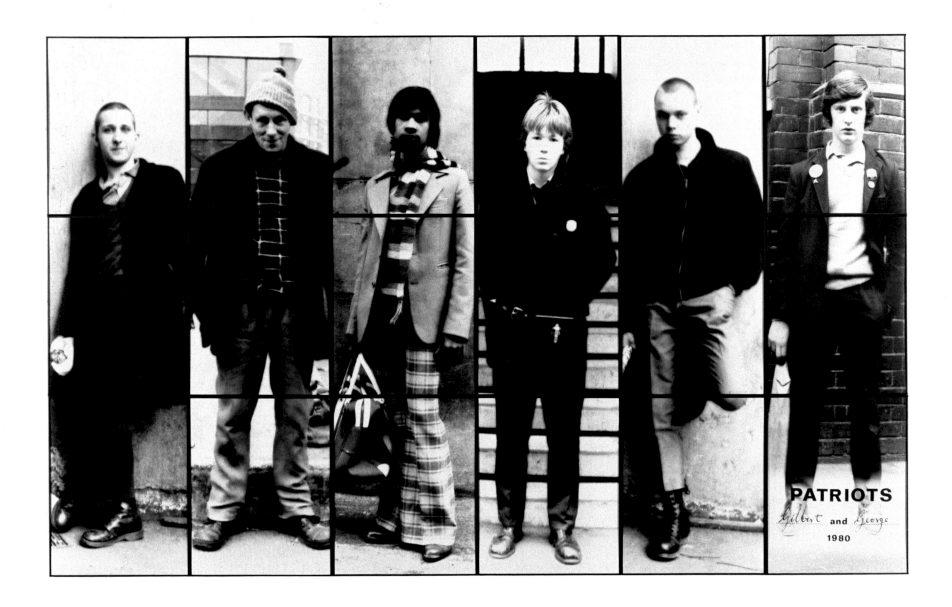

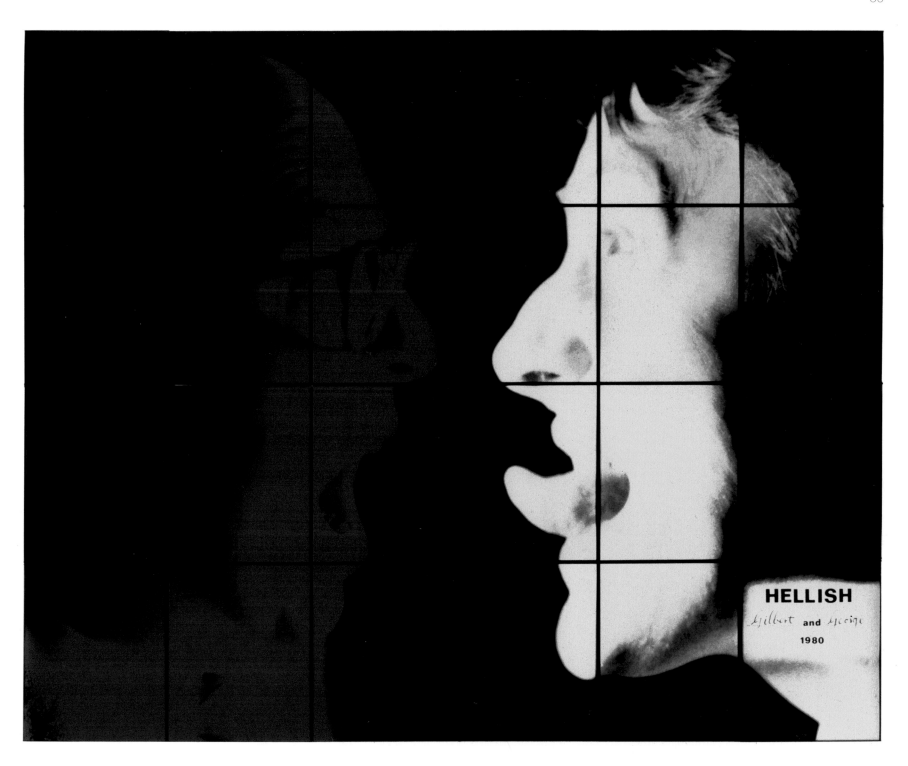

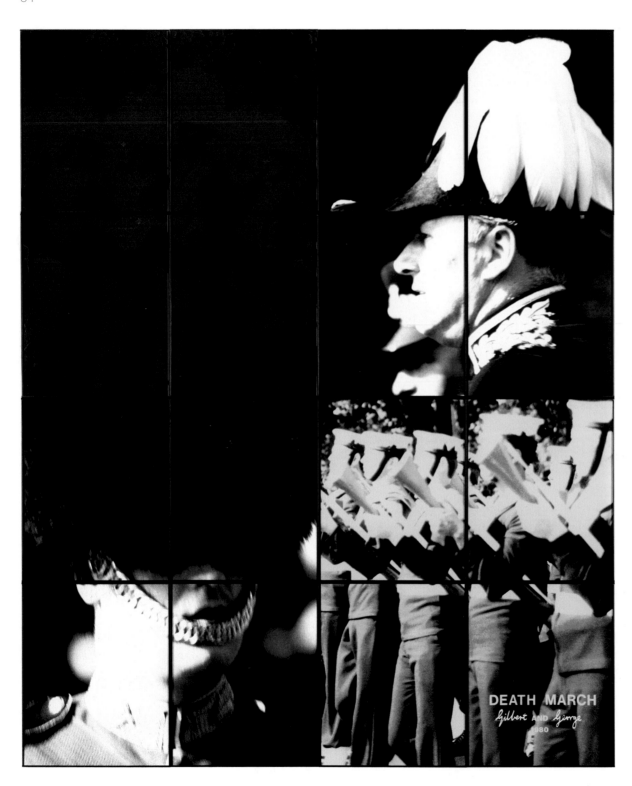

85
ANTICHRIST
1980
181 x 151 cm

86
LIVING WITH FEAR
1980
242 x 202 cm

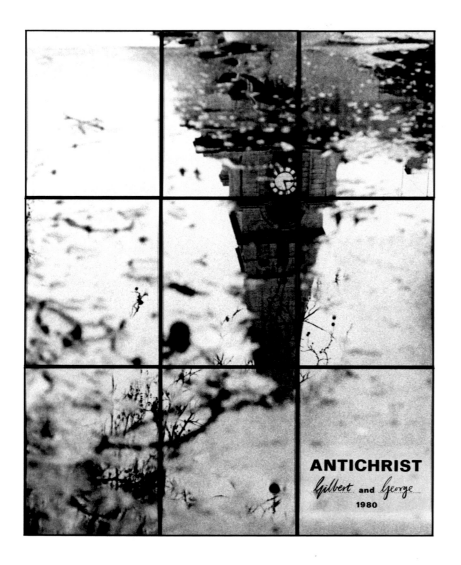

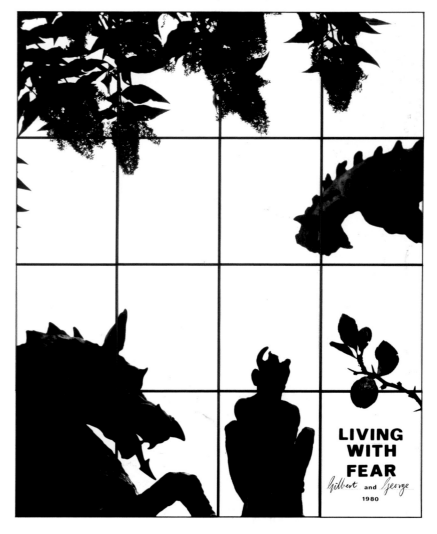

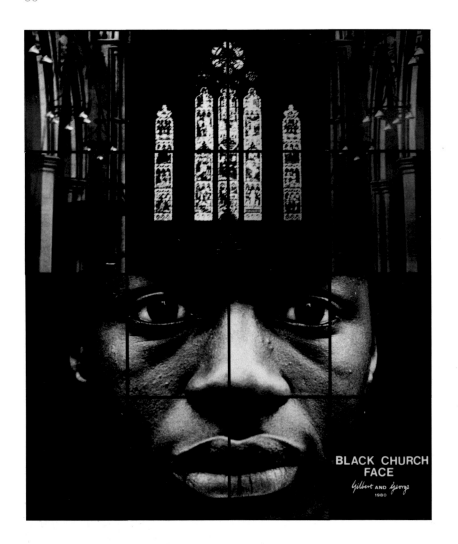

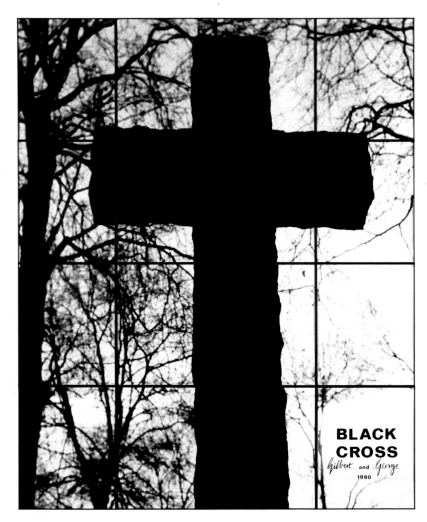

87
BLACK CHURCH FACE
1980
242 x 202 cm

88
BLACK CROSS
1980
242 x 202 cm

89
FOUR KNIGHTS
1980
242 x 202 cm

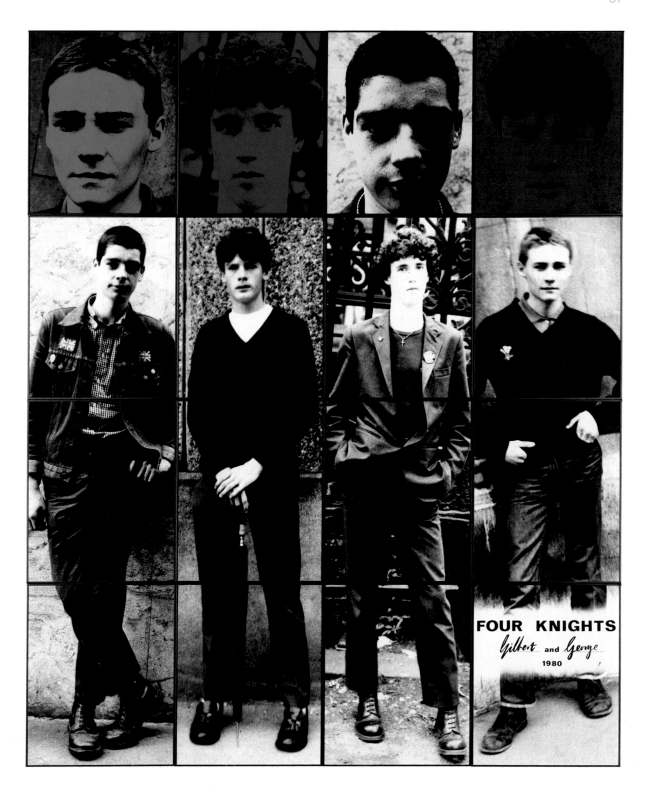

90
ROSE HOLE
1980
181 x 303 cm

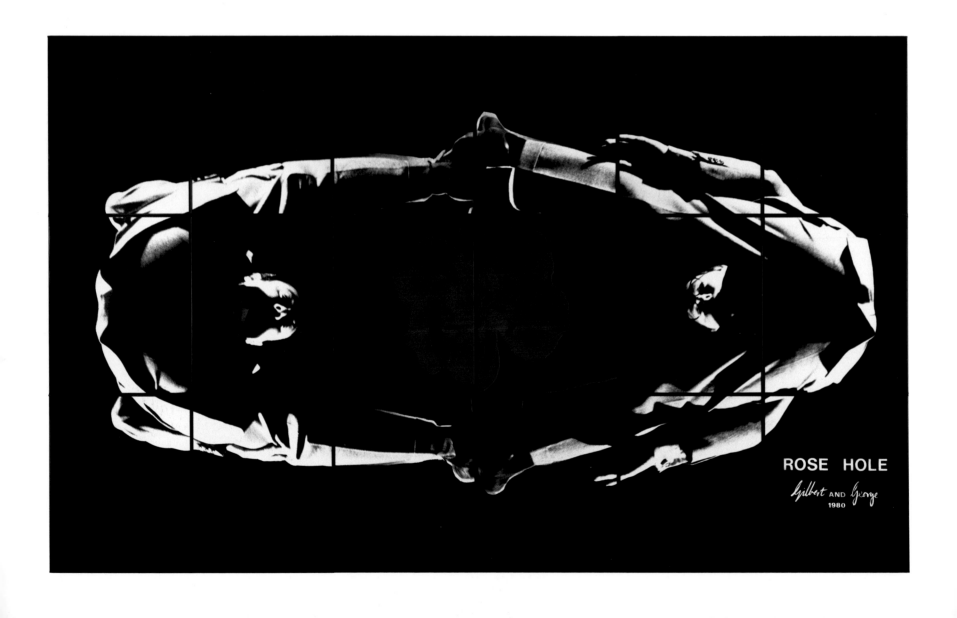

91
ENGLAND
1980
302 x 303 cm

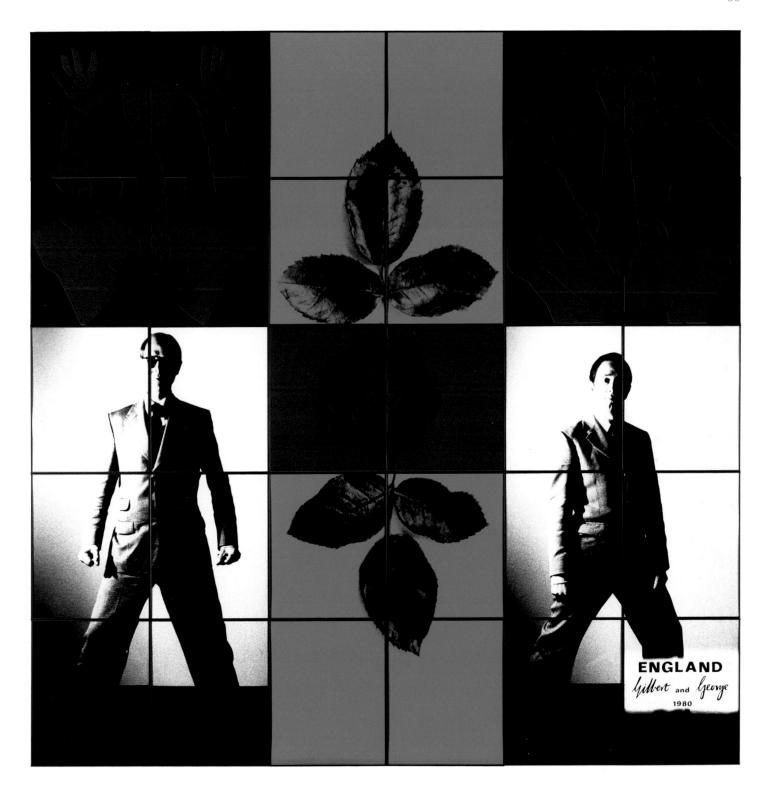

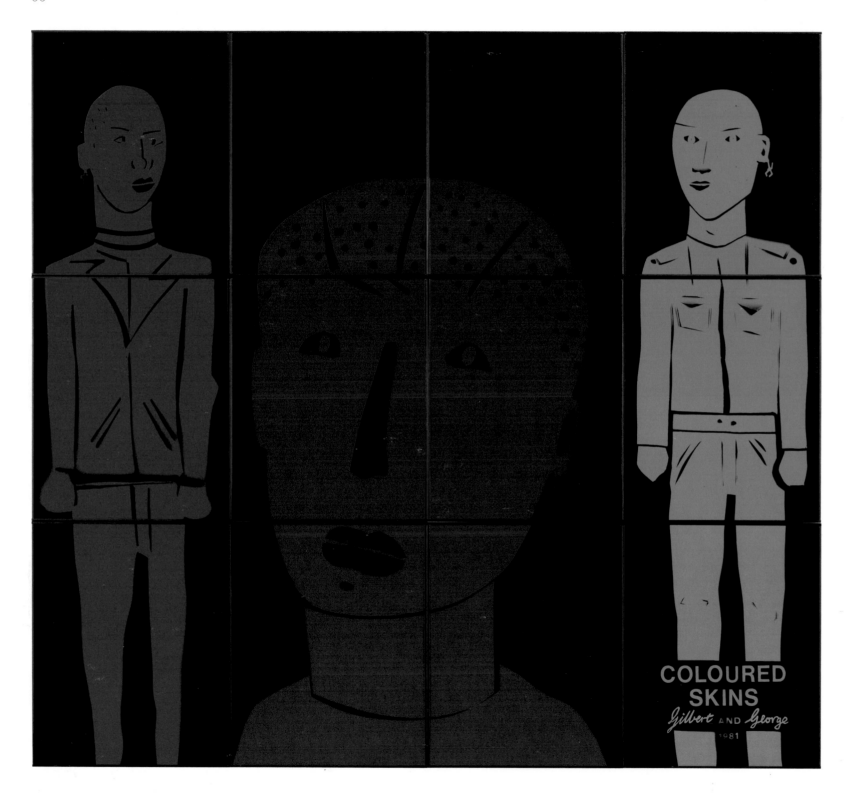

92
COLOURED SKINS
1981
181 x 202 cm

93
THIRST
1982
242 x 202 cm

94
HUNGER
1982
242 x 202 cm

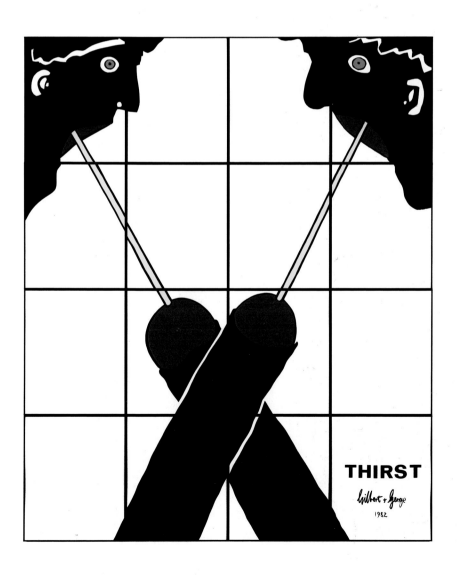

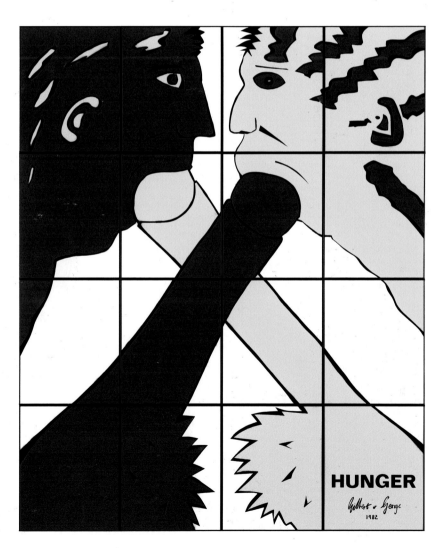

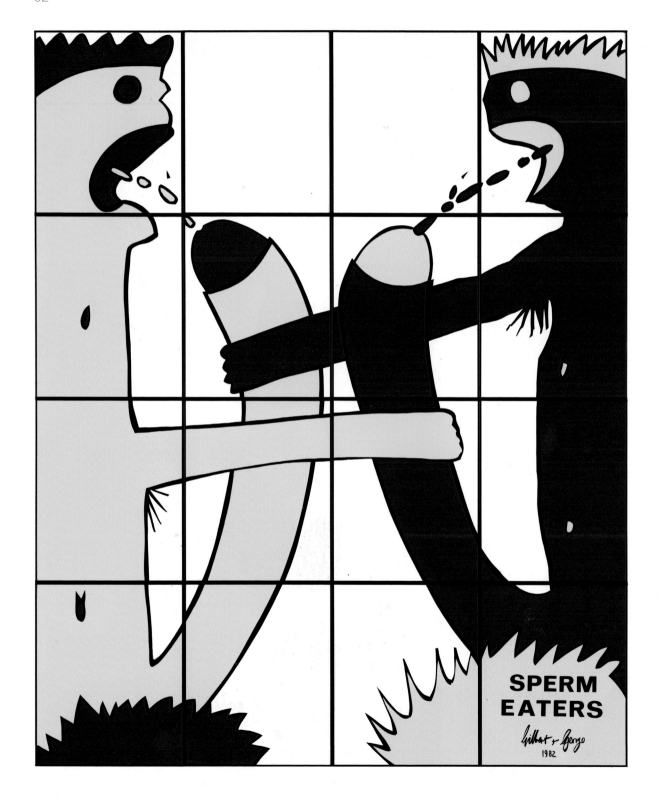

95
SPERM EATERS
1982
242 x 202 cm

96
WINTER TONGUE FUCK
1982
242 x 202 cm

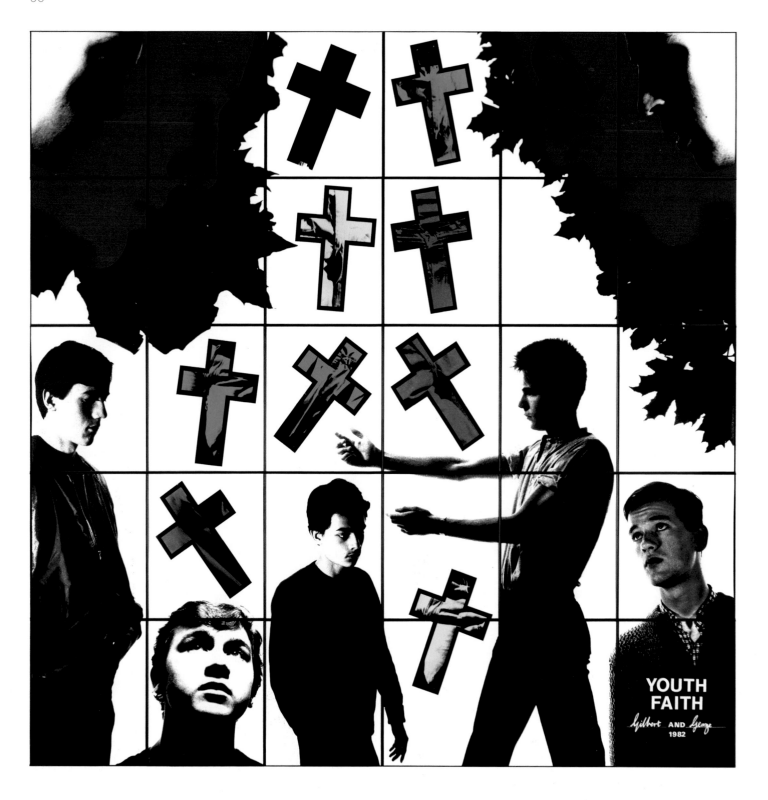

100
YOUTH FAITH
1982
302 x 303 cm

101
COLOURED LOVES
1982
242 x 252 cm

102
WINTER FLOWERS
1982
242 x 252 cm

(Following page)
103
LIFE WITHOUT END
1982
423 x 1111 cm

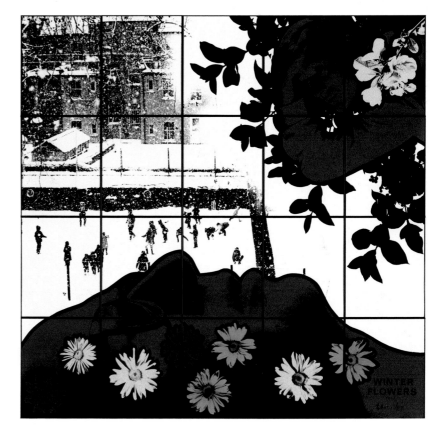

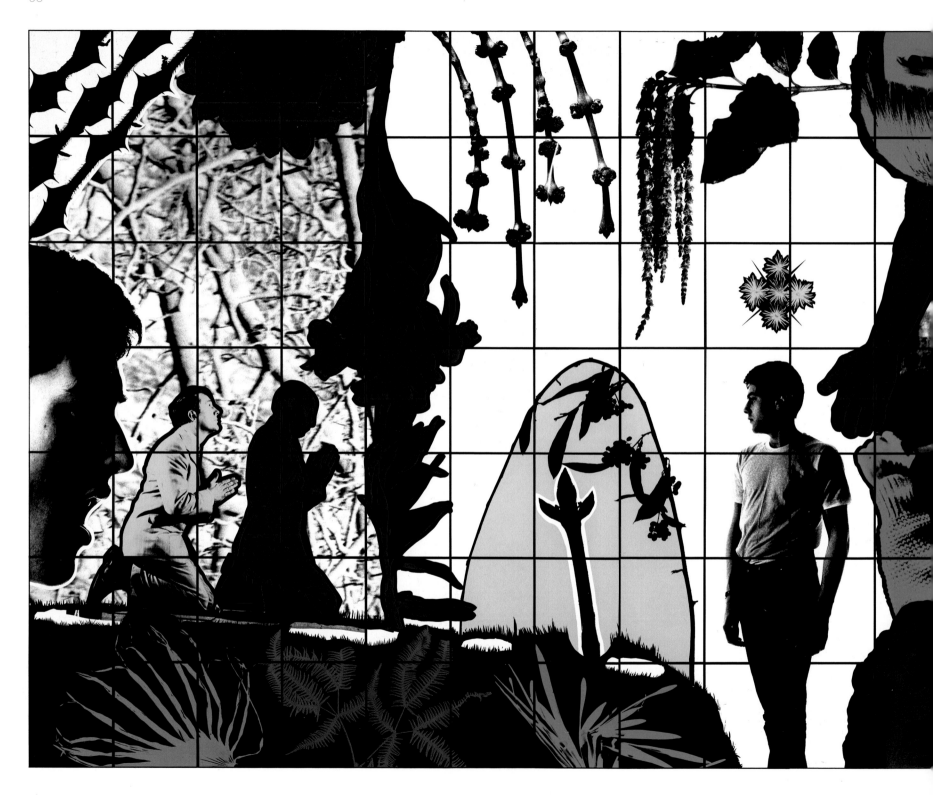

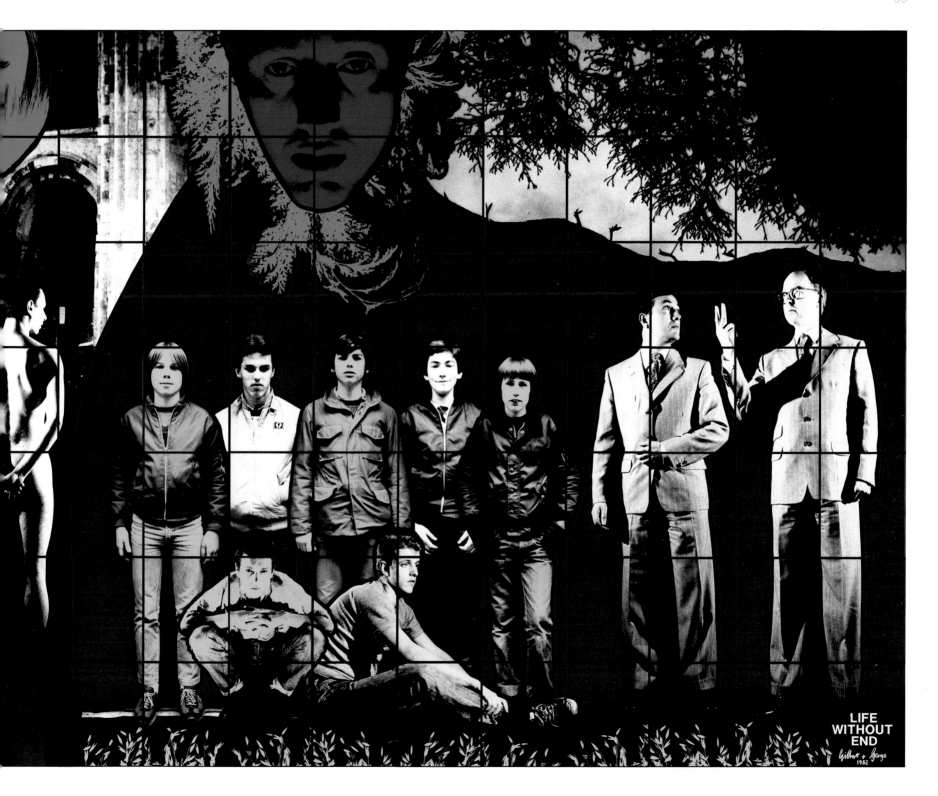

LIFE
WITHOUT
END

104
FINDING GOD
1982
423 x 606 cm

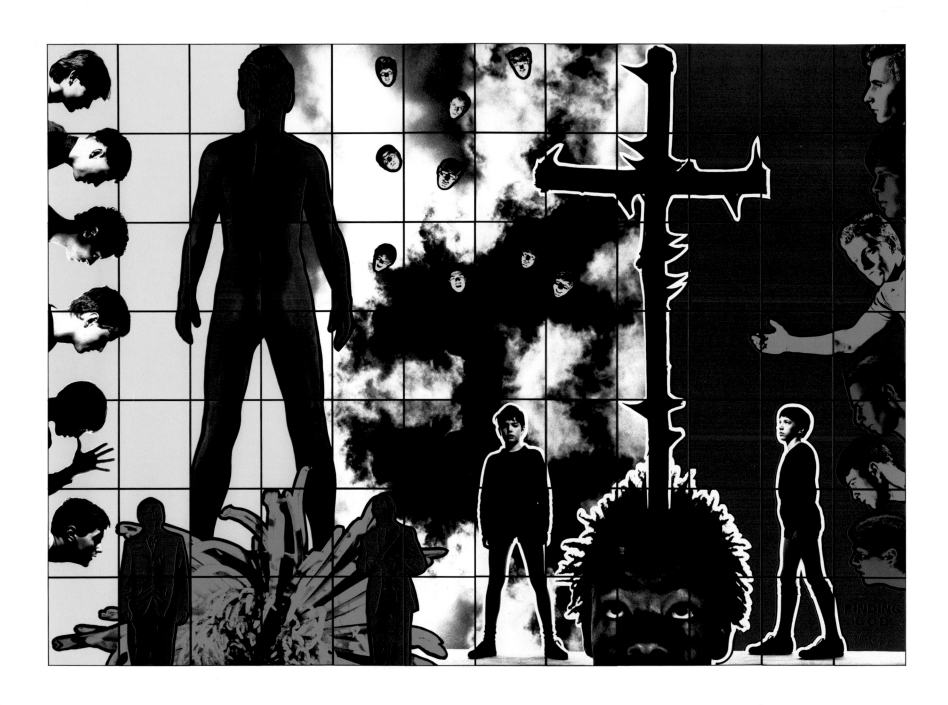

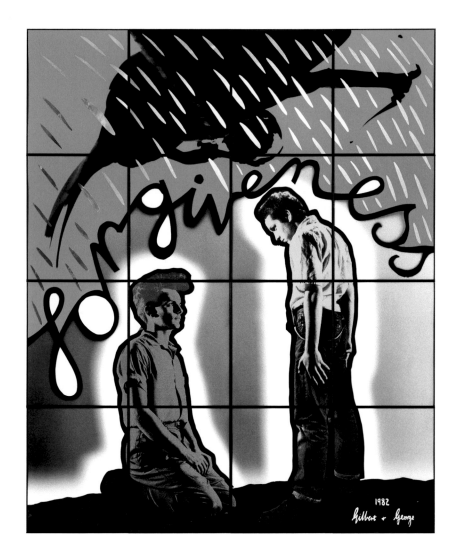

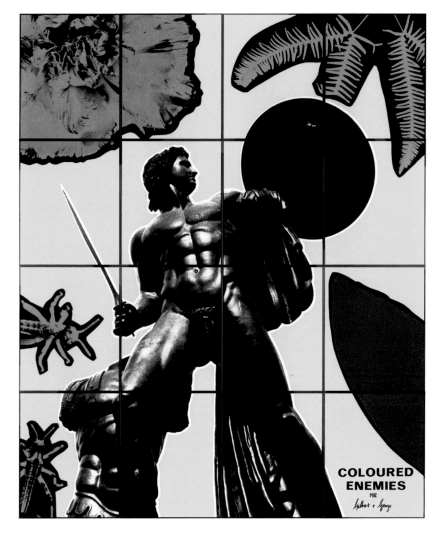

105
FORGIVENESS
1982
242 x 202 cm

106
COLOURED ENEMIES
1982
242 x 202 cm

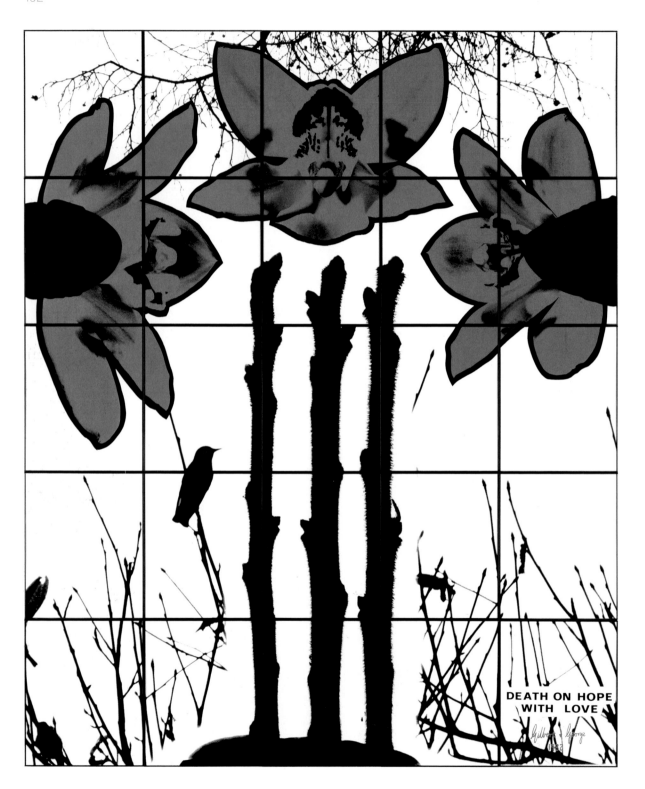

107
DEATH ON HOPE
WITH LOVE
1982
302 x 252 cm

108
REAMING
1982
302 x 303 cm

109
YOUTH ATTACK
1982
302 x 606 cm

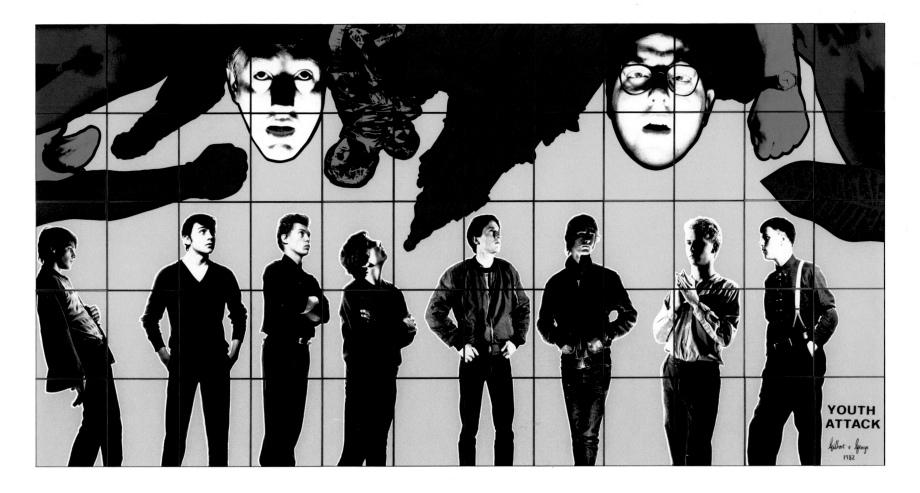

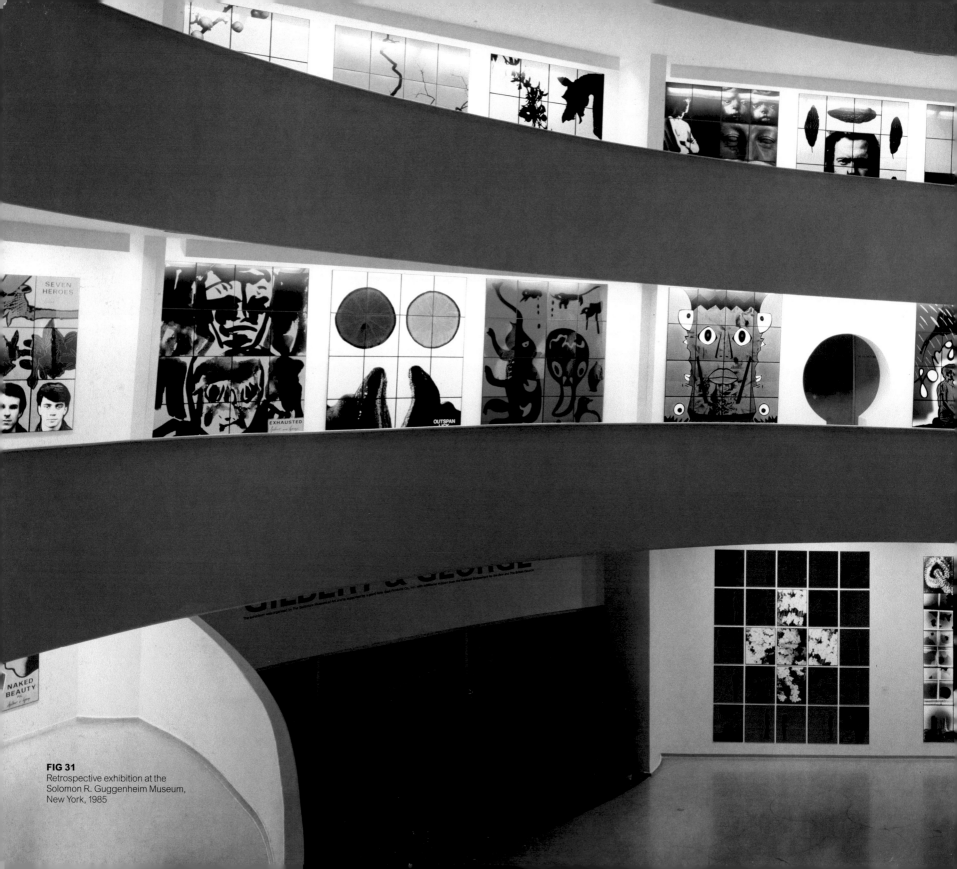

FIG 31
Retrospective exhibition at the
Solomon R. Guggenheim Museum,
New York, 1985

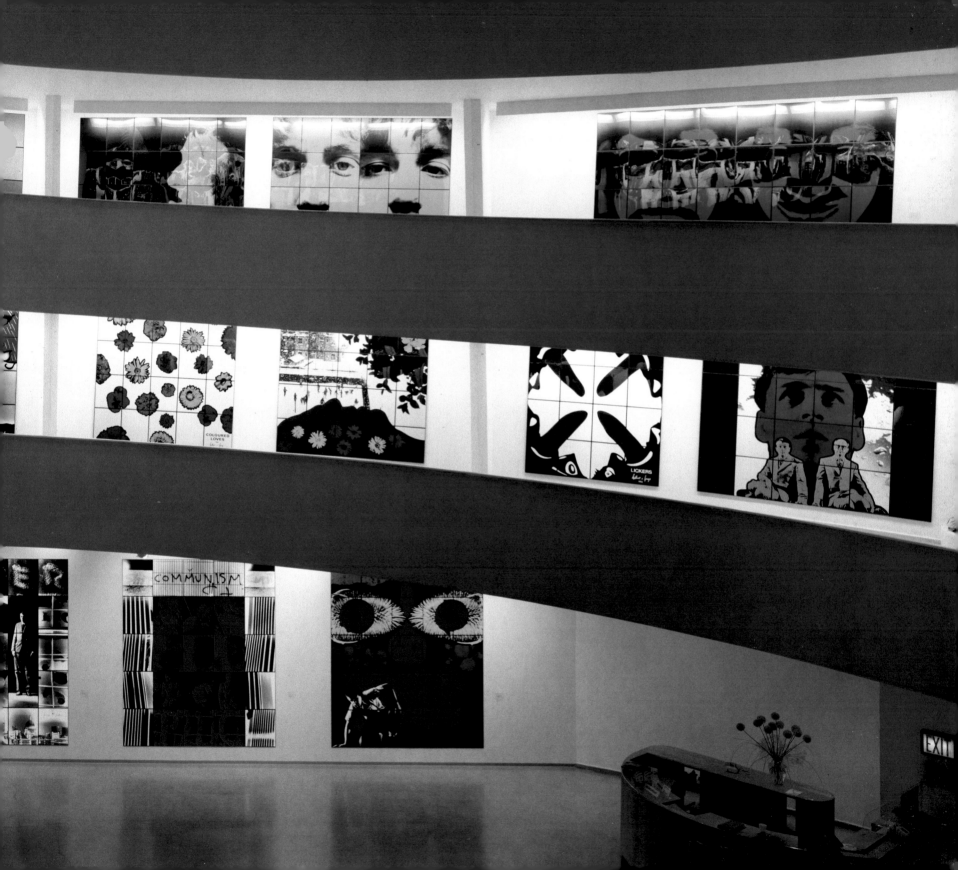

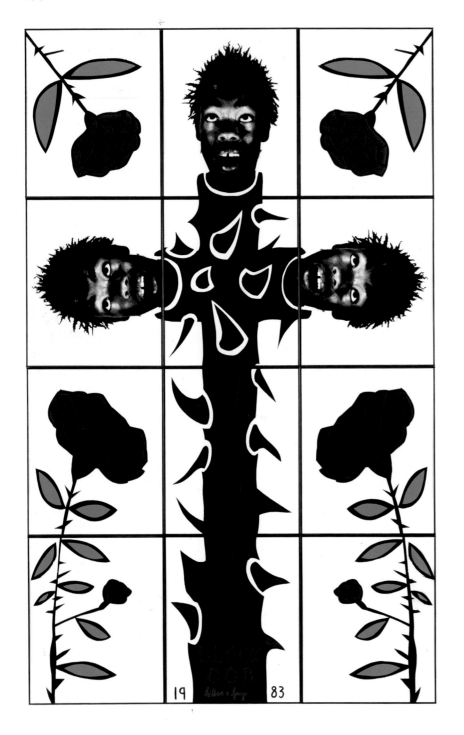

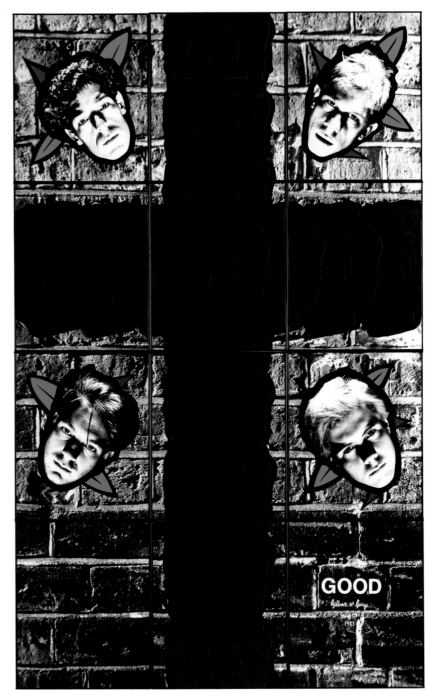

110
BLACK GOD
1983
242 x 151 cm

111
GOOD
1983
242 x 151 cm

112
SHITTED
1983
242 x 202 cm

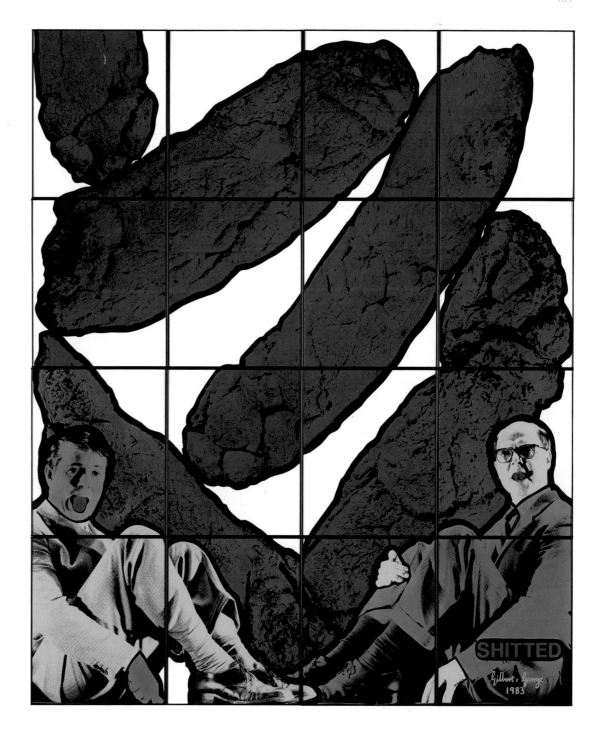

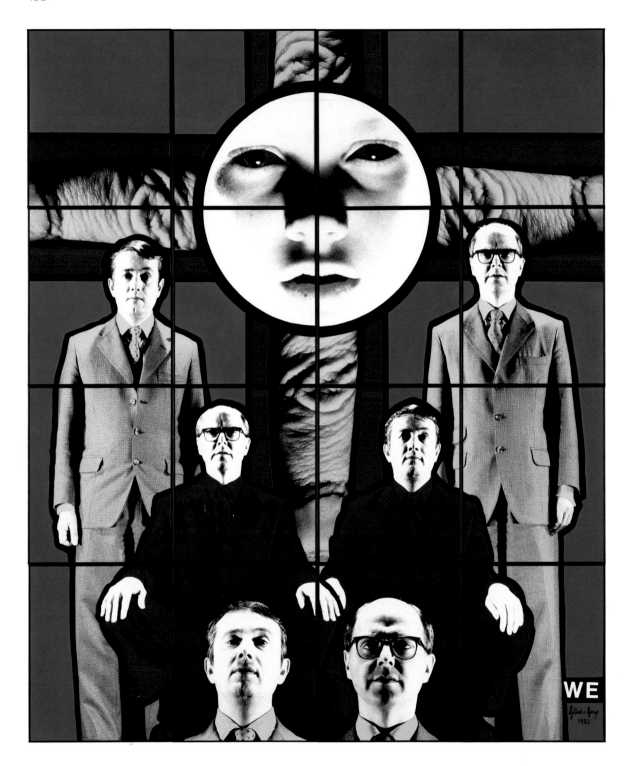

113
WE
1983
242 x 202 cm

114
WORLD
1983
242 x 303 cm

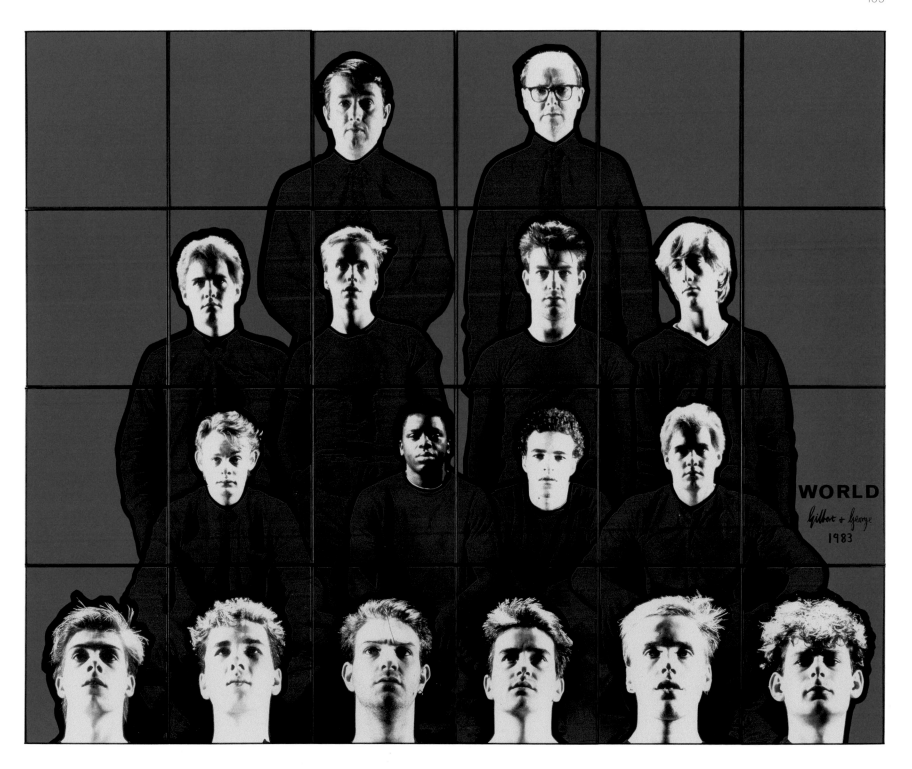

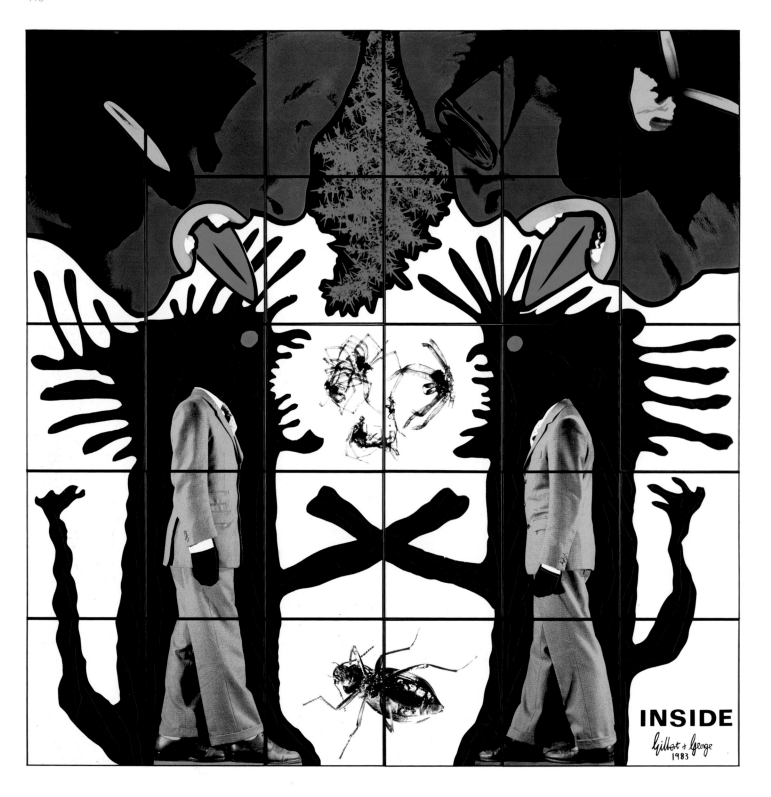

115
INSIDE
1983
302 x 303 cm

116
BLOODED
1983
302 x 252 cm

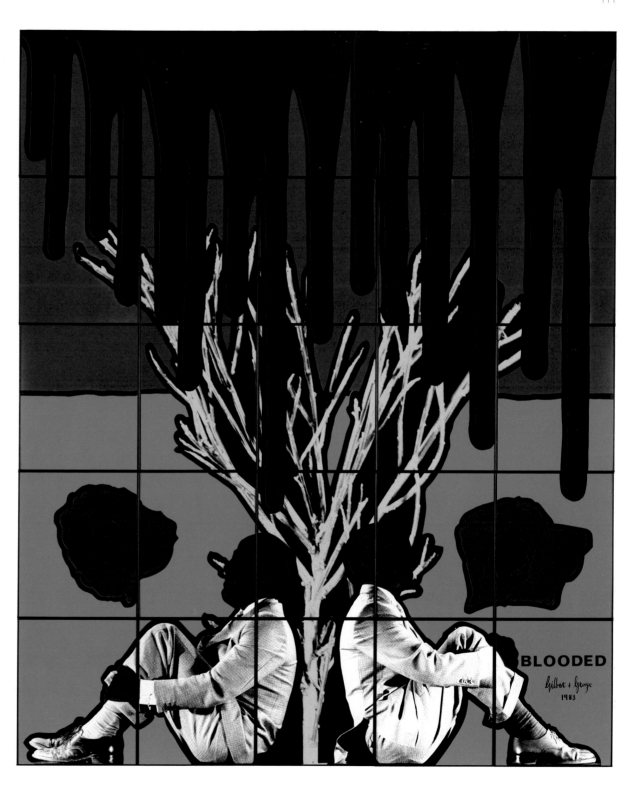

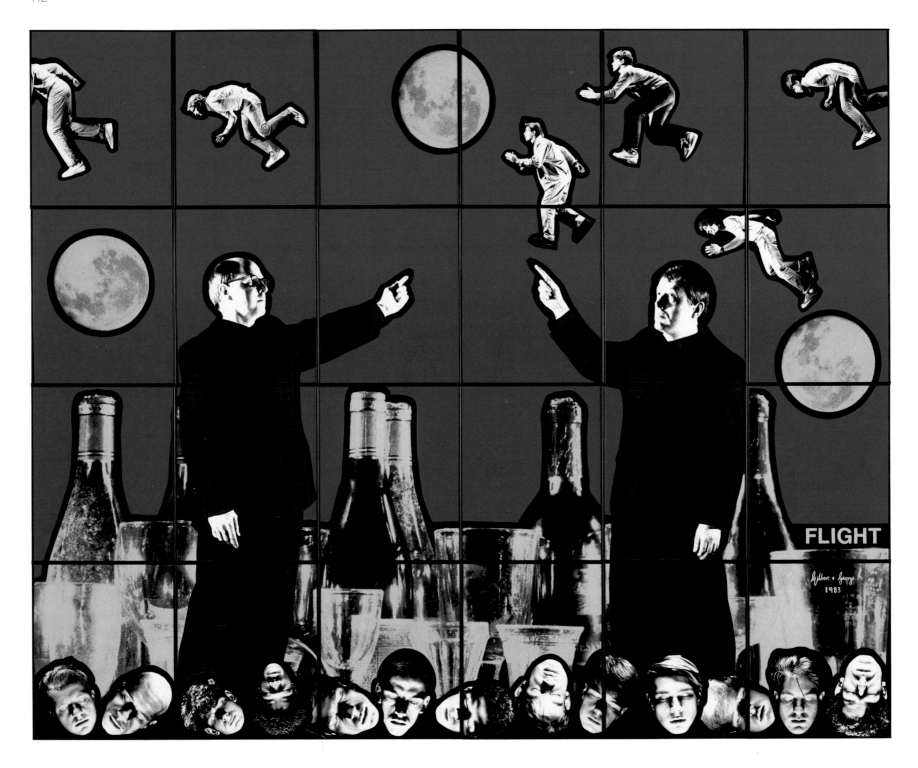

117
FLIGHT
1983
242 x 303 cm

118
EXISTERS
1984
242 x 353 cm

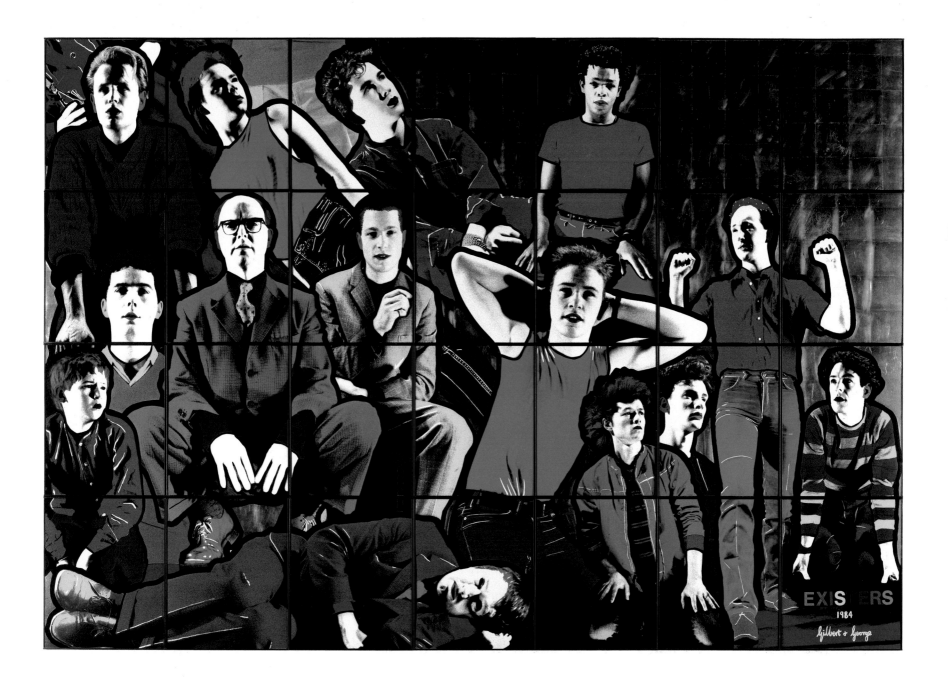

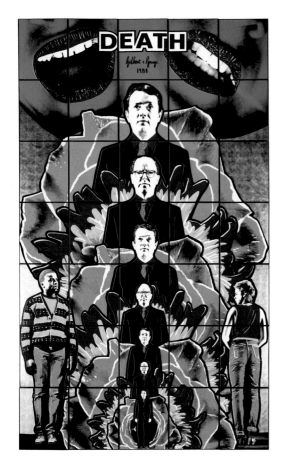

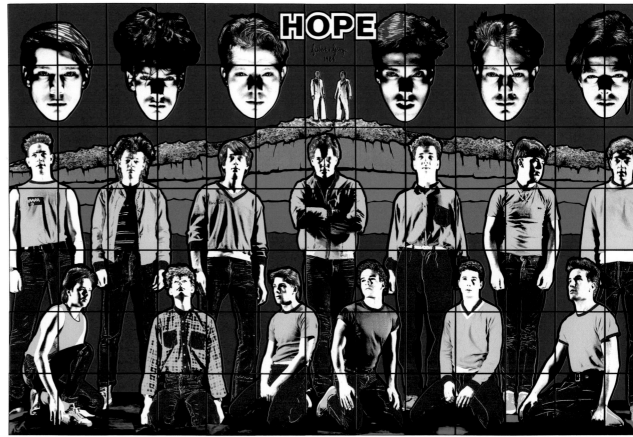

119
DEATH HOPE LIFE FEAR
1984
A quadripartite picture
Left to right: 423 x 252 cm; 423 x 656 cm;
423 x 656 cm; 423 x 252 cm

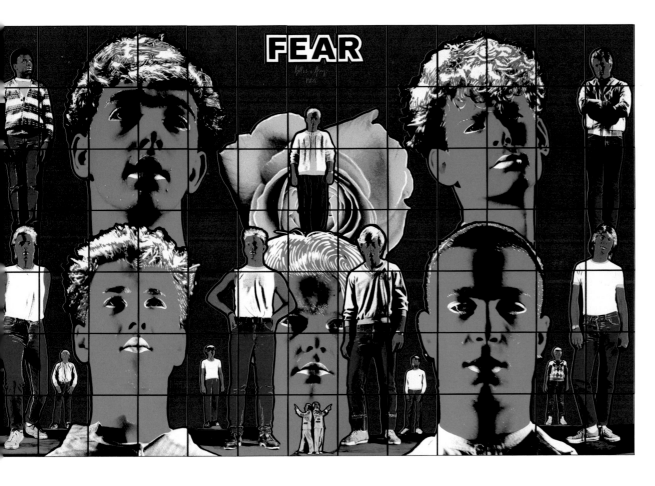

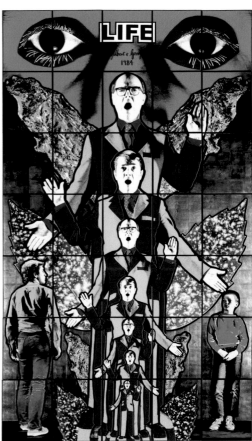

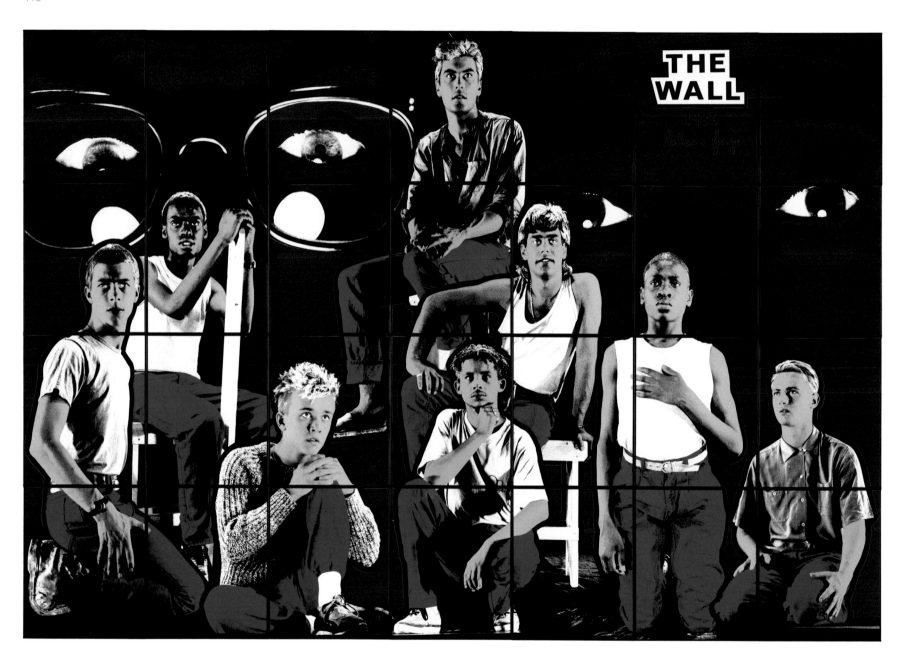

120
THE WALL
1986
242 x 353 cm

121
SPORE
1986
242 x 505 cm

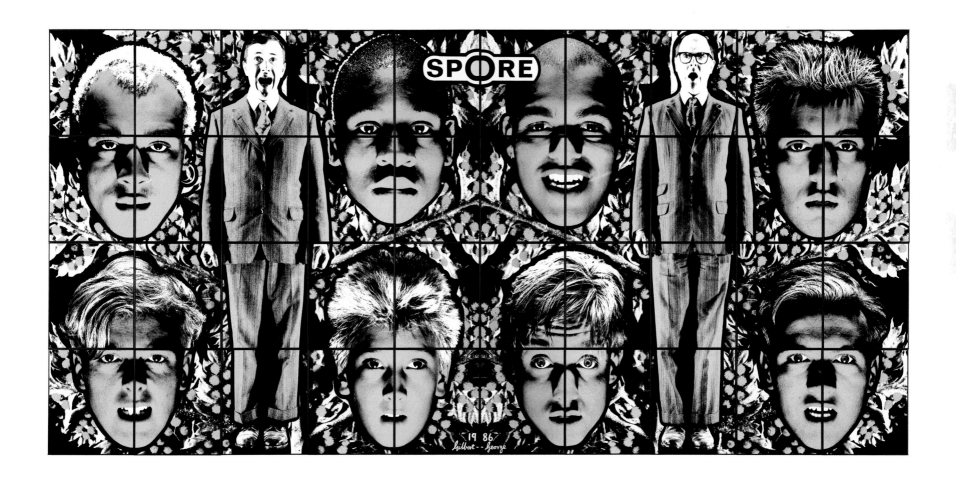

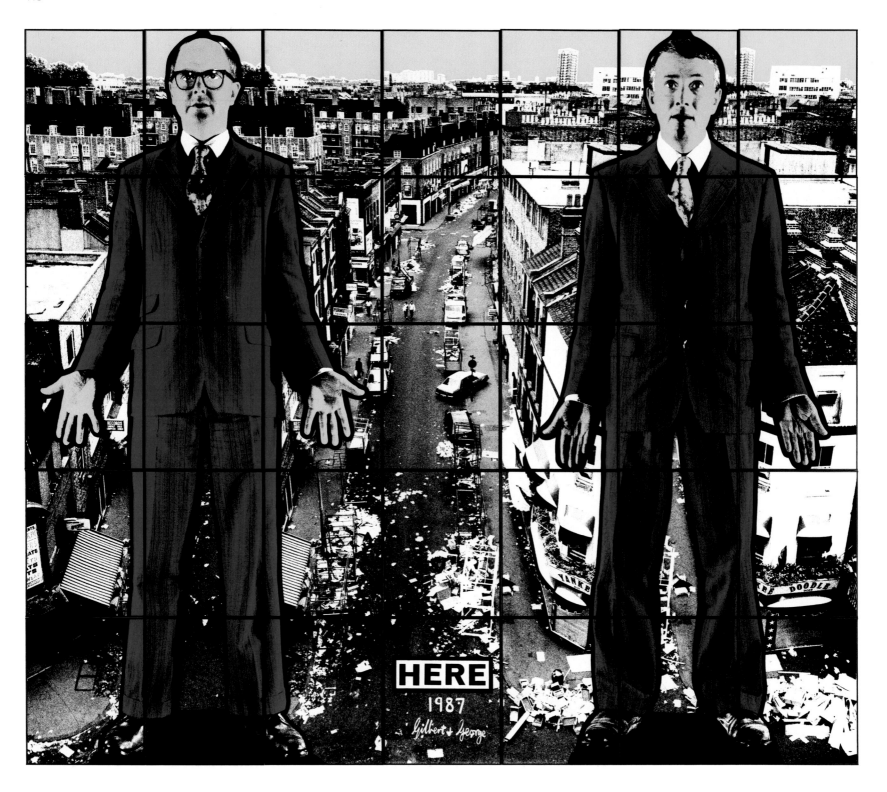

122
HERE
1987
302 x 353 cm

123
THERE
1987
302 x 252 cm

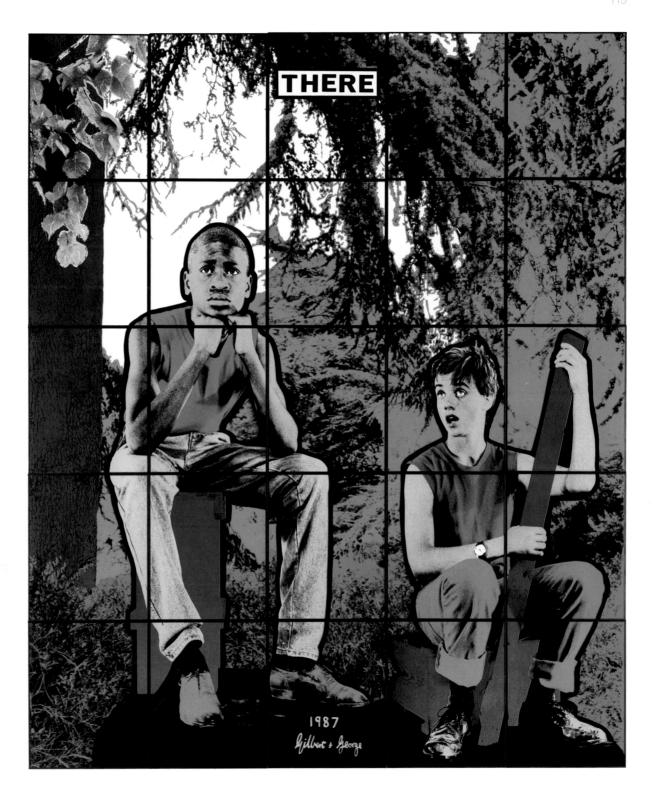

124
A.D.
1987
302 x 252 cm

125
TEARS
1987
242 x 202 cm

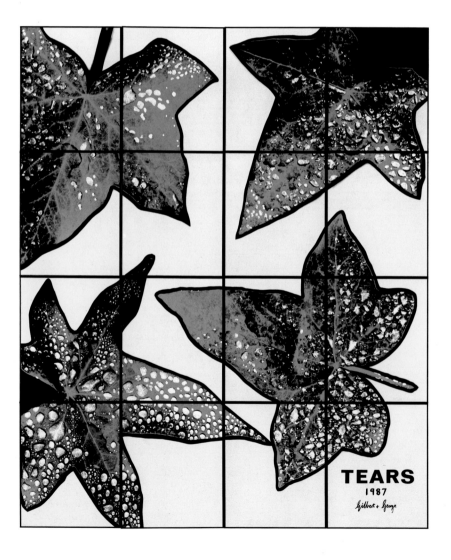

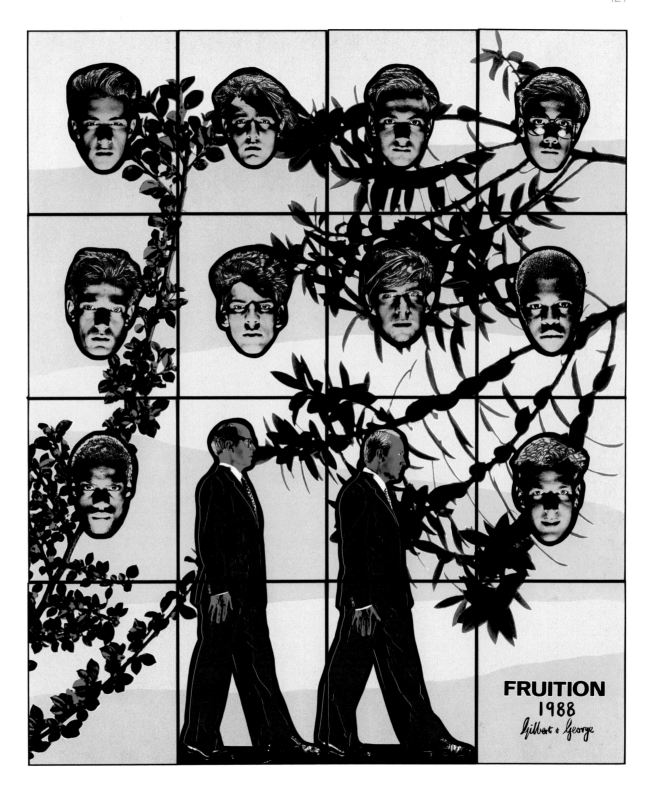

126
FRUITION
1988
302 x 254 cm

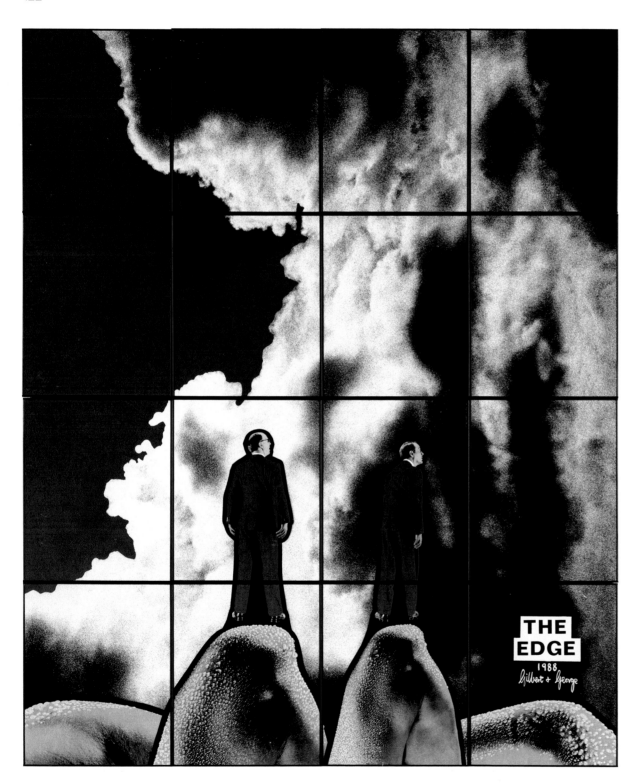

127
THE EDGE
1988
242 x 202 cm

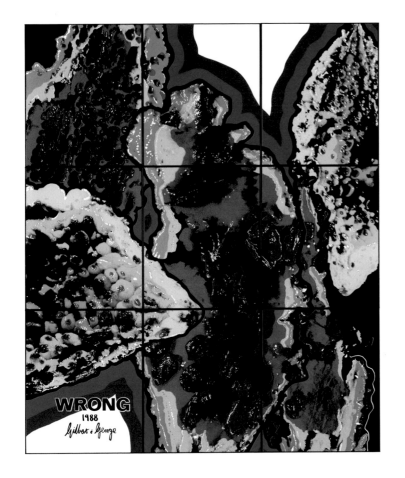

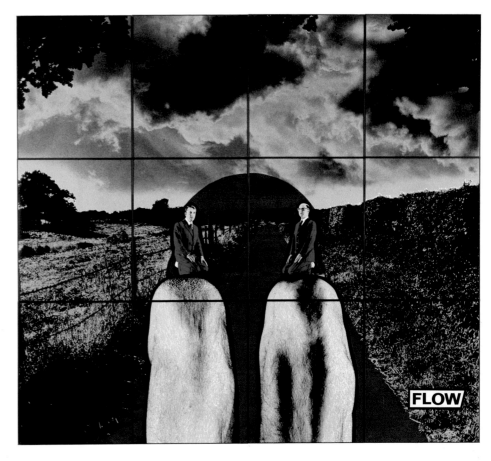

128
WRONG
1988
253 x 213 cm

129
FLOW
1988
253 x 284 cm

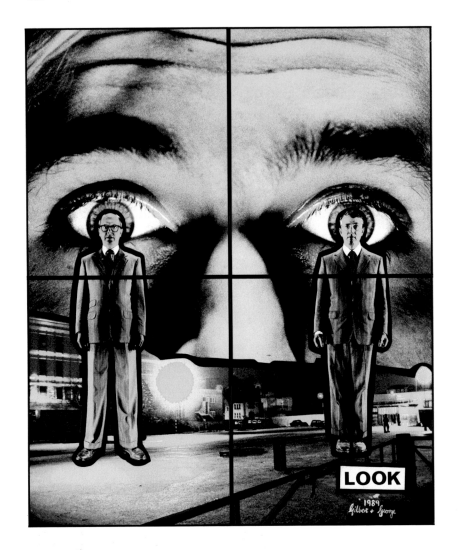

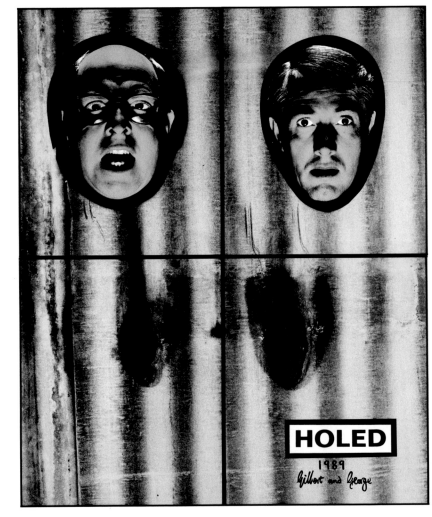

133
LOOK
1989
169 x 142 cm

134
HOLED
1989
169 x 142 cm

135
MY WORLD
1989
226 x 190 cm

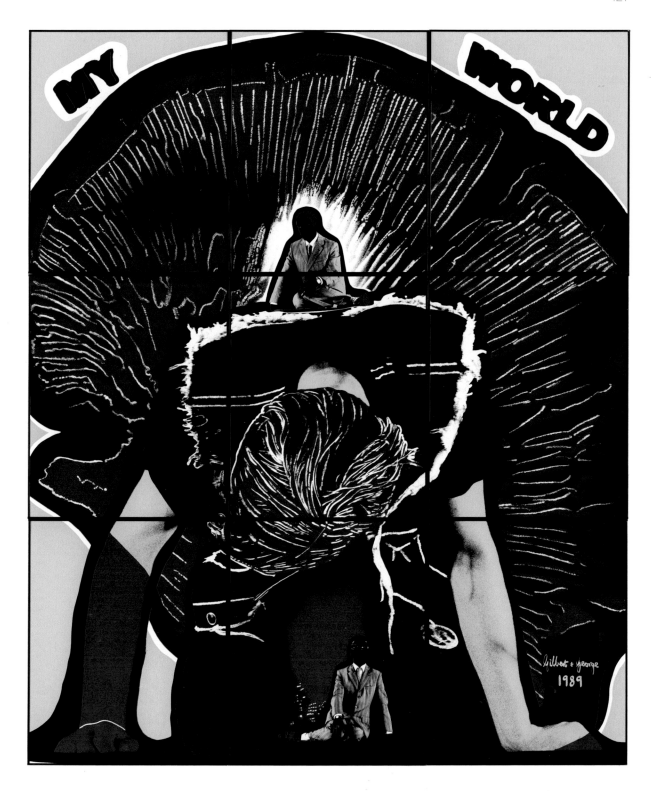

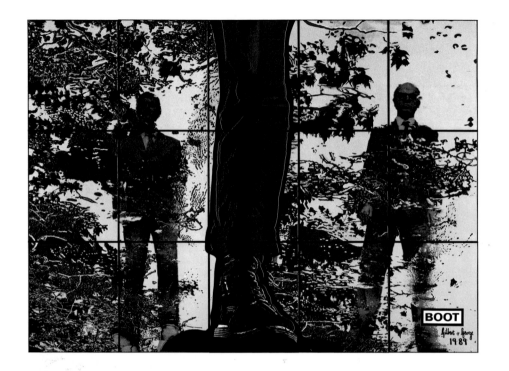

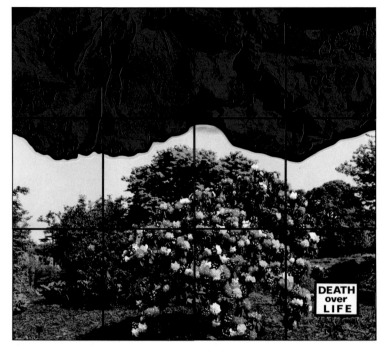

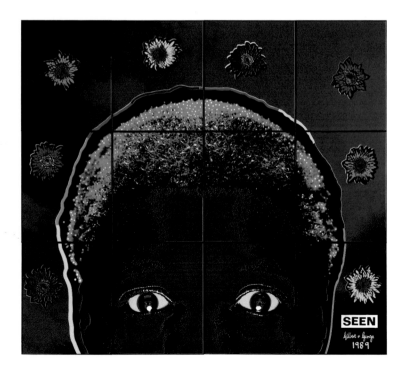

136
BOOT
1989
226 x 317 cm

137
DEATH OVER LIFE
1989
226 x 254 cm

138
SEEN
1989
226 x 254 cm

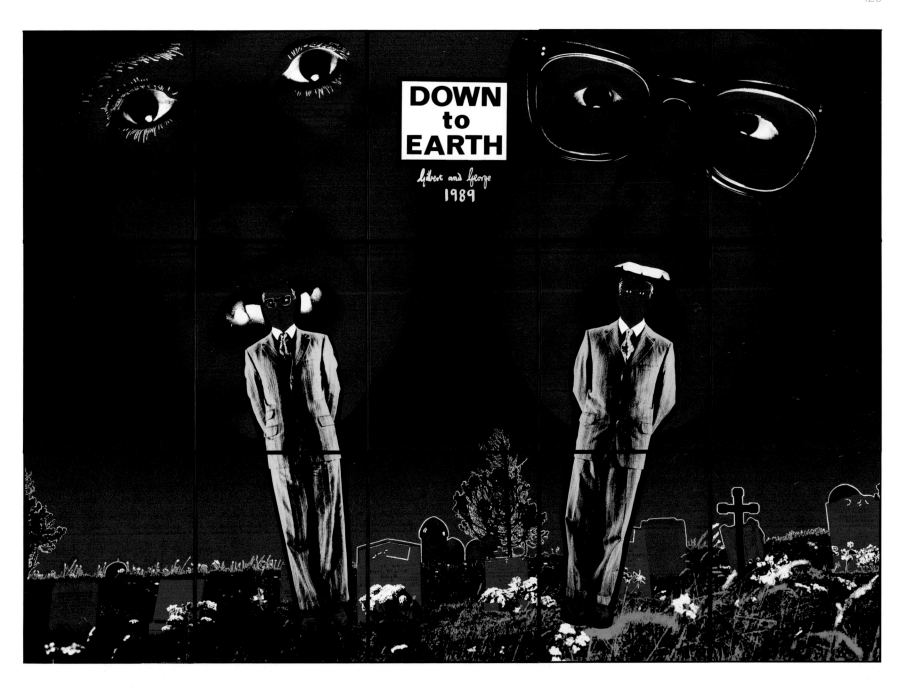

139
DOWN TO EARTH
1989
226 x 317 cm

140
BLOOD HEADS
1989
226 x 381 cm

141
DEAD HEAD
1989
226 x 508 cm

142
ALL
1989
226 x 381 cm

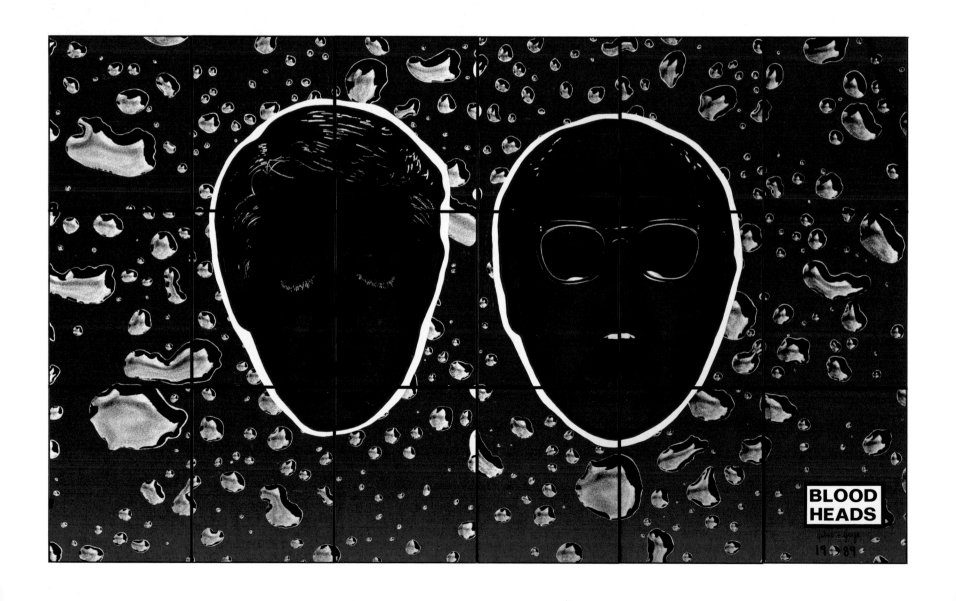

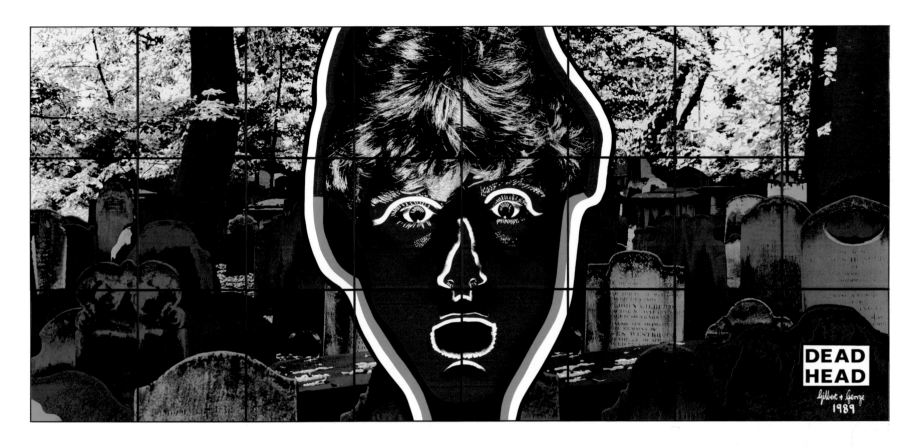

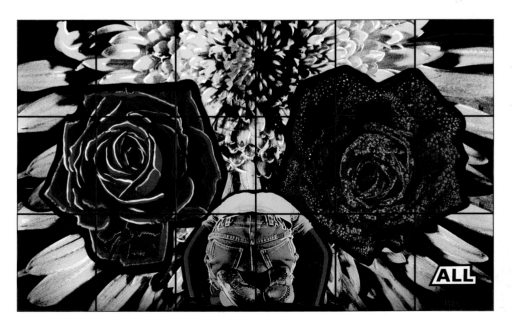

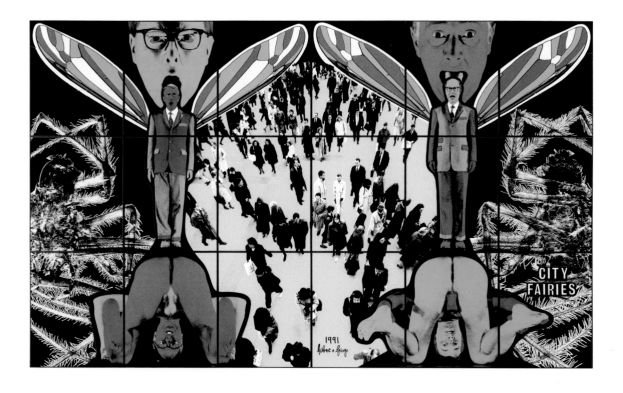

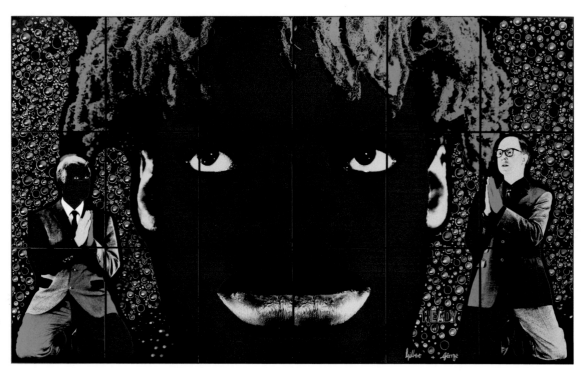

143
CITY FAIRIES
1991
253 x 426 cm

144
HEADY
1991
253 x 426 cm

'When they discuss classical paintings or sculptures, they never say, there's a naked Roman. It's always a nude. And these are naked, and we believe there's a very great difference. Naked isn't physical, it's more mental, more frightening'

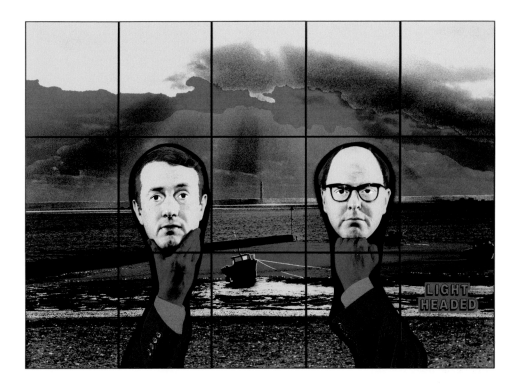

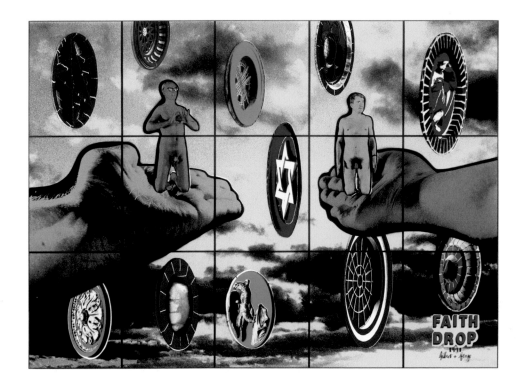

145
LIGHT HEADED
1991
253 x 355 cm

146
FAITH DROP
1991
253 x 355 cm

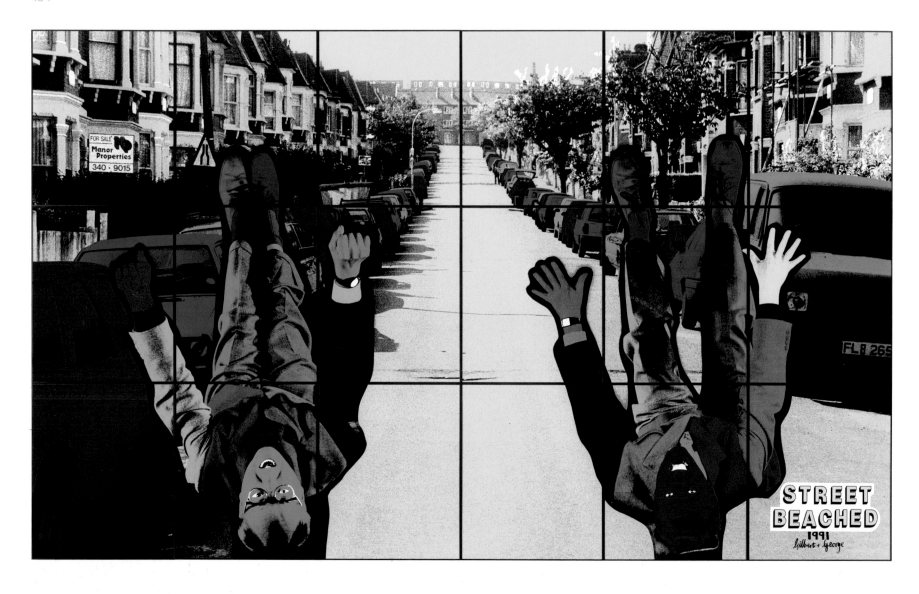

147
STREET BEACHED
1991
253 x 426 cm

148
HEADACHE
1991
253 x 497 cm

(Following page)
149
COLD STREET
1991
253 x 639 cm

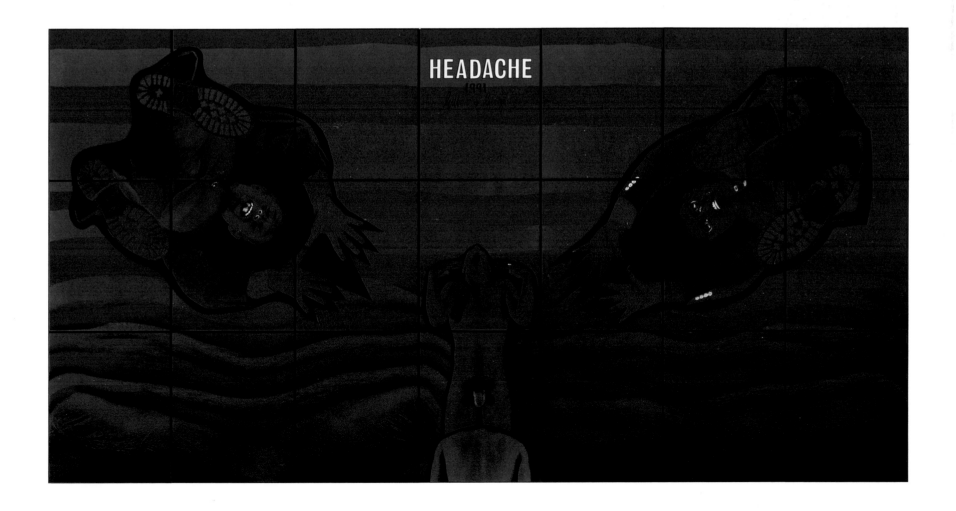

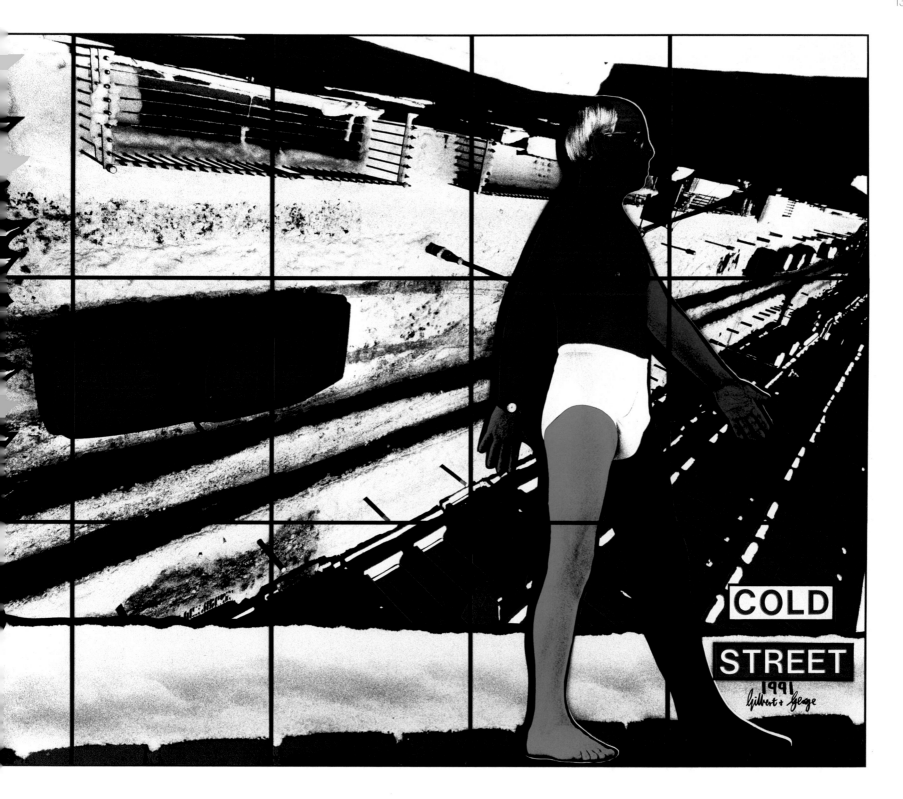

COLD
STREET
1991
Gilbert + George

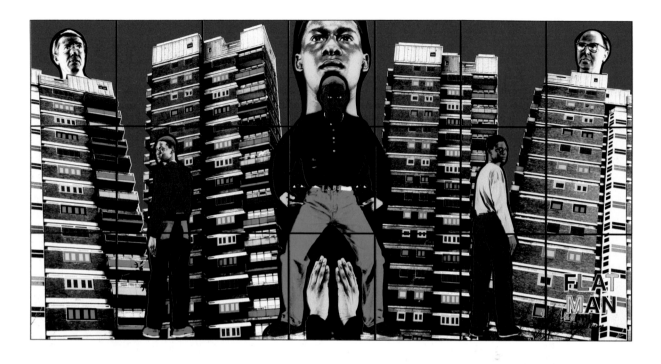

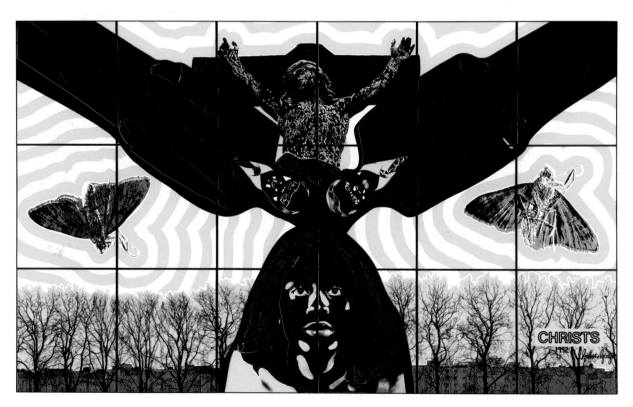

150
FLAT MAN
1991
253 x 497 cm

151
CHRISTS
1992
253 x 426 cm

152
YELL
1992
253 x 213 cm

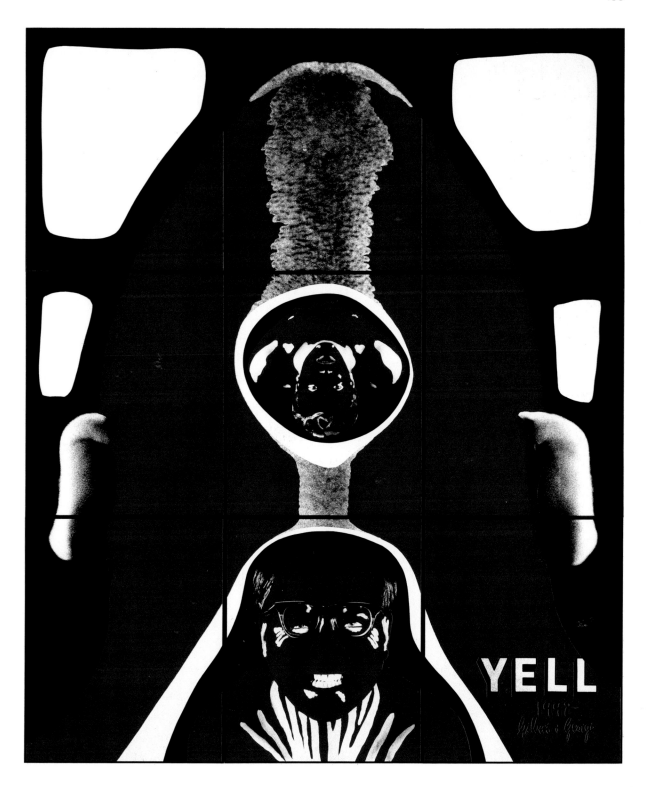

153
SHITTY NAKED HUMAN WORLD
1994
A quadripartite picture
Each part 338 x 639 cm

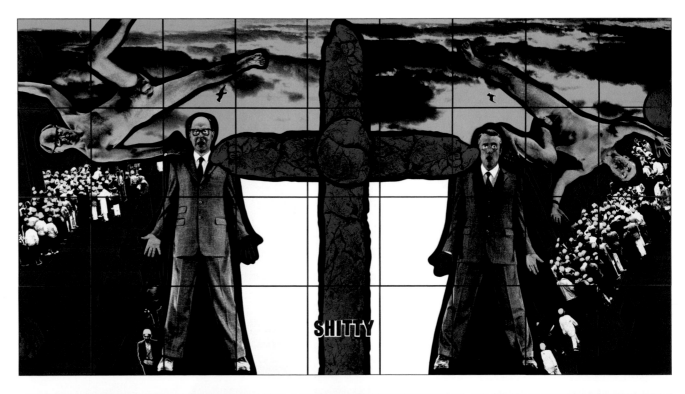

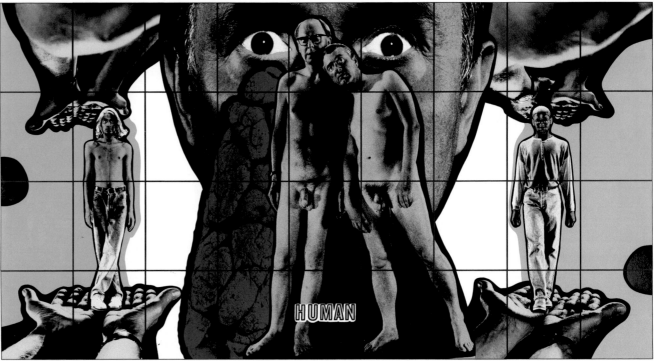

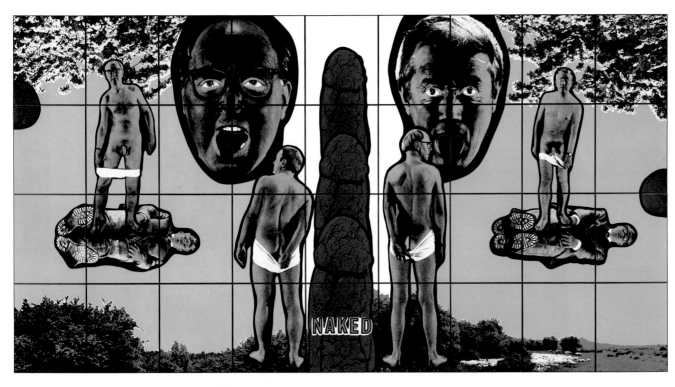

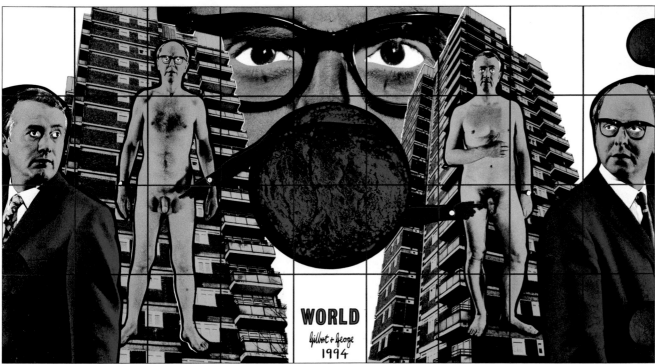

FIG 32
Exhibition at
Kunstmuseum
Wolfsburg, 1994

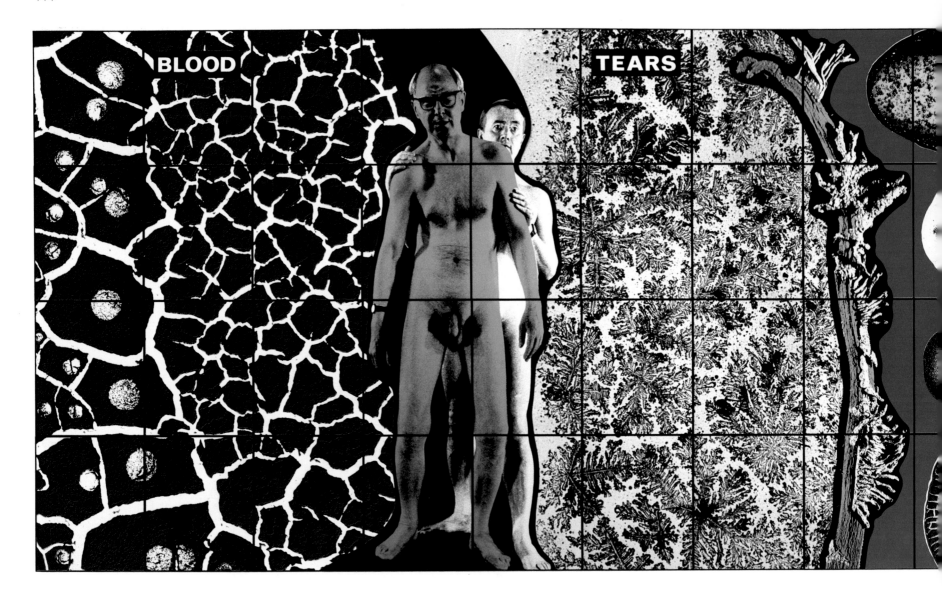

154
BLOOD TEARS SPUNK PISS
1996
338 x 1207 cm

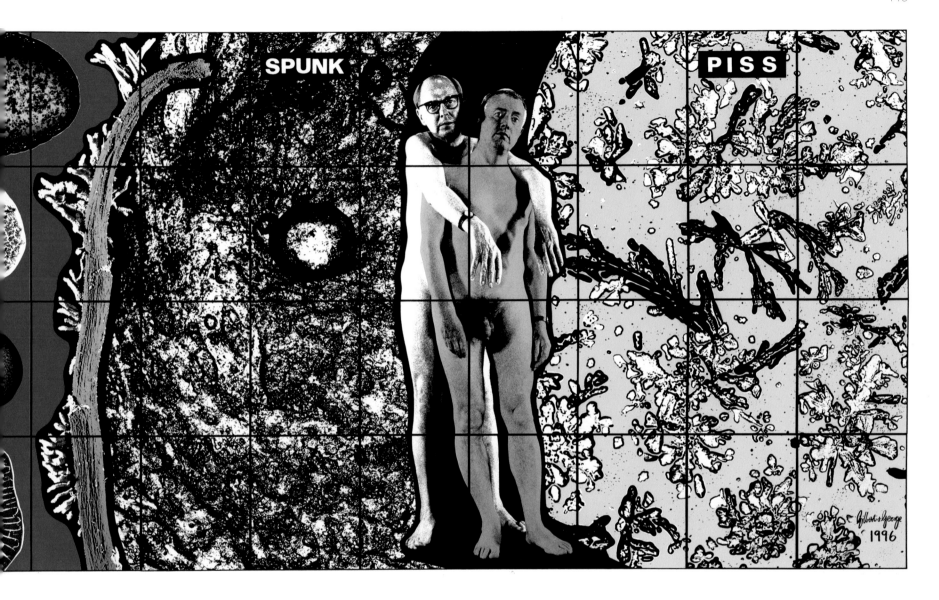

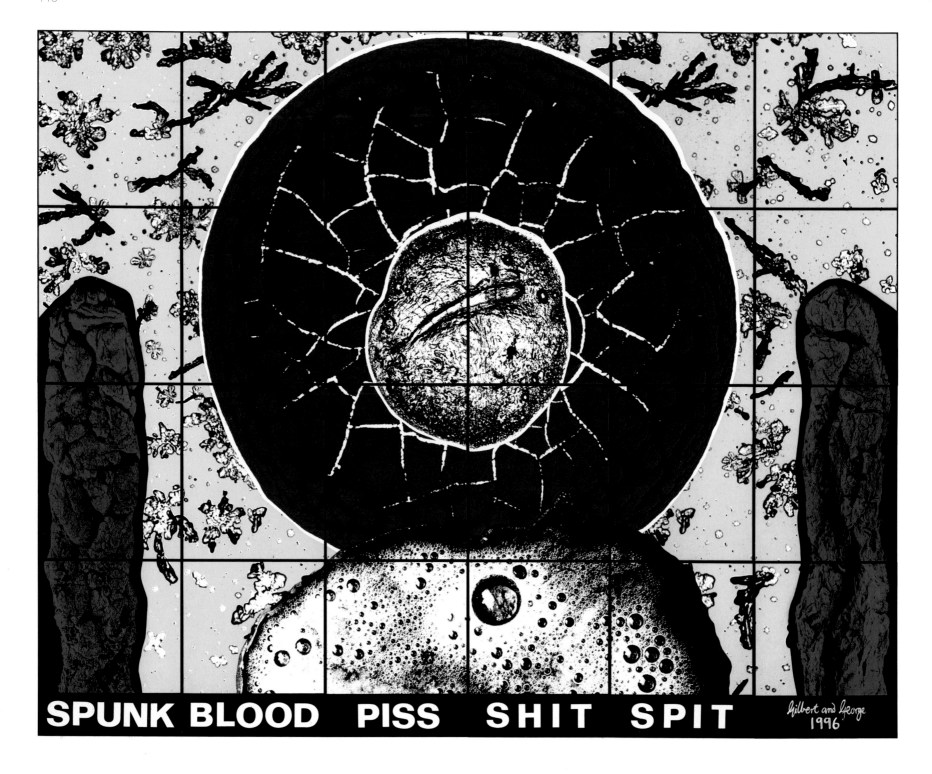

155
SPUNK BLOOD PISS SHIT SPIT
1996
338 x 426 cm

156
BLOODY MOONING
1996
338 x 568 cm

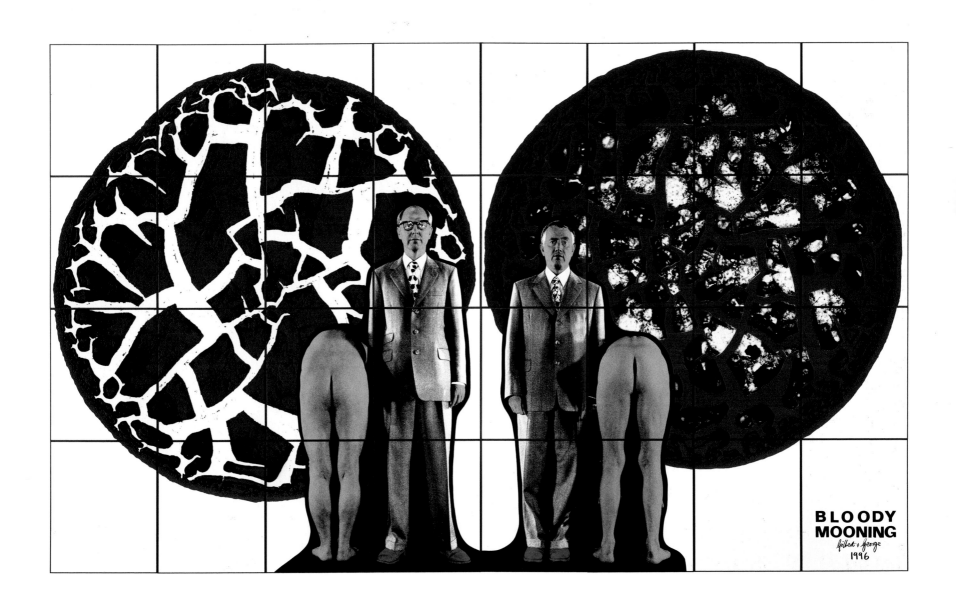

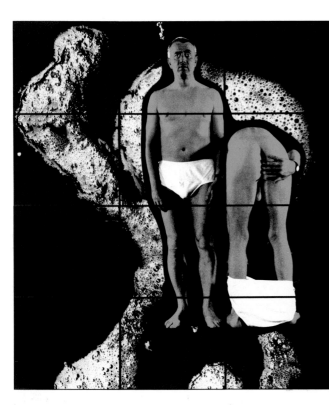

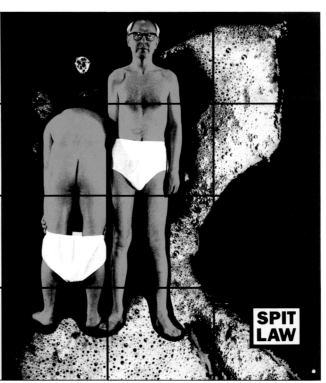

4 And if the people of the land do any ways hide their eyes from the man, when he giveth of his seed unto Molech, and kill him not:
5 Then I will set my face against that man, and against his family, and will cut him off, and all that go a whoring after him, to commit whoredom with Molech, from among their people.
6 ¶ And the soul that turneth after such as have familiar spirits, and after wizards, to go a whoring after them, I will even set my face against that soul, and will cut him off from among his people.

8 And ye shall keep my statutes, and do them: I *am* the LORD which sanctify you.
9 ¶ For every one that curseth his father or his mother shall be surely put to death: he hath cursed his father or his mother; his blood *shall be* upon him.
10 ¶ And the man that committeth adultery with *another* man's wife, *even he* that committeth adultery with his neighbour's wife, the adulterer and the adulteress shall surely be put to death.

11 And the man that lieth with his father's wife hath uncovered his father's nakedness: both of them shall surely be put to death; their blood *shall be* upon them.
12 And if a man lie with his daughter in law, both of them shall surely be put to death: they have wrought confusion; their blood *shall be* upon them.
13 If a man also lie with mankind, as he lieth with a woman, both of them have committed an abomination: they shall surely be put to death; their blood *shall be* upon them.

14 And if a man take a wife and her mother, it *is* wickedness: they shall be burnt with fire, both he and they; that there be no wickedness among you.
15 And if a man lie with a beast, he shall surely be put to death: and ye shall slay the beast.
16 And if a woman approach unto any beast, and lie down thereto, thou shalt kill the woman, and the beast: they shall surely be put to death; their blood *shall be* upon them.
17 And if a man shall take his sister, his father's daughter, or his mother's daughter, and see her nakedness, and she see his nakedness; it is a wicked

SPIT LAW

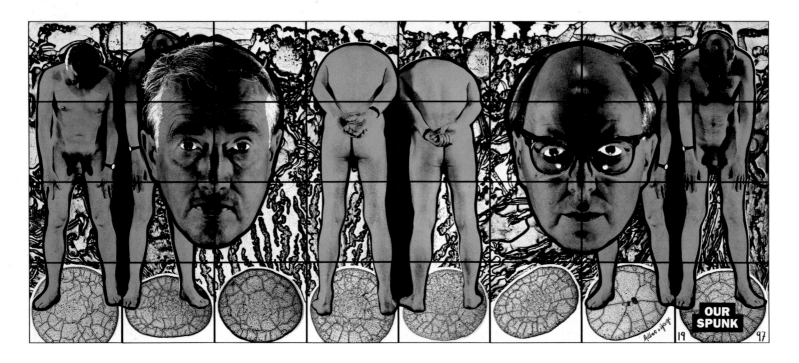

OUR SPUNK

Gilbert & George 19 97

157
SPIT LAW
1997
254 x 528 cm

158
OUR SPUNK
1997
254 x 604 cm

159
GUM CITY
1998
338 x 284 cm

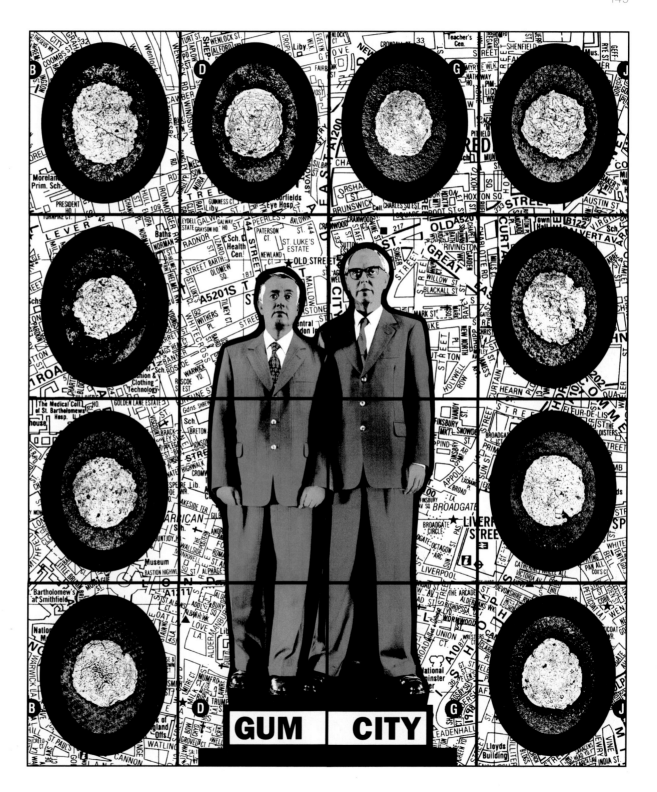

'Sex, money, race, religion; it's all there'

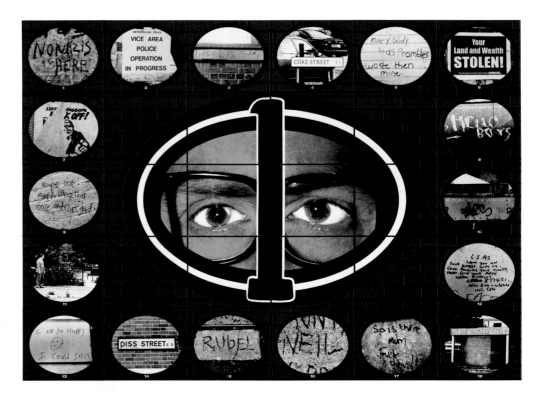

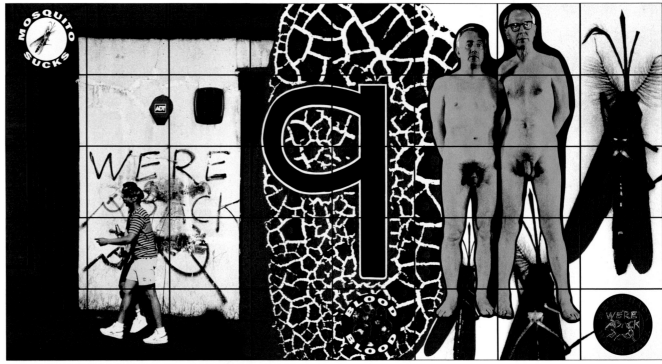

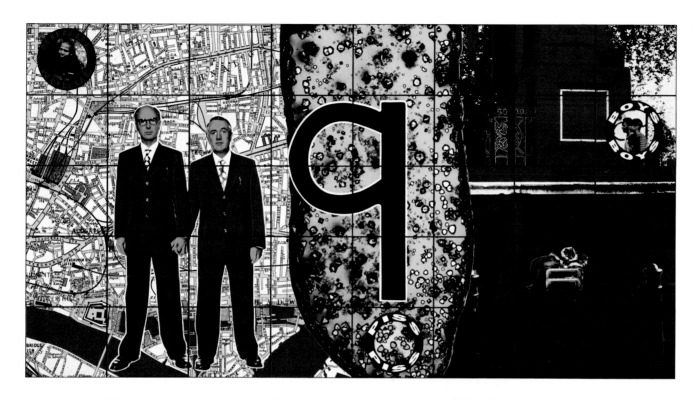

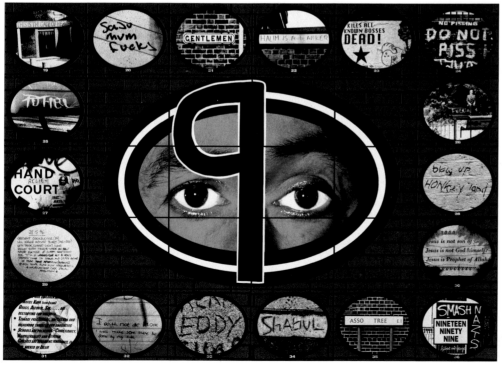

160
NINETEEN NINETY NINE
1999
A quadripartite picture
Left to right: 355 x 507 cm; 355 x 676 cm;
355 x 676 cm; 355 x 507 cm

161
ZIG-ZAG KISMET
2000
284 x 845 cm

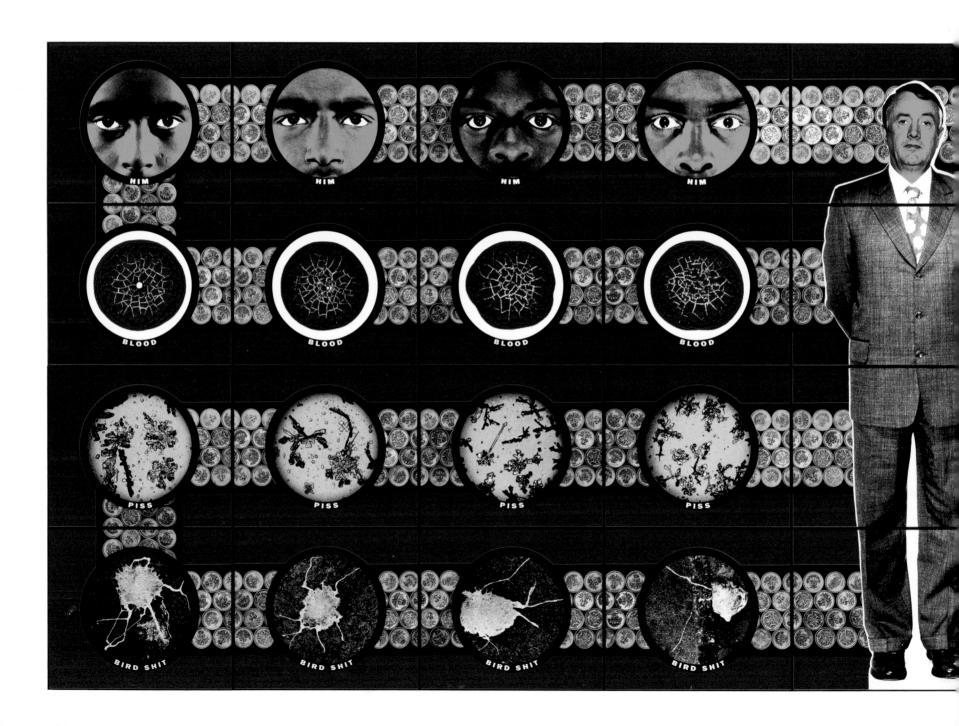

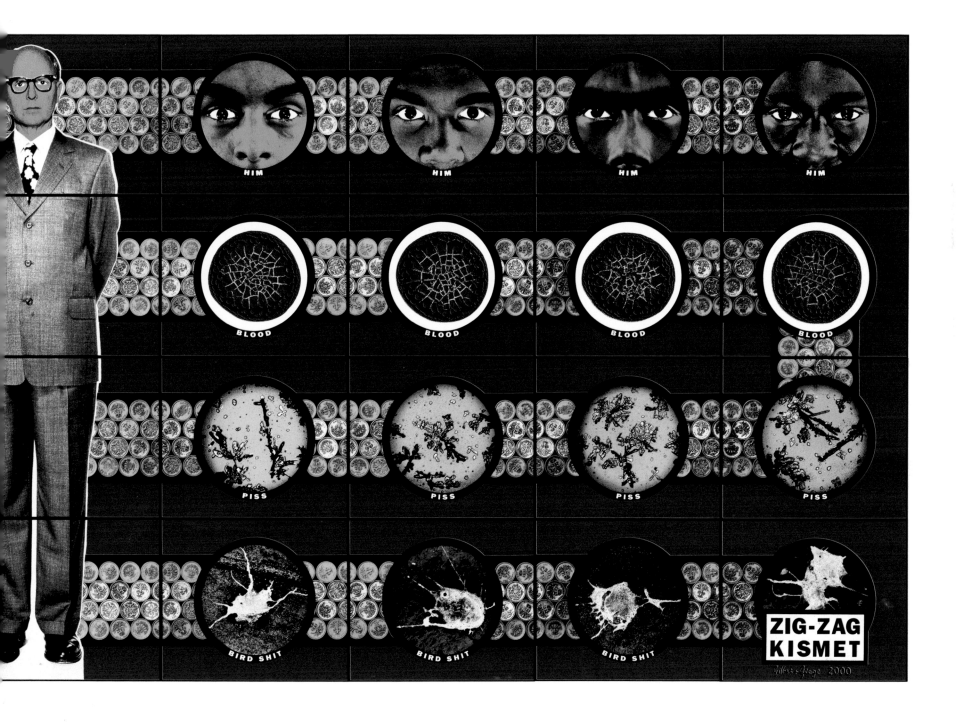

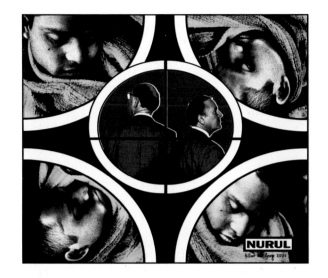

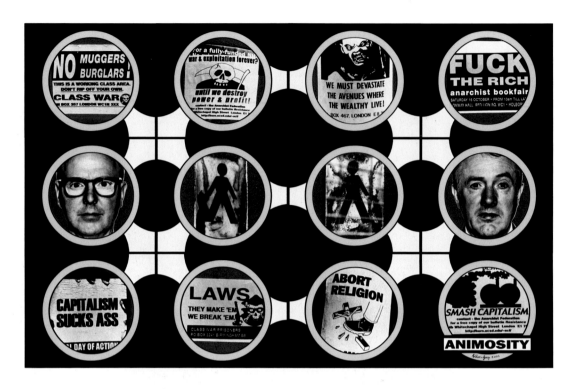

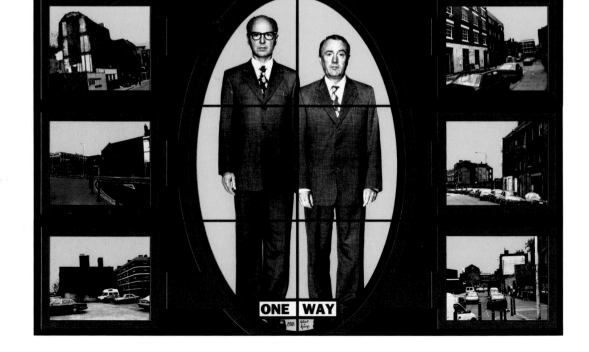

162
NURUL
2001
127 x 151 cm

163
ANIMOSITY
2001
190 x 302 cm

164
ONE WAY
2001
190 x 302 cm

165
LOCKED
2001
190 x 226 cm

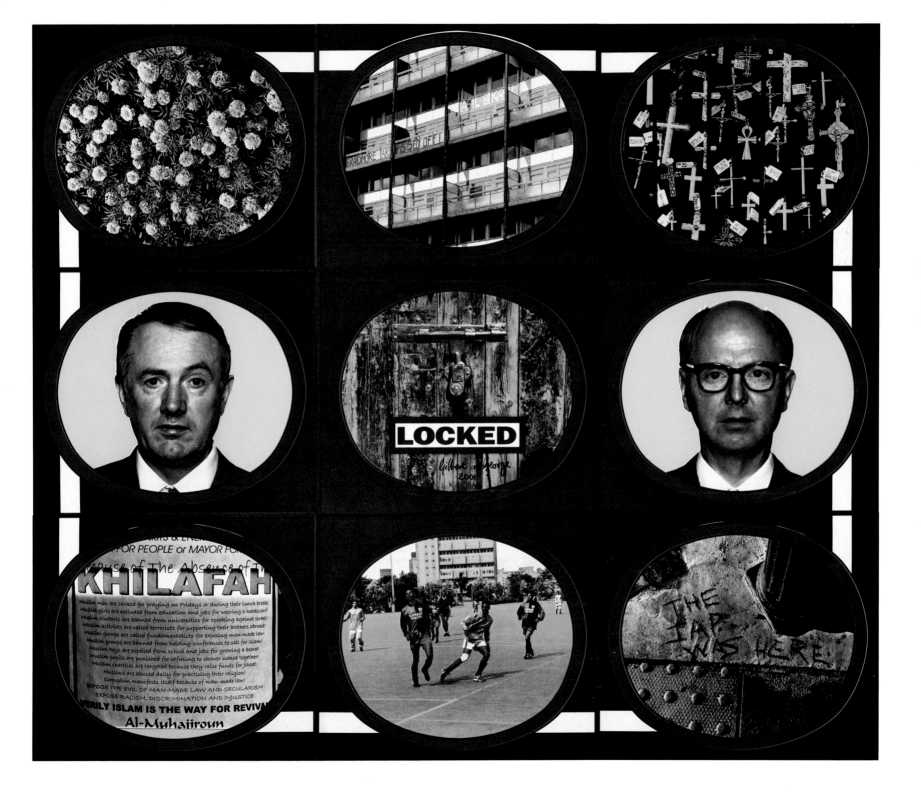

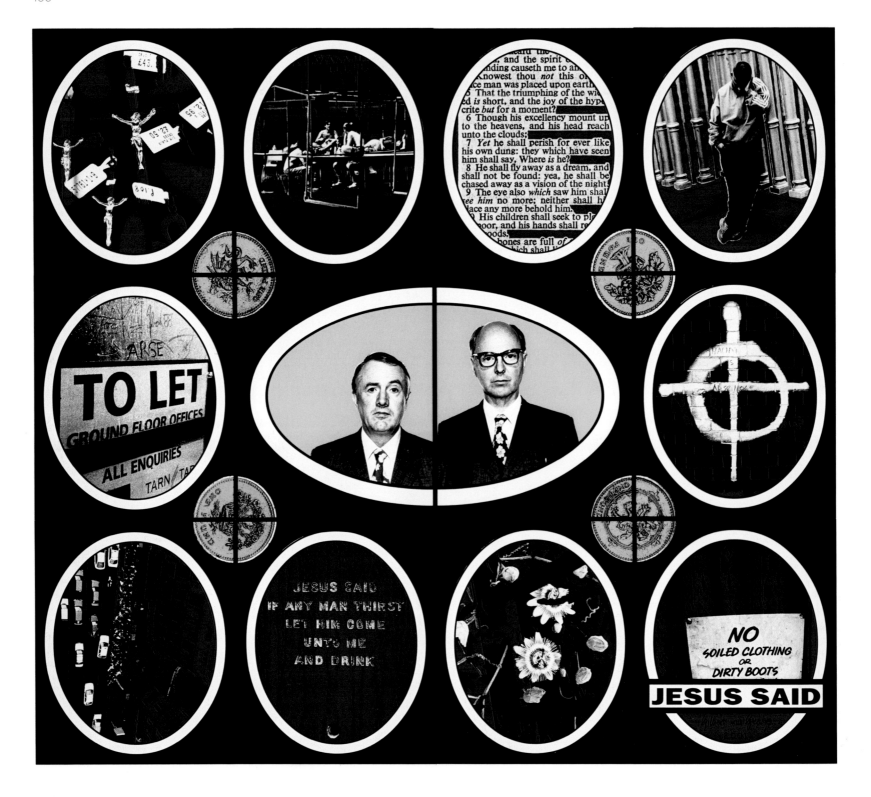

166
JESUS SAID
2001
226 x 254 cm

167
CHAINED UP
2001
254 x 528 cm

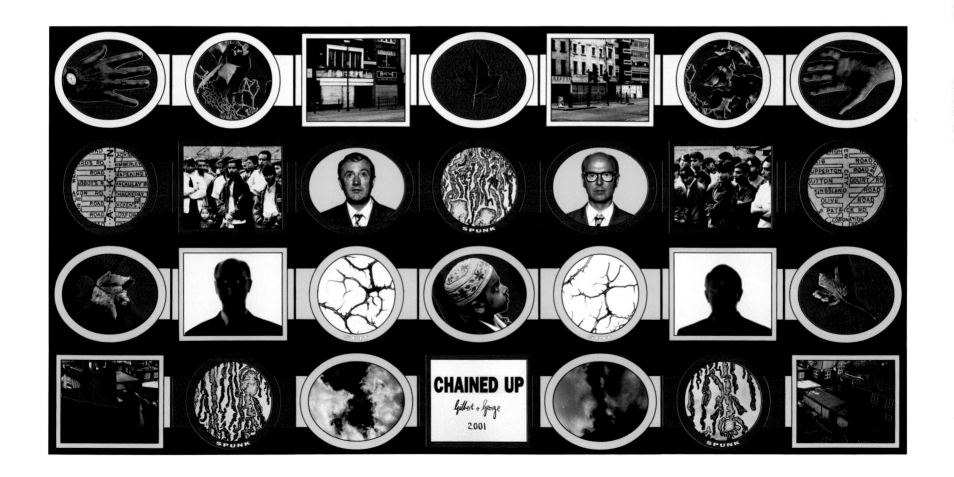

ROB
very good looking,
boy-next-door. Straight
acting, very good body,
washboard stomach,
very well equipped.
Central and discreet.
Call 0171 439 3586
1

MATT
21, fresh boyish looks,
smooth muscular body,
toned and very well
equipped. Sportswear,
rubber and cp. Private
apartment in Holborn.
In/out calls anytime.
Tel: 0171 278 9351
2

DANIEL
Latin blond boy, 5ft 8",
VWE, smooth,
well defined,
athletic body.
26 years old.
24 hours in/out.
0966 303 244
3

GAVIN
29, exceptional gym
trained body, 100% pure
muscle, tanned, smooth,
masculine, cropped dark
hair, offering a full
service. Out calls only
Tel: 0956 908 841
4

BRUNO
Ex-gymnast, 6ft 2", very
handsome, great cut
body, dark hair, blue
eyes. Discreet. In/out
service.
0171 727 8349
5

LIAM
25, good looks, tanned
body, intelligent, sensual,
not in a hurry. With own
car for visits anywhere in
London or UK.
Ring 0171 709 0472
24 hours
6

ROGER
Very good looking, blue
eyes, 25 years old, 5ft 8",
swimmers body, well
defined, smooth and very
well equipped. Friendly,
unhurried service.
In/out calls.
0958 688 665
7

DARREN
Fit, fun, and horny 20
year old, living in SE1
next to BR and Tube.
0171 403 7048
In/out/hotel calls
8

JOHAN
New, good looking, warm,
friendly, articulate,
discreet, 23 year old, 6ft
2", blond, in/out calls.
0958 377 347
9

LOUIS
Just 18, blond hair, blue
eyes, very cute, slim,
smooth, horny, sexy. 24/7.
XVWE. Out/in. Hotels, W1
07930 263237
19

KURTIS
Good attitude, 24 hr, in,
out and nationwide
visiting service.
Smooth, swimmers body
based in West London.
0958 347 665
20

NICK
the boy with the toy you
know you'll enjoy.
Sensitive, slow, versatile
escort. Well defined
physique, tanned body
and good looking, in/out,
hotel visits, 24 hours.
Discretion assured.
0171 787 4363
21

GUIDO
24, Italian model, 6ft tall,
32" waist, blue eyes,
astonishing chest. Style
and passion offered for
deep satisfaction. Out and
hotel bookings, also
Covent Garden, in/out
0956 468 377
22

BROCK
Healthy, young boyish
Canadian, with natural
beauty and body.
Tanned, toned, 23,
offering attitude-free
discreet service.
0958 619 134
24 hours. In/out.
Unhurried.
23

CARLOS
23, very good looking
Latino, fit muscular body,
6ft, tanned. Offers discreet
and friendly service
Piccadilly Circus W1
0370 822225
24

MIRKO
Cute Italian, 21yo, athletic
body, versatile service,
in/out, 24 hours.
07713 714 632
25

ADAM
Sexy, muscular, top, 20
years old 5' 8", blonde
hair, blue eyes, CP, role
play, versatile service,
leeds/anywere
07940 358620
26

STEVE
Massively equip,
thick, 28, good
6ft 2" tall, No.
Fit, smooth bod
horny. Good att
24 hours. In/o
0171 701 72
0467 3
27

FILIPE
21 years
Portuguese
Good looking
In/out
0956 324 207
37

PASCAL
French, good-looking, nice
body, gives full service for
men of any race, age,
size.
Beginners, all welcome.
Fun time guaranteed.
Earl's Court. In/out.
0930 750 608
38

TODD
18, good looking, well
equipped, English boy,
with a fit, tanned,
swimmers body.
Offers a friendly exciting
service in
Central London.
0171 839 7792
39

MOSES
Black, equipped,
handsome, masculine,
discreet, nationwide,
in/out.
0171 357 8092
Mobile 0374 44 34 51
40

DENVA
26, young black and
muscular, friendly,
discreet service for active
type guys. Hot time
guaranteed. In/out.
Hotel visits.
0171 401 9780
41

SHANE
26, well-defined, sporty,
good looking guy, 5ft 10",
blond, blue eyed and
smooth, offers a relaxed,
explosive service.
0171 341 9348
42

MOHAN
29, 6ft 4", handsome,
Anglo/Indian, xxx long
and thick, hot, horny and
fully versatile. Will travel.
Out calls
0378 423 407
43

SPYKE
Cruel skinhead biker
0171 689 7841
Boots
Leather
Masks
Rubber
Army
i'll take control
Call anytime
44

JAS
South Indian boy, 23,
slim, smooth, dark and
handsome, very well
equipped. In/out,
24 hours.
0181 880 1929
55

RICHARD
22, slim, athletic build,
smooth and defined.
Tanned, straight acting,
friendly and discreet.
0171 221 9833
Central location. In/out.
56

CAIN
Firm handed leather
clad masterful type,
offers you the chance to
live out your darkest
fantasies.
0973 691 419
57

AL
Made in Surrey. 6ft 2"
eyes of blue, educated,
business professional,
international travel
considered. Servicing
Surrey, Heathrow and
Gatwick.
0956 145 302
58

HUNTER
Big, black, equipped, 28
years old, 6ft 3" tall,
muscular, very
handsome, unhurried,
sensual, active type
service. In/out calls.
24 hour availability.
0966 448 192
59

COLM
27, 5ft 10", dark blond,
broad shoulders,
athletic build, handsome
guy, straight acting/S.O.H.
Very discreet, in/out, hotel
visits, close to
underground.
Call 0171 381 6244
60

SERGIO
Horny Spanish 24, very
handsome, firm body,
very well equipped,
offers unhurried
discreet service.
0956 427 078
61

CONNOR
Fresh Kiwi stud, for hot
rubdown. Ex-sailor,
strong, good looking,
25, with big, hard
equipment.
0956 204 874
62

ROBIN
Attractive young masseur,
slim bodied, toned, gives
a massage at your
request.
0171 584 8869
73

STEPH
26, slim, fit, handsome gym trained
body, personable and
accommodating. Passive
type service for men who
require the best.
Tel: 0171 372 5909
Maida Vale
74

ROBERTO
Sexy, hot, handsome guy,
muscular build 6ft, 13 st.
Latin American with great
abilities, available for
in and out calls
Tel:
07930 24 96 50
75

NATHAN
24, VGL, fit, worked body,
masculine London lad,
always horny. Nice tight butt,
VWE, offers versatile-type
service. 24hrs. Call Nathan
in/out
07957 226 097
76

JESSIE
Strong, sexy, sensual, all
the attention you need.
Thick, black wavy hair,
big blue-eyes, full lips,
athletic. Well-trained,
well-educated,
well-groomed, well there.
0956 511 410
77

JOE
27, your ultimate fantasy
man. Smooth, gym
trained hunk, offers
sportwear, leather,
combats, dominating type
service and correction on,
0171 385 7775
78

PAUL
Genuinely good looking,
22 years old,
offers versatile,
xvwe masculine service
from a professional.
Call 07957 226 097
in or out, 24 hours.
79

SEBASTIAN
23 year old, French, blond,
boyish, very good-looking,
slim, fit body. Versatile.
Based Central London.
Phone me on
07947 684554
80

RAY
ce. 6ft, mid 20's
n athletic body for
he exotic escort
ence of your life ring
07971 355 628
81

168
NAMED
2001
355 x 1521 cm

BLAKE
Attractive, athletic, American, offers caring and discreet services in central London apartment
0171 916 1548
10

BRYAN
If you want some fun times with no hurry, young Bryan will provide just that.
0171 225 1970
11

BJÖRN
20, Swedish, extremely good looking blond. Warm personality, 6ft, 28" waist, smooth, boyish, central location. Hotels/evenings/ dinners
0958 724 023
12

DAMON
Dark
Strong
Discreet
0850 482 238
A Luxurious Fantasy
13

TYRONE
Black, 21, good looking, VWE guy with a slim well defined body. Offers a 1to1 service to remember. Call me on
0956 184436
14

RIC
24, 5ft 10" light brown hair, smooth skin, hot body, extra extra large, great looks, full unhurried service. New in England. Central. Anything considered. In/out calls
0468 693 648
15

SAM
Long, hard thick equipment, 25, 6ft 1", handsome gymnast, smooth, gym trained, muscular body. 43" chest, 31" waist, great pecs and butt, full versatile service.
0378 629 390
16

RICO
Italian, 27, beautiful face, great swimmers athletic, smooth body. 5ft 10", 11 stone, 41" chest, 29" waist. very sexy. Offers great active type service. W2.
0171 229 6916
17

MATTHEW
Ex-Public school boy, cp, and discipline in luxurious Soho apartment.
0171 439 0704
18

LEO
young 21 years old, boyish lad, slim, tanned body, dark friendly. Versatile. Playing, uniform, etc. In/out N1/City 71 684 8351 or 0410 758 896
28

VALENTIN
28, Latin, professional. First class escort. Hotel visits only.
0171 652 2326 or 0961 131 072
29

RAFAEL
26, sexy Latino. VW equipped
0171 244 0677
Fulfil your fantasies
30

RICARDO
19, 5ft 11", tall, dark brown hair, smooth boyish looks, swimmers physique, offers versatile unhurried service. Hotels, overseas visits. Call Ricardo
0958 286 844
31

BEN
Just 18, 6', dark brown hair and eyes very good looking, well equipped. In and out hotels.
0867 857664
32

RUDY
18 and horny, boyish and slim, cute and genuine, offers a friendly and unhurried service, in or out calls. Older gentlemen welcome, call 24 hours.
0797 057 4289
33

THOMAS
23, good looking lad, hot, submissive bottom. Waiting for your call.
Tel: 07930 483038
Out calls
34

JASON
27 yo, good looking guy, slim and healthy, open minded, versatile role-playing and CP. Top/Dom. In/out.
07958 410 277
020 7387 4750
Euston
35

SCOTT
30, XXX well equipped, sexy, muscular black guy, with more to offer than most.
0374 809 271
36

CHASE
23, stunning looks, hard, beautifully defined, muscular body. 5ft 11", 43" chest, dark hair, green eyes, well equipped and very hot. Anytime.
0956 878 201
47

VIGO
Masculine boy, 24, 6ft, 12 stone, discreet. Nice apartment. In/out/hotels. Service for gentlemen.
0956 692 439
48

TOMMY
18, young, very good looking. Dutch/English, well equipped, smooth, tanned, swimmers body, offers full, friendly and playful service in Central London. In/out. 24 hours.
0802 485 396
49

FABIO
South American lad, swimmers body, blond fair hair. Masculine 5ft 8", 26 yo. Just out. Hot guaranteed. 24 hours.
0966 303 244
50

ETHAN
22, great looking guy, beautiful smooth, tanned body, body definition, bubble behind, winning smile, offers versatile service. Call me on
07930 910 753
In/out 24 hours
51

NANDO
Cute Latin guy, offers versatile service. In/out calls. Central location.
Mobile:
0411 156 114
52

DECLAN
24, 5ft 11", fit, athletic body, straight acting, totally active type. Educated and can be presentable.
01523 488 210
Hotel visits not a problem
53

CELSO
New young, gorgeous boy in London, 19 year old, smooth, exotic, very sexy and well equipped. The best.
Call 0956 939 208
54

MICHAEL
Hairy, horny and handsome. Educated, 35, VWE. Active type. Luxury apartment near Piccadilly Circus and visits. Great guy, great body, great value.
07788 446176
65

SPARKS
Gives qualified massage in clean, private surroundings North London. Smooth, slim, young good looking man, white tanned, 30 yrs. 30" waist, 38" chest, 5ft 9" tall. Please call
0961 875 461
for fun
66

JAMIE
Public schoolboy type, 27, 6'4", smooth, athletic body. Intelligent, Professional, broadminded and straight acting. Discreet service for discerning man. London.
07970 450 744
67

ZITO
Goan/African, 23, exotic looks, swimmers build, smooth, lovely behind, versatile. 24 hours, Holland Park.
0171 603 1583
68

MARCO
Masculine, South American lad, swimmers body, 6ft with blond fair hair. 26 yo. Hot guaranteed and ultimate discretion assured, 24 hours.
0966 303 244
69

KARL
Black, active type. 24 hours. Exceptionally well equipped. Any time for deep satisfaction.
Tel: 0958 204 897
70

KHAN
Big Arab man, hairy, 6ft 2", 32 y + feet 14, offers active/dominant type service. In/out. Hammersmith. 24 hours.
0961 341 616
71

JEFF
22, South African student. Handsome, tanned, slim, well defined body. Very well equipped. Private and discreet service. In/out.
0958 702 501
72

MIKA
Fashion model, 24, 5' 11", smooth, 28", dark blond, blue eyed, friendly, sensual, very sexy.
07932 984 655
83

MARTIN
22, offers accurate cp service. 5ft 10" 42" chest, athletic body, sportswear, leather etc. Central London, WC1 area.
Tel: 0171 837 7631
84

RYAN
6'3", 16 stone, good looking, great body, fit, hairy, rugby player, VWE and friendly. Always attentive to your needs.
Home:
0171 207 3431
Mob:
07957 707 061
85

TIM
6ft, 28, muscular physique, short dark hair, handsome features. Looks good in denims, jock, full leather or a suit, just specify. VW equipped in all the above. Just call
0966 132 431
86

MITCH
I'm back for a limited time only. 26, gorgeous, educated and friendly. 6ft, athletic, muscular, V-shape, big blue eyes. Very masculine. Don't be shy. I'm not.
0956 511 410
87

BOB
29, 6ft, ex rugby player. Manly good looks, 50" chest, 19" arms. Big legs and shoulders.
0589 705 067
88

LUC
28, French, hot, sensual, versatile, smooth, athletic body, full service. In/out. 24 hours.
0958 493 894
89

LANCE
Good looking South African, 30, 6ft, XXVWE. Heathrow in/out.
Tel: 0777 608 3946
NAMED
2001
90

'A sea, an endless sea of names ... like a war memorial'

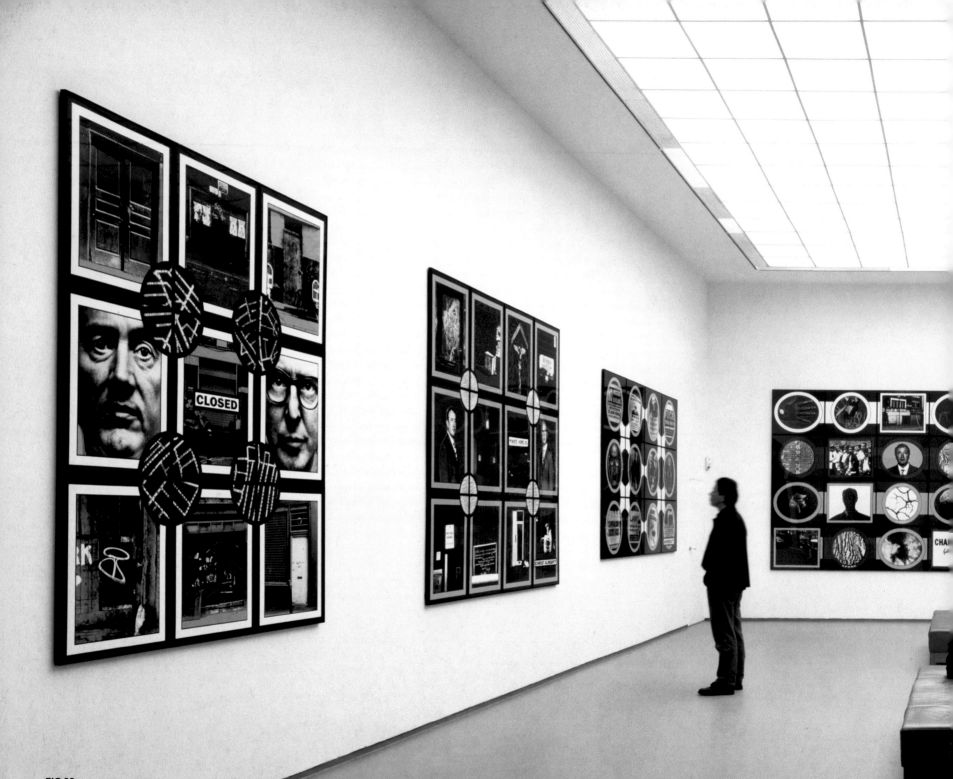

FIG 33
'Nine Dark Pictures'
Portikus, Frankfurt, 2002

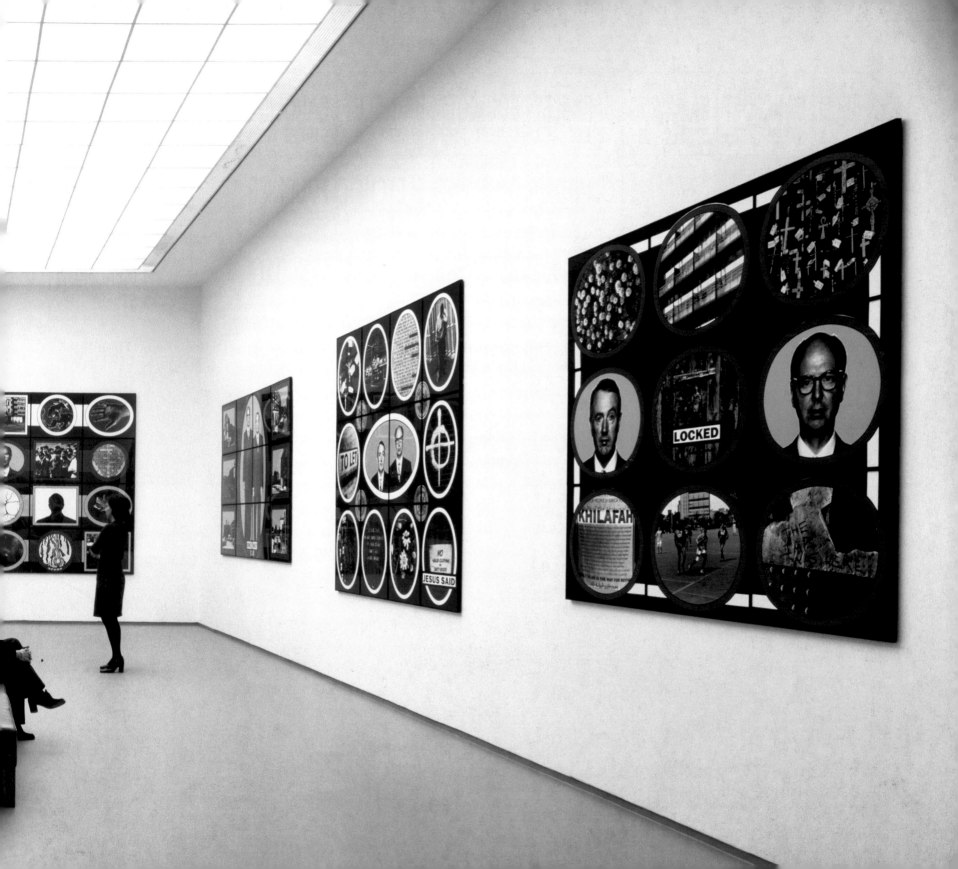

ASHFIELD STREET E1 · BANCROFT STREET E1 · BARNARDO STREET E1 · BARNSLEY STREET E1 · BOULCOTT STREET E1 · BRINSLEY STREET E1 · CAROLINE STREET E1 · CHANDLER STREET E1 · CINNAMON STREET E1 · CLOTHIER STREET E1 · CORNWALL STREET E1 · CRANFORD STREET E1 · DAVENANT STREET E1 · FLETCHER STREET E1 · FOURNIER STREET E1 · GOULSTON STREET E1 · GRANTLEY STREET E1 · HARDINGE STREET E1 · HAVERING STREET E1 · HECKFORD STREET E1 · HELLINGS STREET E1 · LANGDALE STREET E1 · MERCERON STREET E1 · MILLWARD STREET E1 · MULBERRY STREET E1 · RATCLIFF STREET E1 · SHADWELL STREET E1 · SHERIDAN STREET E1 · STOTHARD STREET E1 · VIRGINIA STREET E1 · WALBURGH STREET E1 · WESTPORT STREET E1 · WICKFORD STREET E1 · WIDEGATE STREET E1 · WINTHROP STREET E1 · WOODSEER STREET E1

THREE DOZEN STREETS 2003 Gilbert and George

'Every word creates a visual image.
A visual memory, like a landscape'

169
THREE DOZEN
STREETS
2003
355 x 760 cm

170
THIRTY-FOUR STREETS
2003
355 x 591 cm

171
TWENTY-EIGHT STREETS
2003
355 x 676 cm

172
HEART
2004
190 x 226 cm

173
HARAM
2004
190 x 226 cm

174
HANDS
2004
142 x 169 cm

175
SALUTE
2004
142 x 169 cm

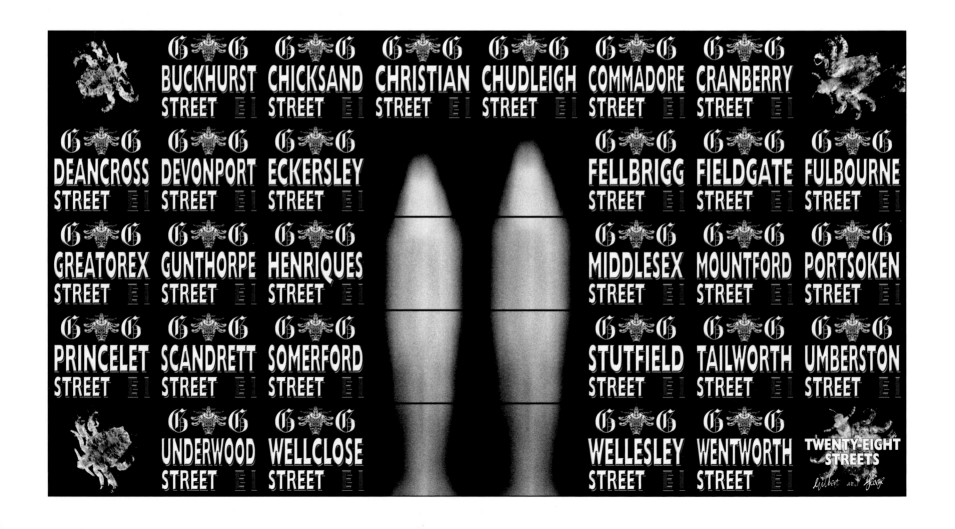

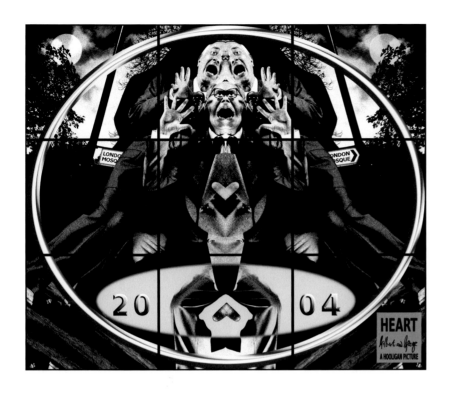

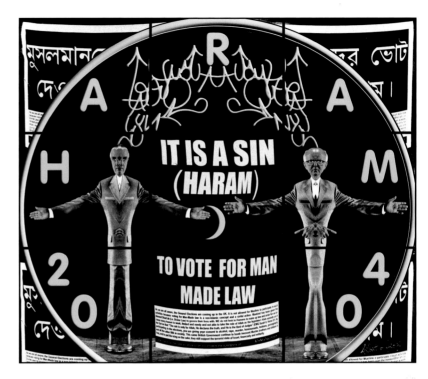

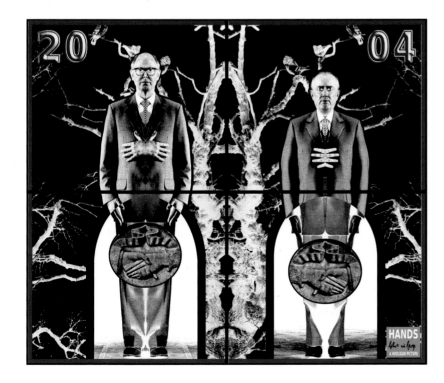

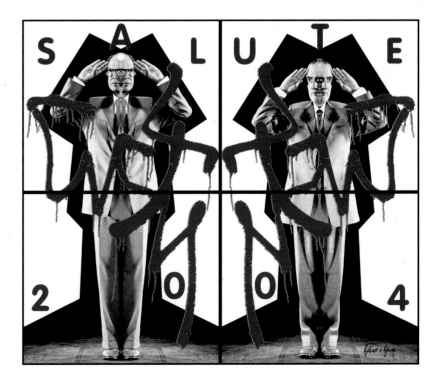

176
TAG DAY
2004
254 x 377 cm

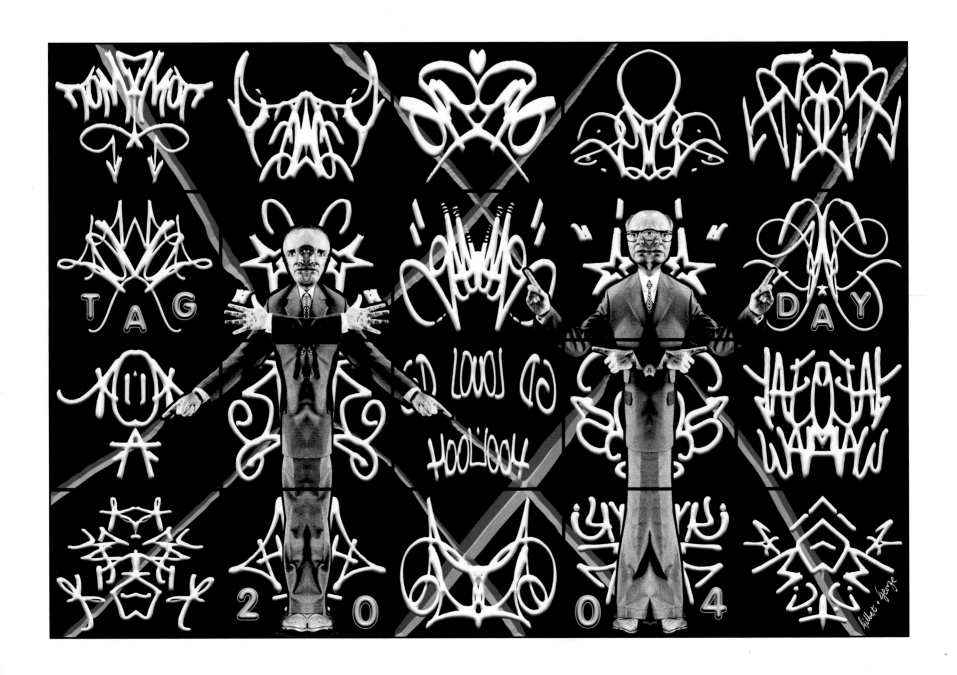

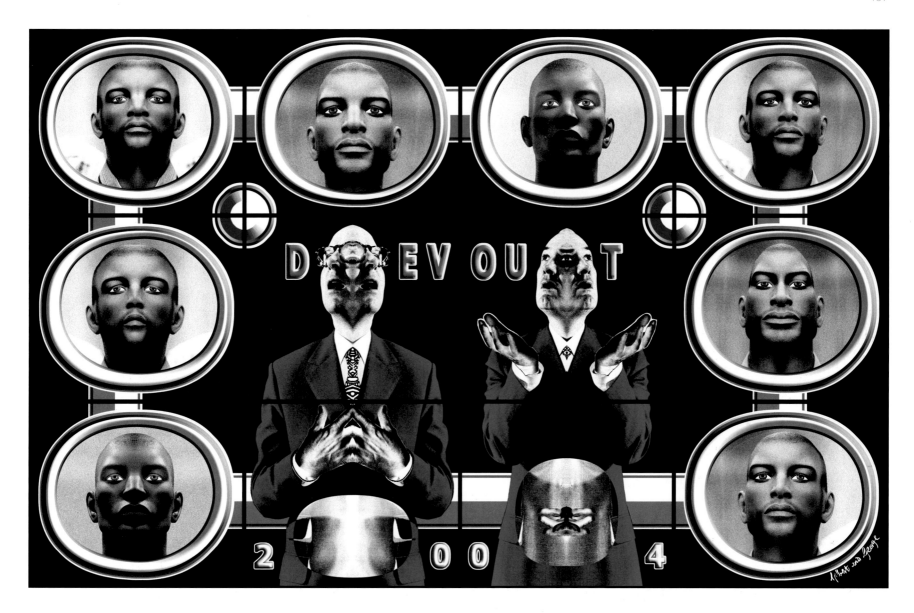

177
DEVOUT
2004
190 x 302 cm

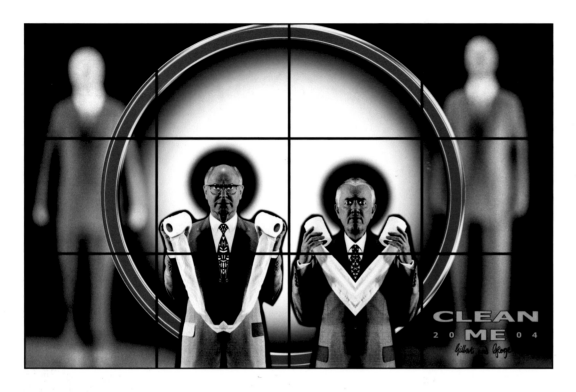

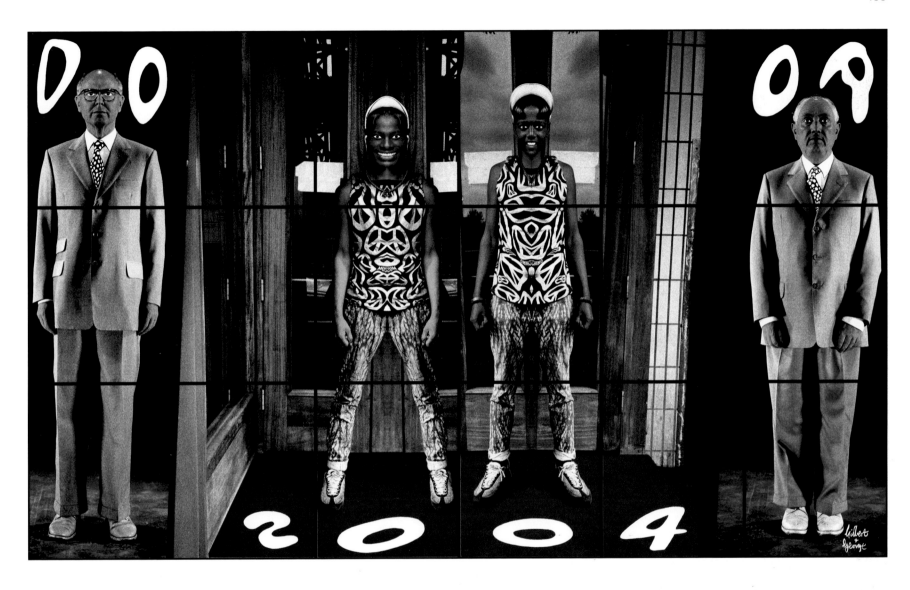

180
DOOR
2004
226 x 381 cm

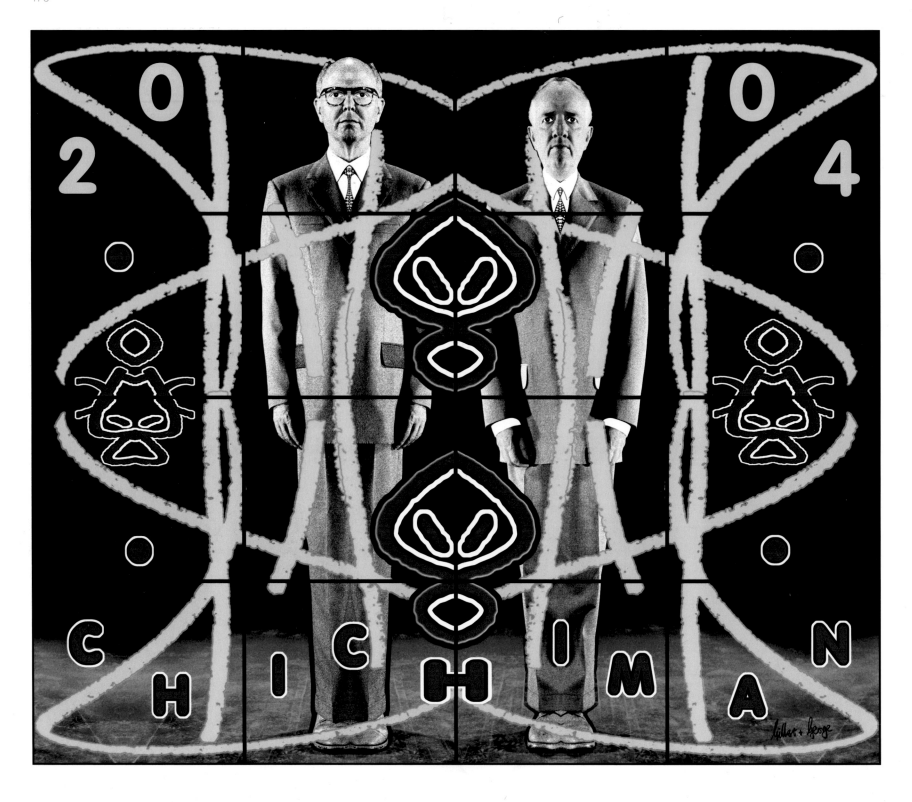

181
CHICHIMAN
2004
284 x 338 cm

182
FINGLE-FANGLE
2004
284 x 507 cm

183
ISHMAEL
2004
284 x 591 cm

(Following page)
184
APOSTASIA
2004
284 x 760 cm

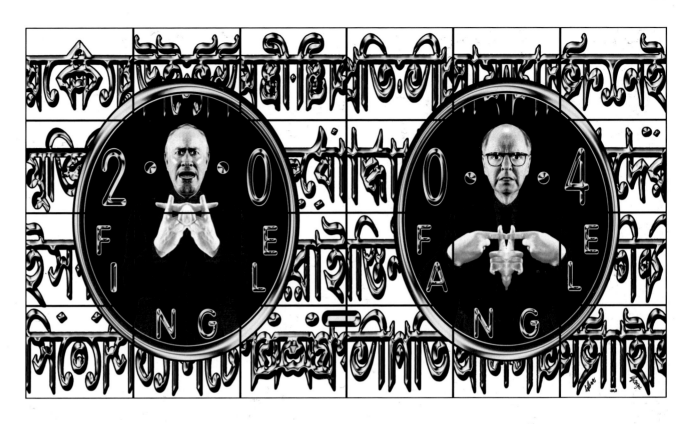

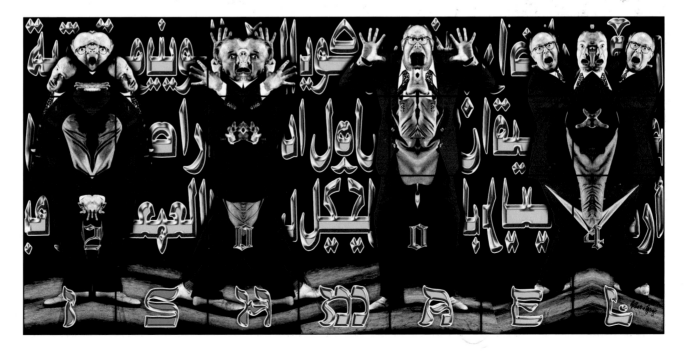

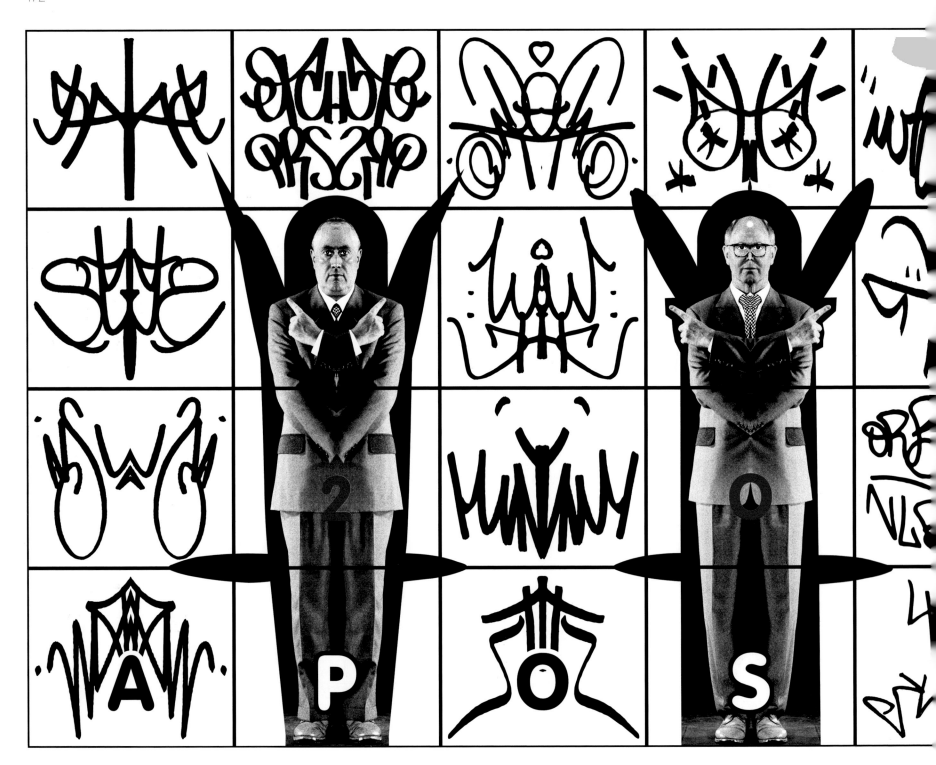

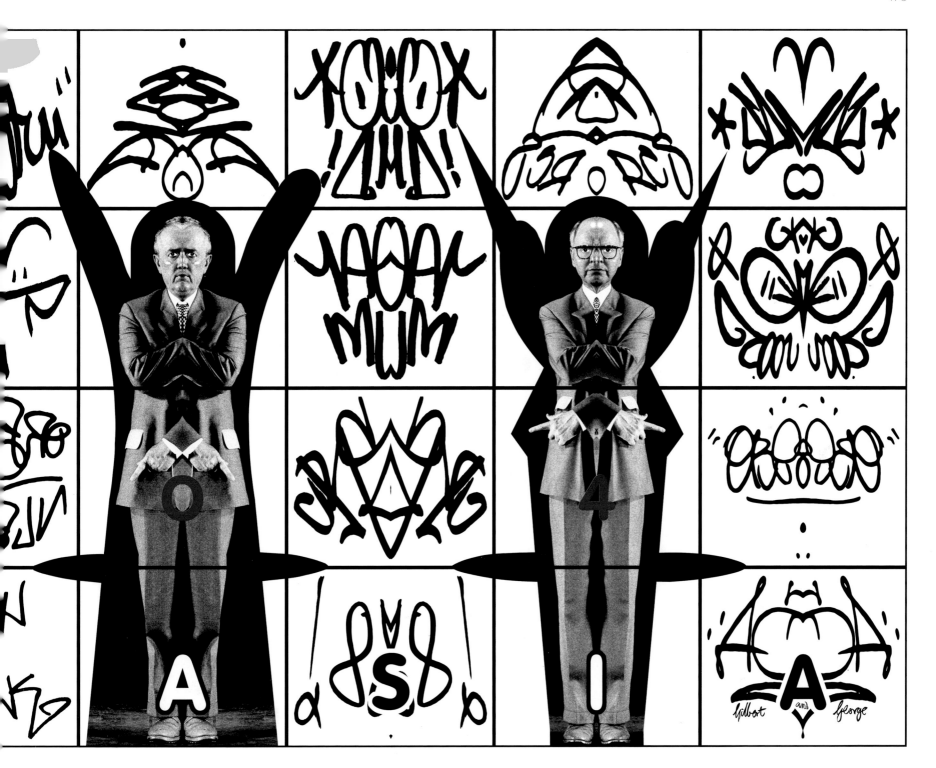

185
HOODED
2005
284 x 507 cm

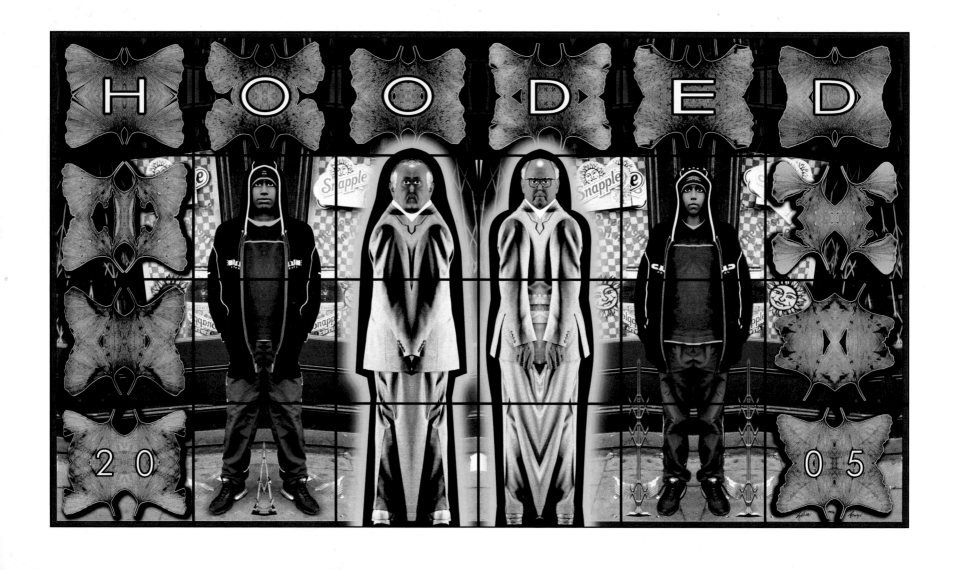

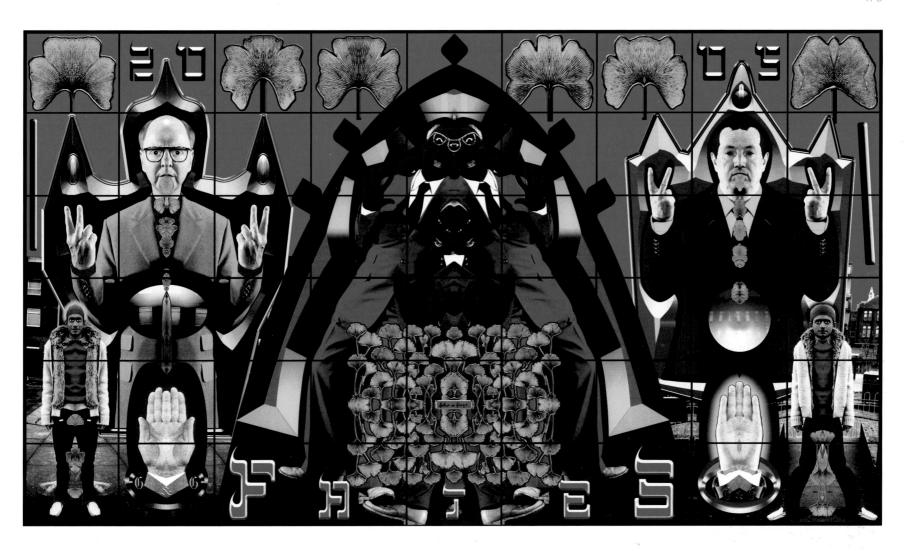

186
FATES
2005
426 x 760 cm

187
GINK
2005
284 x 422 cm

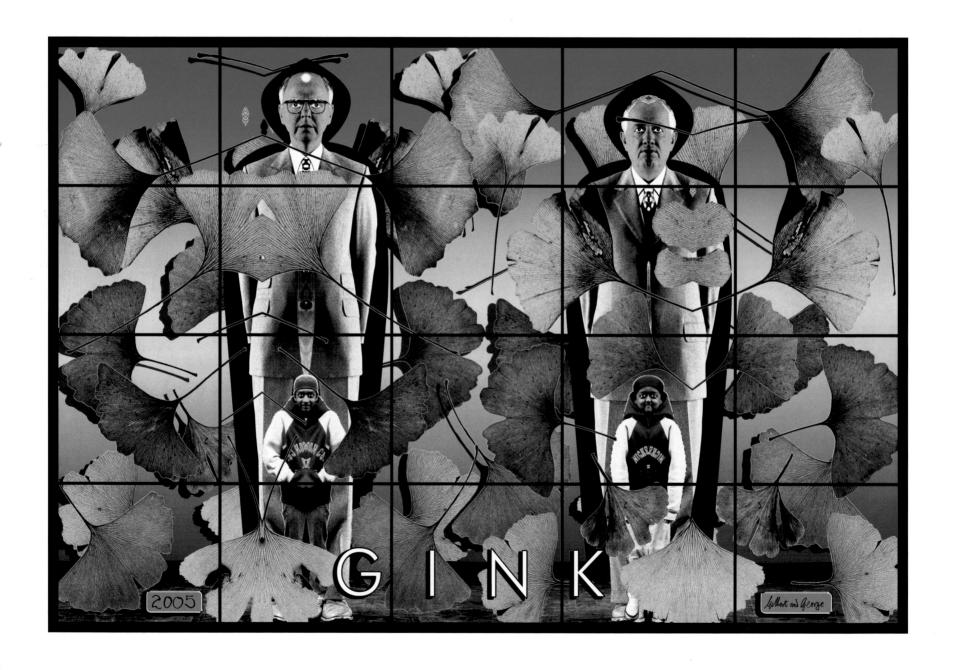

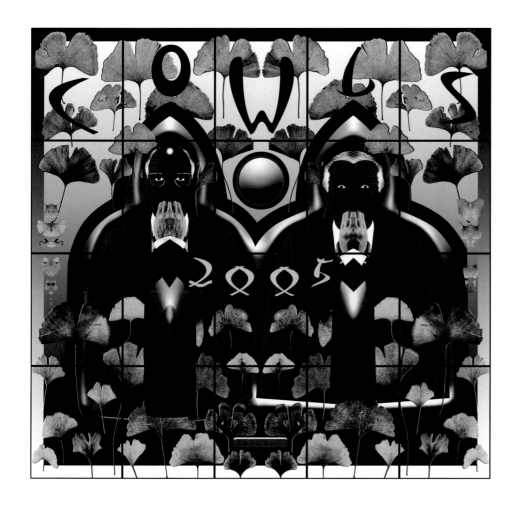

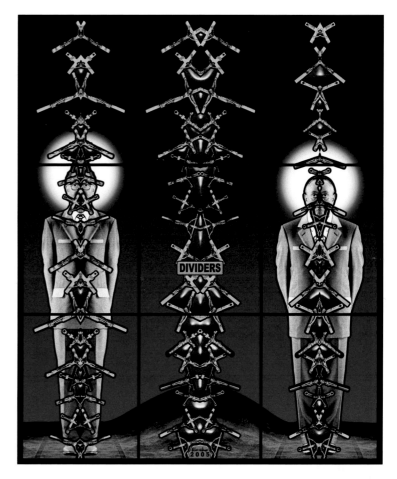

188
COWLS
2005
338 x 355 cm

189
DIVIDERS
2005
226 x 190 cm

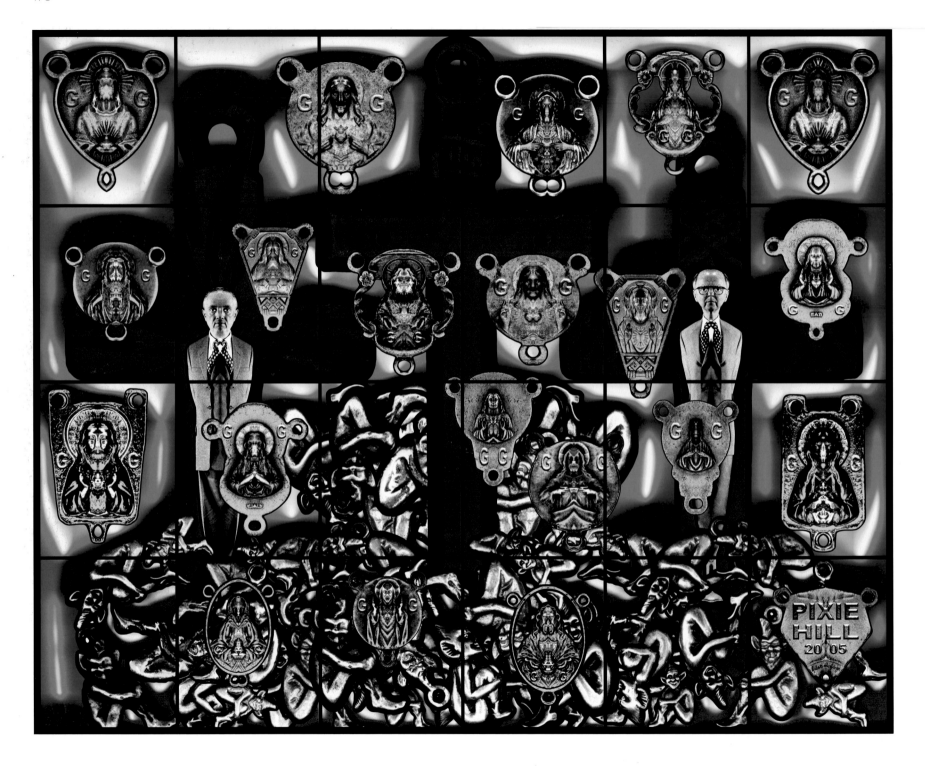

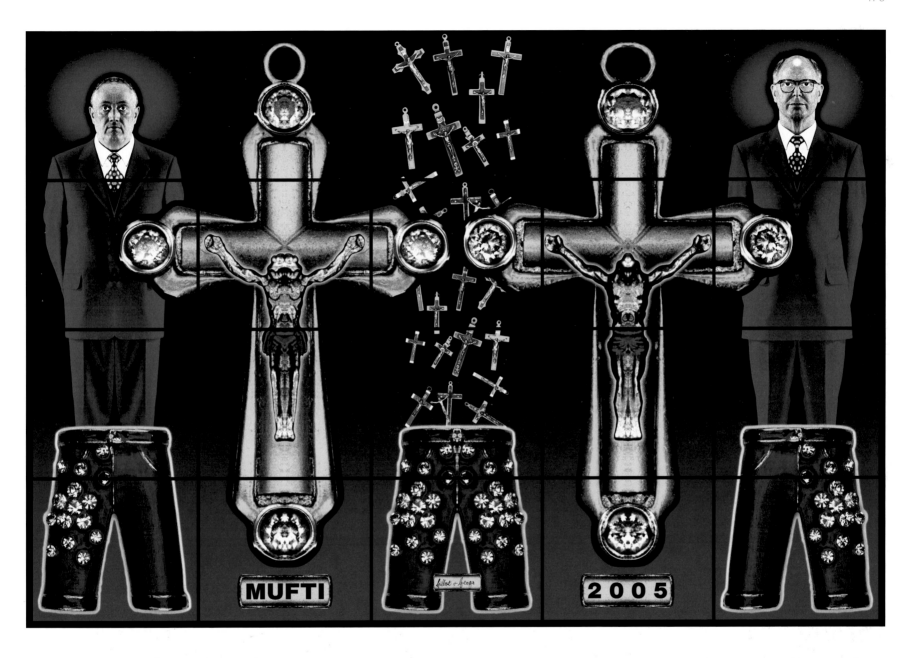

190
PIXIE HILL
2005
302 x 381 cm

191
MUFTI
2005
254 x 377 cm

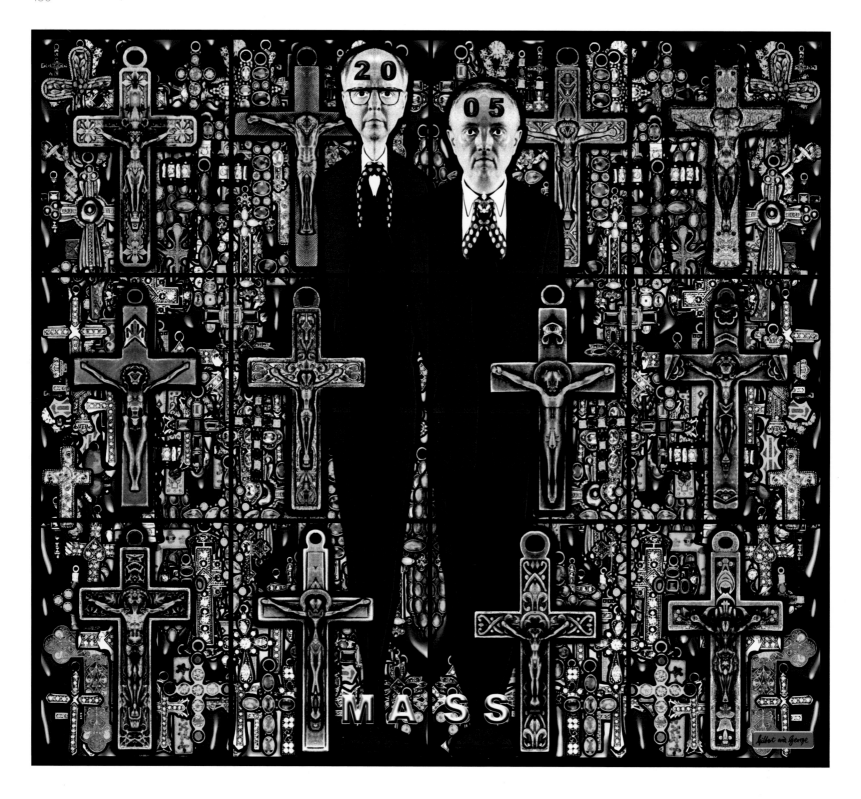

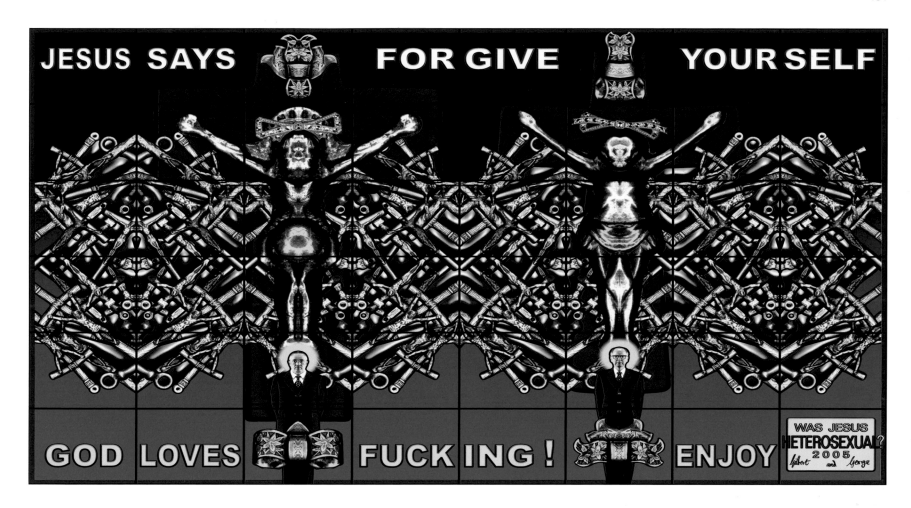

192
MASS
2005
226 x 254 cm

193
WAS JESUS HETEROSEXUAL?
2005
381 x 604 cm

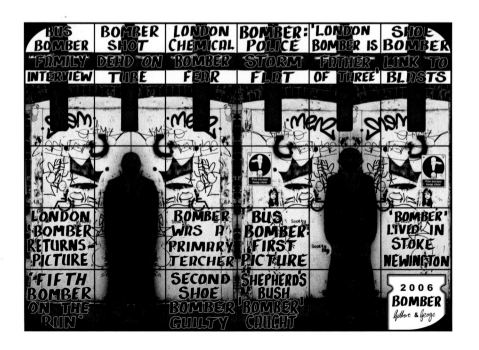

194
TERROR
2006
336 x 775 cm

195
BOMBING
2006
336 x 423 cm

196
BOMBER
2006
352 x 504 cm

197
BOMBS
2006
336 x 493 cm

198
BOMBERS
2006
336 x 493 cm

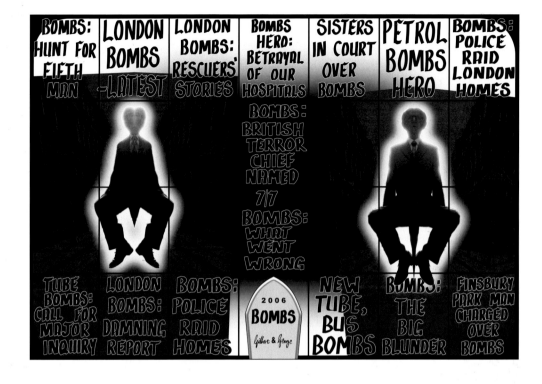

199
BOMB
2006
A triptych picture
Left to right: 336 x 352 cm;
336 x 705 cm; 336 x 352 cm

BOMB	BOMB VICTIM'S MOTHERS DEATH...		NET CLOSES ON BOMB GANG	POLICE SEIZE BOMB SUSPECT
G'S				
RSAL				BETRAYAL
B				HEROES
E MB' ECTS SSION				RUCKSACK BOMB – FIRST PICTURE
				BOMB VICTIM'S MRSA ORDEAL

HEATHROW BOMB PLOT	BOMB SUSPECTS IN COURT	HOLIDAY FLIGHT BOMB ALERT	BOMB PLOT DATE REVEALED	BOMB SUSPECT LINKED TO MODEL
BOMB SURVIVOR... TRAUMA	'BOMB' SUSPECTS AMAZING CLAIM		BOMB SUSPECTS -NEW DETAILS	BOMB VICTIM'S FUNERAL
BOMB VICTIM'S BRAVE DEFIANCE				BOMB SUSPECTS SECRET LIVES
'LONDON TERROR BOMB PLOT'				LONDON CAR BOMB PLOT

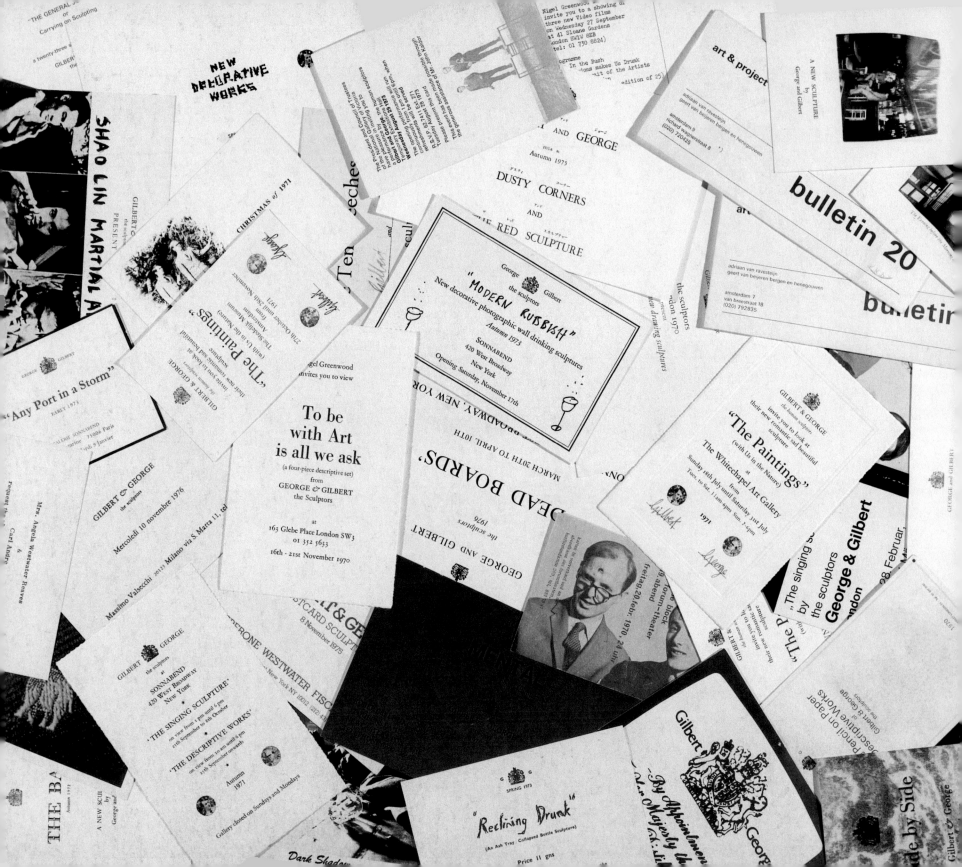

In their earliest art, beginning in the late 1960s, Gilbert & George explored the totality of life through a wide range of media. Instead of quantifying these initial pieces as so many living sculptures, postal or postcard sculptures and films, however, one can see them as a series of statements that continue to define their practice to this day. The cumulative effect is like a manifesto in which Gilbert & George not only redefine both art and the very notion of what it is to be an artist, but democratise it and make it available to everyone. To this end, there is an intimacy and sincerity about their endeavours that is always located in lived experience; the border between the self and everyday life becomes the surface of their art. These surfaces are not just constituted by their bodies, but by the thoughts, emotions, statements, habits and cultural traditions through which they experience the world.

Instead of taking part in the radical politics that arose in 1968 in order to oppose 'the establishment', Gilbert & George challenged the status quo in a less orthodox manner. By conspicuously differentiating themselves from the existing avant-garde, they situated themselves as the ultimate outsiders: their formal suits and decorous manners set them apart from the student radicalism of the time, while their redefinition of art practice put them way outside the mainstream. Their maxim 'Art for All' is grounded in a belief that art should employ recognisable forms with which the public are familiar in order to eliminate any formal barrier to engaging with the ideas. No matter how radical their ideas seem, they are popular but always far from populist – the artists want a genuine engagement with the broadest possible cross-section of society. The early 'living sculptures', for example, were presented in art schools, galleries and museums, but also at night clubs, music festivals and the derelict bombsites of London's East End.

The choice of soundtrack for Gilbert & George's most famous 'living sculpture' in 1969 – the 1930s music hall song 'Underneath the Arches', popularised by Flannagan & Allen – is no arbitrary one. Instead of offering a sentimental romanticisation of the social misfits represented in the song, Gilbert & George are deadpan in their delivery, absolutely serious in their commitment to a position on the fringes of society. Like the tramps in the song, they reject the material trappings of society and the glamorous life that was available to them with their early success. An uncanny distance is created between 'us and them', which for the artists means between anyone who elects to be, or finds themselves, on the margins of society and the consensus. At the first presentation of Underneath the Arches (fig.37), the extreme economy of means with which they approached their practice was chalked up on a blackboard behind: '2 sculptors; 1 stick; 1 glove; 1 record.' This pivotal living piece did not require a steel works or a vast studio, specialist technicians or a complex logistical team, but was portable and could be presented anywhere to anyone.

The democratic values of 'Art for All' are also beautifully expressed in the Message from the Sculptors 1970 (fig.39), a simple index of the familiar materials that demonstrate Gilbert & George's new idea of what constitutes art: make-up, tobacco and ash, hair, clothing and food – all materials to which anyone has access. This piece offers a taxonomy of the everyday, sculpture that resembles samples collected by amateur scientists of the Romantic era for examination under a microscope, true to the Enlightenment belief that by observation of one's immediate surroundings, knowledge is within the reach of everyone rather than being a remote privilege for the few. Unlike the empiricism that makes so much conceptual art seem cold and statistical, or the exotic abstractions of high modernism, their examples resonate with lived experience, the natural world and their own bodies.

MANIFESTOS FOR A MODERN WORLD: THE EARLY ART OF GILBERT & GEORGE
BEN BORTHWICK

FIG 34
A selection of invitations to early Gilbert & George exhibitions

FIG 36
The sheet music
for Bud Flanagan's
'Underneath the Arches',
with annotations by
Gilbert & George

FIG 37
UNDERNEATH THE ARCHES
1969
Presented at Slade School
of Fine Art, London, 1969

FIG 38
SINGING SCULPTURE
1991
Presented at Sonnabend Gallery,
New York, 1991

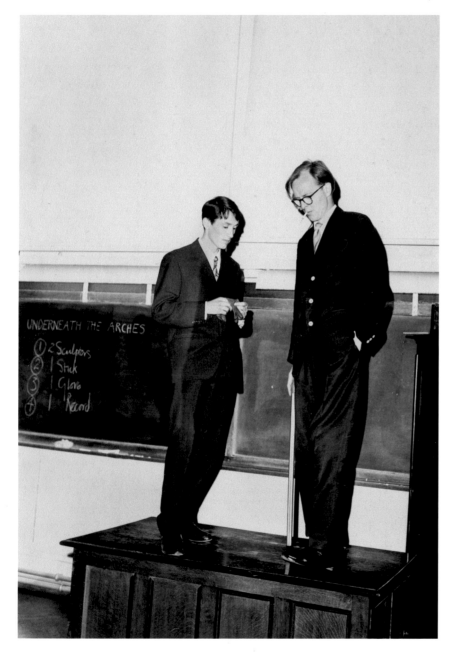

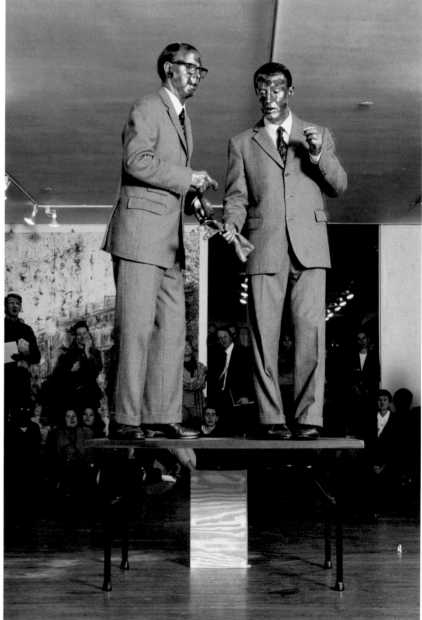

A SCULPTURE SAMPLE
ENTITLED
SCULPTORS' SAMPLES

1. *G &G's make-up.*

2. *G &G's tobacco and ash.*

3. *G &G's hair.*

4. *G &G's coat and shirt.*

5. *G &G's breakfast.*

Gilbert and George have a wide range of sculptures for you—singing sculpture, interview sculpture, dancing sculpture, meal sculpture, walking sculpture, nerve sculpture, cafe sculpture, and philosophy sculpture.

So do contact us

George and Gilbert

'ART FOR ALL'
12 FOURNIER STREET
LONDON, E.1

Telephone 01 - 247 0161

FIG 39
A MESSAGE FROM
THE SCULPTORS
1969
A postal sculpture

FIG 40
'GILBERT &
GEORGE, THE
SCULPTORS, SAY:–'
1970
A magazine sculpture
commissioned by the
*Sunday Times Colour
Supplement*

FIG 41
SNOW POSTAL
SCULPTURE
1969

Gilbert and George, the sculptors, say:— LONDON 1970

'WE ARE ONLY HUMAN SCULPTORS'

We are only human sculptors in that we get up every day, walking sometimes, reading rarely, eating often, thinking always, smoking moderately, enjoying enjoyment, looking, relaxing to see, loving nightly, finding amusement, encouraging life, fighting boredom, being natural, daydreaming, travelling along, drawing occasionally, talking lightly, tea drinking, feeling tired, dancing sometimes, philosophising a lot, criticising never, whistling tunefully, dying very slowly, laughing nervously, greeting politely and waiting till the day breaks.

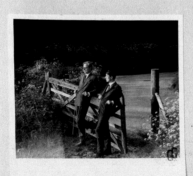

These two people resting on a five-bar gate. Such a simple easy thing to do and yet there is a little more to the story. Observe, for instance, the similarity of their poses, or look to the differences, one dark, one light. See the walking stick. One single-breasted suit and one double-breasted suit. Think of all that diagonal relaxation, for only the picture behind is symmetrical.

With Very Best Wishes to You All from

'ART FOR ALL' Autumn 1970

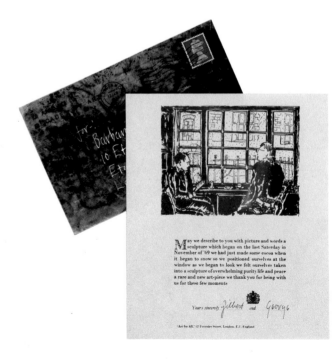

May we describe to you with picture and words a sculpture which began on the last Saturday in November of '69 we had just made some cocoa when it began to snow so we positioned ourselves at the window as we began to look we felt ourselves taken into a sculpture of overwhelming purity life and peace a rare and new art-piece we thank you for being with us for these few moments

Yours sincerely Gilbert and George

'Art for All' 12 Fournier Street, London, E.1. England

FIG 42
CORONATION
CROSS
1981
133 x 100 cm
A postcard piece

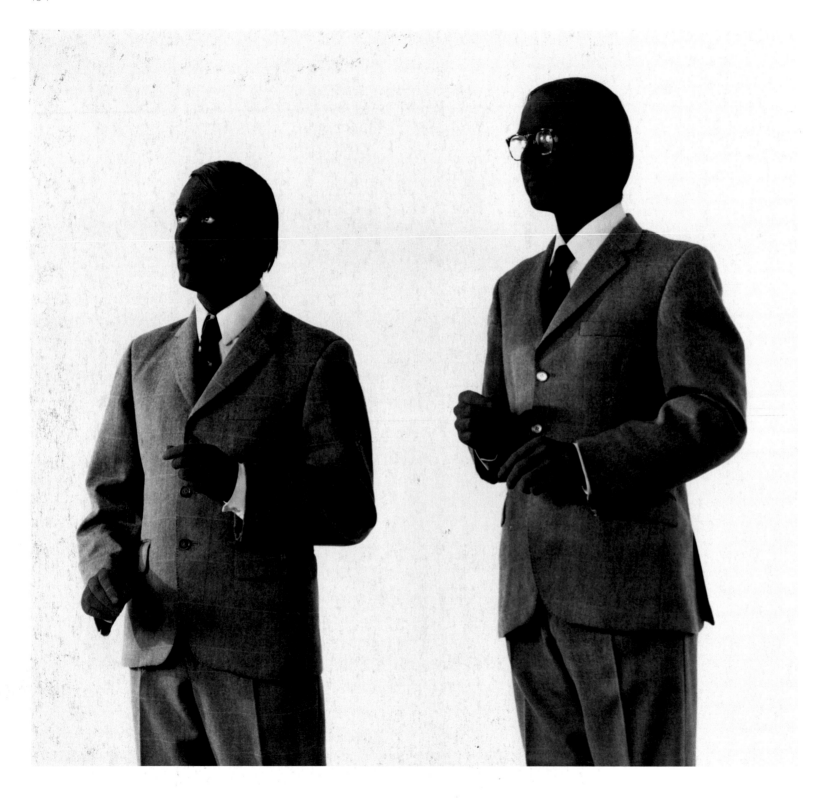

FIG 43
THE RED SCULPTURE
1975

FIG 44
Certificate for
A PORTRAIT OF THE
ARTISTS AS YOUNG MEN
1972
A sculpture on video tape

"A PORTRAIT OF THE ARTISTS AS YOUNG MEN"

Summer 1972

Sculpture on Video Tape

NO. 1 OF 25

the sculptors

This tape should be viewed with
'high contrast' as in this photograph

'ART FOR ALL' 12 Fournier Street London E1
01-247 0161

FIG 45
Excerpts from the storyboard for
THE WORLD OF GILBERT & GEORGE
1981
Film produced by Philip Haas for the
Arts Council of Great Britain, 70 mins.

FIG 46
Stills from 'The Lords Prayer' in
THE WORLD OF GILBERT & GEORGE
1981
Film produced by Philip Haas for the
Arts Council of Great Britain, 70 mins.

Our Father

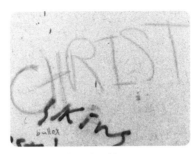

Which art in Heaven

Hallowed be thy Name.

Thy kingdom come

Thy will be done

On Earth

As it is in Heaven.

Give us this day

Our daily bread

And forgive us our trespasses

As we forgive them who trespass against us

And lead us not into temptation

But deliver us from evil.

For thine is the kingdom

The power

And the glory, for ever and ever. Amen.

Gilbert
Born Dolomites, Italy, 1943

Studied
Wolkenstein School of Art,
Hallcin School of Art,
Munich Academy of Art

George
Born Devon, England, 1942

Studied
Dartington Adult Education Centre,
Dartington Hall College of Art,
Oxford School of Art

Met and Studied
St Martin's School of Art, London, 1967

FIG 47
In a moment of
relaxation, on the
roof of St Martin's
School of Art,
London, Spring 1968

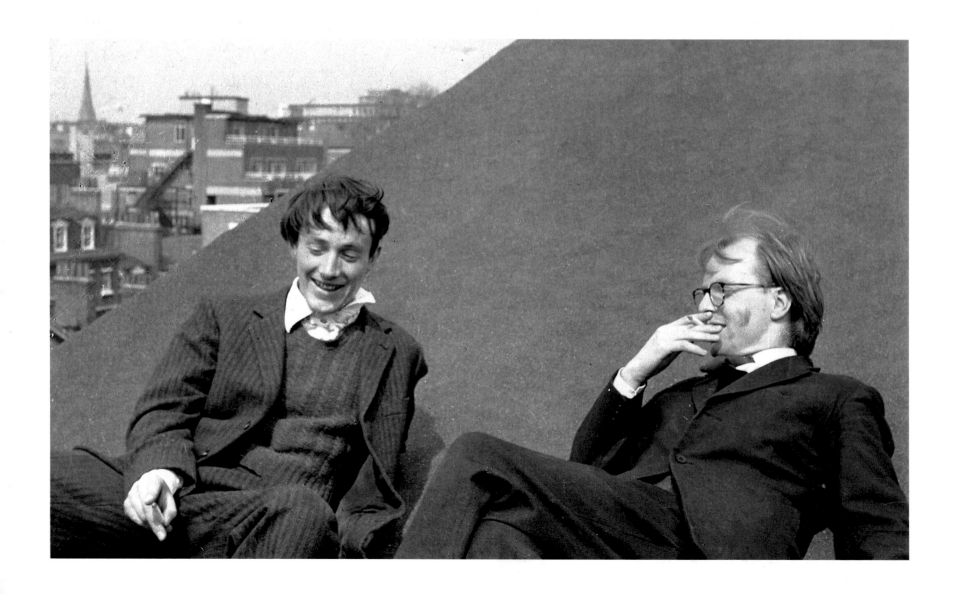

Gallery Exhibitions

1968
THREE WORKS/
THREE WORKS
Frank's Sandwich Bar,
London

1968
SNOW SHOW
St Martin's School
of Art, London

1968
BACON 32
Allied Services,
London

1968
CHRISTMAS SHOW
Robert Fraser Gallery,
London

1969
ANNIVERSARY
Frank's Sandwich Bar,
London

1969
SHIT AND CUNT
Robert Fraser Gallery,
London

1970
GEORGE BY GILBERT
& GILBERT
BY GEORGE
Fournier Street,
London

1970
ART NOTES AND
THOUGHTS
Art & Project,
Amsterdam

1970
THE PENCIL ON
PAPER DESCRIPTIVE
WORKS
Konrad Fischer
Gallery, Düsseldorf

1970
FROZEN INTO
THE NATURE
FOR YOU ART
Françoise Lambert
Gallery, Milan

1970
THE PENCIL ON
PAPER DESCRIPTIVE
WORKS
Folker Skulima Gallery,
Berlin

1970
FROZEN INTO
THE NATURE
FOR YOU ART
Heiner Friedrich
Gallery, Cologne

1970
TO BE WITH ART
IS ALL WE ASK
Nigel Greenwood
Gallery, London

1971
THERE WERE
TWO YOUNG MEN
Sperone Gallery, Turin

1971
THE GENERAL
JUNGLE
Sonnabend Gallery,
New York

1971
THE TEN SPEECHES
Nigel Greenwood
Gallery, London

1971
NEW PHOTO-PIECES
Art & Project,
Amsterdam

1972
NEW PHOTO-PIECES
Konrad Fischer
Gallery, Düsseldorf

1972
THREE SCULPTURES
ON VIDEO TAPE
Gerry Schum Video
Gallery, Düsseldorf

1972
THE BAR
Anthony d'Offay,
London

1972
THE EVENING
BEFORE THE
MORNING AFTER
Nigel Greenwood
Gallery, London

1972
IT TAKES A BOY
TO UNDERSTAND
A BOY'S POINT
OF VIEW
Situation Gallery,
London

1972
A NEW SCULPTURE
Sperone Gallery, Rome

1973
ANY PORT
IN A STORM
Sonnabend Gallery,
Paris

1973
RECLINING DRUNK
Nigel Greenwood
Gallery, London

1973
MODERN RUBBISH
Sonnabend Gallery,
New York

1973
NEW DECORATIVE
WORKS
Sperone Gallery, Turin

1974
DRINKING
SCULPTURES
Art & Project / MTL
Gallery, Antwerp

1974
HUMAN BONDAGE
Konrad Fischer
Gallery, Düsseldorf

1974
DARK SHADOW
Art & Project,
Amsterdam

1974
DARK SHADOW
Nigel Greenwood
Gallery, London

1974
CHERRY BLOSSOM
Sperone Gallery, Rome

1975
BLOODY LIFE
Sonnabend Gallery,
Paris

1975
BLOODY LIFE
Sonnabend Gallery,
Geneva

1975
BLOODY LIFE
Lucio Amelio Gallery,
Naples

1975
POST-CARD
SCULPTURES
Sperone/ Westwater/
Fischer, New York

1975
BAD THOUGHTS
Gallery Spillemaekers,
Brussels

1975
DUSTY CORNERS
Art Agency, Tokyo

1976
DEAD BOARDS
Sonnabend Gallery,
New York

1976
MENTAL
Robert Self Gallery,
London

1976
MENTAL
Robert Self Gallery,
Newcastle

1977
RED MORNING
Sperone/ Fischer,
Basel

1977
DIRTY WORDS
PICTURES
Art & Project,
Amsterdam

1977
DIRTY WORDS
PICTURES
Konrad Fischer
Gallery, Düsseldorf

1978
PHOTO-PIECES
Dartington Hall
Gallery, Dartington

1978
NEW PHOTO-PIECES
Sonnabend Gallery,
New York

1978
NEW PHOTO-PIECES
Art Agency, Tokyo

1980
POST-CARD
SCULPTURES
Art & Project,
Amsterdam

1980
POST-CARD
SCULPTURES
Konrad Fischer
Gallery, Düsseldorf

1980
NEW PHOTO-PIECES
Karen & Jean Bernier,
Athens

1980
NEW PHOTO-PIECES
Sonnabend Gallery,
New York

1980
MODERN FEARS
Anthony d'Offay
Gallery, London

1981
PHOTO-PIECES
1980–1981
Chantel Crousel
Gallery, Paris

1982
CRUSADE
Anthony d'Offay
Gallery, London

1983
MODERN FAITH
Sonnabend Gallery,
New York

1983
PHOTO-PIECES
1980–1981
David Bellman Gallery,
Toronto

1983
NEW WORKS
Crousel-Hussenot
Gallery, Paris

1984
THE BELIEVING
WORLD
Anthony d'Offay
Gallery, London

1984
HANDS UP
Gallery Schellmann &
Klüser, Munich

1984
LIVES
Gallery Pieroni, Rome

1985
NEW MORAL WORKS
Sonnabend Gallery,
New York

1987
NEW PICTURES
Anthony d'Offay
Gallery, London

1987
NEW PICTURES
Sonnabend Gallery,
New York

1988
THE 1988 PICTURES
Ascan Crone Gallery,
Hamburg

1988
THE 1988 PICTURES
Sonnabend Gallery,
New York

1989
THE 1988 PICTURES
Christian Stein Gallery,
Milan

1989
FOR AIDS
EXHIBITION
Anthony d'Offay
Gallery, London

1989
GILBERT & GEORGE:
POSTCARD
SCULPTURES
Paul Kasmin Gallery,
New York

1990
GILBERT AND
GEORGE
Hirschl & Adler
Modern, New York

1990
25 WORLDS BY
GILBERT & GEORGE
Robert Miller Gallery,
New York

1990
THE
COSMOLOGICAL
PICTURES
Sonnabend Gallery,
New York

1990
WORLDS &
WINDOWS
Anthony d'Offay
Gallery, London

1990
ELEVEN WORLDS BY
GILBERT & GEORGE
AND ANTIQUE
CLOCKS
Desire Feurele Gallery,
Cologne

1991
20TH ANNIVERSARY
EXHIBITION
Sonnabend Gallery,
New York

1992
NEW DEMOCRATIC
PICTURES
Anthony d'Offay
Gallery, London

1994
GILBERT & GEORGE
Robert Miller Gallery,
New York

1994
THE NAKED SHIT
PICTURES
Galerie Rafael
Jablonka, Cologne

1995
GILBERT & GEORGE
Galerie Nikolas Sonne,
Berlin

1997
THE FUNDAMENTAL
PICTURES
Sonnabend Gallery /
Lehmann Maupin,
New York

1998
SELECTED WORKS
FROM THE
FUNDAMENTAL
PICTURES
Massimo Martino Fine
Arts & Projects,
Mendrisio, Switzerland

1998
NEW TESTAMENTAL
PICTURES
Galerie Thaddaeus
Ropac, Paris

1998
NEW TESTAMENTAL
PICTURES
Galerie Thaddaeus
Ropac, Salzburg

1998
BLACK WHITE AND
RED 1971–1980
James Cohen Gallery,
New York

CHRONOLOGY

2000
ZIG-ZAG PICTURES
2000
FIAC, Galerie
Thaddaeus Ropac,
Paris

2000
THE RUDIMENTARY
PICTURES
Gagosian Gallery,
Los Angeles

2000
GILBERT & GEORGE
Parkhaus, Düsseldorf

2001
NINE DARK
PICTURES
Bernier/ Eliades,
Athens

2001
NEW HORNY
PICTURES
White Cube 2, London

2004
THIRTEEN
HOOLIGAN
PICTURES 2004
Bernier/ Eliades,
Athens

2004
20 LONDON E1
PICTURES
Galerie Thaddaeus
Ropac, Paris

2004
PERVERSIVE
PICTURES
Sonnabend Gallery,
New York

2004
PERVERSIVE
PICTURES
Lehmann Maupin,
New York

2006
SONOFAGOD
PICTURES:
WAS JESUS
HETROSEXUAL?
White Cube, London

**Museum
Exhibitions**

1971
THE PAINTINGS
Whitechapel Art
Gallery, London

1971
THE PAINTINGS
Stedelijk Museum,
Amsterdam

1971
THE PAINTINGS
Kunstverein,
Düsseldorf

1972
THE PAINTINGS
Koninklijk Museum
voor Schone Kunsten,
Antwerp

1972
THE PAINTINGS
Kunstmuseum Luzern,
Lucerne

1973
THE SHRUBBERIES
& SINGING
SCULPTURE
National Gallery of
New South Wales
(John Kaldor project),
Sydney

1973
THE SHRUBBERIES
& SINGING
SCULPTURE
National Gallery of
Victoria (John Kaldor
project), Melbourne

1976
THE GENERAL
JUNGLE
Albright-Knox Gallery
Buffalo, New York

1980
PHOTO-PIECES
1971–1980
Van Abbemuseum,
Eindhoven

1981
PHOTO-PIECES
1971–1980
Kunsthalle, Düsseldorf

1981
PHOTO-PIECES
1971–1980
Kunsthalle, Bern

1981
PHOTO-PIECES
1971–1980
Centre Georges
Pompidou, Paris

1981
PHOTO-PIECES
1971–1980
Whitechapel Art
Gallery, London

1981
16 BIENAL DE SAO
PAULO
São Paulo

1982
NEW PHOTO-PIECES
Geward, Ghent

1984
GILBERT & GEORGE
The Baltimore
Museum of Art,
Baltimore

1984
GILBERT & GEORGE
Contemporary Arts
Museum
Houston, Texas

1984
GILBERT & GEORGE
The Norton Gallery of
Art, West Palm Beach,
Florida

1985
GILBERT & GEORGE
The Solomon R.
Guggenheim
Museum, New York

1985
GILBERT & GEORGE
Milwaukee Art
Museum, Milwaukee

1986
PICTURES 1982–1985
CAPC, Musée d'Art
Contemporain,
Bordeaux

1986
CHARCOAL ON
PAPER SCULPTURES
1970–1974
CAPC, Musée d'Art
Contemporain,
Bordeaux

1986
THE PAINTINGS 1971
The Fruitmarket
Gallery, Edinburgh

1986
PICTURES 1982–1985
Kunsthalle, Basel

1986
PICTURES 1982–1985
Palais des Beaux-Arts,
Brussels

1987
PICTURES 1982–1985
Palacio de Velázquez,
Madrid

1987
PICTURES 1982–1985
Lenbachaus, Munich

1987
PICTURES 1982–1985
Hayward Gallery,
London

1987
PICTURES
Aldrich Museum
Ridgefield,
Connecticut

1990
PICTURES 1983–88
Central House of the
Artists, New Tretyakov
Gallery, Moscow

1991
THE
COSMOLOGICAL
PICTURES
Palac Sztuki, Krakow

1991
THE
COSMOLOGICAL
PICTURES
Palazzo delle
Esposizioni, Rome

1992
THE
COSMOLOGICAL
PICTURES
Kunsthalle, Zürich

1992
THE
COSMOLOGICAL
PICTURES
Wiener Secession,
Vienna

1992
THE
COSMOLOGICAL
PICTURES
Ernst Múzeum,
Budapest

1992
THE
COSMOLOGICAL
PICTURES
Haags
Gemeentemuseum,
The Hague

1992
NEW DEMOCRATIC
PICTURES
Aarhus Kunstmuseum,
Aarhus

1992
THE
COSMOLOGICAL
PICTURES
Irish Museum of
Modern Art, Dublin

1992
THE
COSMOLOGICAL
PICTURES
Fundació Joan Miró,
Barcelona

1993
THE
COSMOLOGICAL
PICTURES
Tate Gallery, Liverpool

1993
THE
COSMOLOGICAL
PICTURES
Württembergischer
Kunstverein, Stuttgart

1993
GILBERT & GEORGE
CHINA EXHIBITION
National Art Gallery,
Beijing

1993
GILBERT & GEORGE
CHINA EXHIBITION
The Art Museum,
Shanghai

1994
GILBERT & GEORGE
Museo d'Arte
Moderna della Città di
Lugano, Lugano

1994
SHITTY NAKED
HUMAN WORLD
Wolfsburg
Kunstmuseum,
Wolfsburg

1995
THE NAKED SHIT
PICTURES
South London Art
Gallery, London

1996
THE NAKED SHIT
PICTURES
Stedelijk Museum,
Amsterdam

1996
GILBERT & GEORGE
RETROSPECTIVE
Galleria d'Arte
Moderna, Bologna

1997
GILBERT & GEORGE
RETROSPECTIVE
Sezon Museum, Tokyo

1997
GILBERT & GEORGE
Magasin 3, Stockholm

1997
GILBERT & GEORGE
RETROSPECTIVE
Musée d'Art Moderne
de la Ville de Paris,
Paris

1997
THE 2ND KWANGJU
BIENNALE
Kwangju, Korea

1998
NEW TESTAMENTAL
PICTURES
Museo di
Capodimonte, Naples

1999
GILBERT & GEORGE
1970–1988
Astrup Fearnley
Museum of Modern
Art, Oslo

1999
GILBERT & GEORGE
1986–1997
Drassanes, Valencia

1999
GILBERT & GEORGE
1991–1999
Ormeau Baths Gallery,
Belfast

1999
THE RUDIMENTARY
PICTURES
Milton Keynes Gallery
(inaugural exhibition),
Milton Keynes

1999
NINETEEN NINETY
NINE, 1999
Kunstmuseum Bonn

2000
NINETEEN NINETY
NINE, 1999
Museum Moderner
Kunst Stiftung, Vienna

2000
NINETEEN NINETY
NINE, 1999
Museum of
Contemporary Art,
Chicago

2000
MM 2000, BIENNALE
DE LYON
Halle Tony Garnier,
Lyon

2001
GILBERT & GEORGE
Chateau d'Arenton
Fondation pour l'Art
Contemporain, Alex

2001
THE ART OF GILBERT
& GEORGE
The Factory, Athens
School of Art, Athens

2002
THE DIRTY WORDS
PICTURES
Serpentine Gallery,
London

2002
GILBERT & GEORGE
NINE DARK
PICTURES
Portikus, Frankfurt

2002
GILBERT & GEORGE
Centro Cultural de
Belém, Lisbon

2004
20 LONDON E1
PICTURES
Musee d'Art Moderne
de Saint-Etienne
Metropole, Saint-
Etienne

2005
VENICE BIENNALE
The British Pavilion,
Venice

2005
20 LONDON E1
PICTURES
Kestnergesellschaft,
Hanover

2006
SONOFAGOD
PICTURES:
WAS JESUS
HETROSEXUAL?
Bonnefanten Museum,
Maastricht

Postal Sculptures

1969
THE EASTER CARDS

1969
SOUVENIR HYDE PARK WALK

1969
A MESSAGE FROM THE SCULPTORS
(dated 1970)

1969
ALL MY LIFE

1969
SNOW POSTAL SCULPTURE

1969/1970
NEW DECADENT ART

1970
THE SADNESS IN OUR ART

1971
THE LIMERICKS

1972
GENTLEMEN ...

1972
HUMAN SCULPTURE

1973
THE PINK ELEPHANTS

1975
THE RED BOXERS

Magazine Sculptures

1969
THE WORDS OF THE SCULPTORS
Jam Magazine, Autumn, pp.43–7

1970
GEORGE THE CUNT AND GILBERT THE SHIT
Studio International, vol.179, no.922, May, pp.218–21

1970
WITH US IN THE NATURE
Kunstmarkt Cologne (catalogue)

1971
TWO TEXT PAGES DESCRIBING OUR POSITION
Sunday Times Magazine, 10 Jan.

1971
THERE WERE TWO YOUNG MEN
Studio International, vol.181, no.933, May, pp.220–1

1973
BALLS
Avalanche, no. 8, Summer–Fall, pp.26–33

2004
SALUTE SALUTE
Le Monde 2, 27 Nov., pp.66–7

2005
ALL OF OUR LOVE ALWAYS & ALL WAYS NOW AND FOREVER
Tatler, June, pp.126–7

2005
GINKGO
Guardian: G2
2 June, pp.10–11

2006
SONOFAGOD
Numéro, April, pp.28–31

Living Sculpture Presentations

1969
OUR NEW SCULPTURE
St Martin's School of Art, London

1969
READING FROM A STICK
Geffrye Museum, London

1969
OUR NEW SCULPTURE
Royal College of Art, London

1969
OUR NEW SCULPTURE
Camberwell School of Art, London

1969
UNDERNEATH THE ARCHES
Slade School of Fine Art, London

1969
SCULPTURE IN THE 60S
Royal College of Art (with Bruce McLean), London

1969
IN THE UNDERWORLD
St Martin's School of Art (with Bruce McLean), London

1969
IMPRESSARIOS OF THE ART WORLD
Hanover Grand Preview Theatre (with Bruce McLean), London

1969
MEETING SCULPTURES
Various locations, London

1969
THE MEAL
Ripley
(with David Hockney)
Bromley, Kent

1969
METALISED HEADS
Studio International Office, London

1969
TELLING A STORY
Marquee Club, London

1969
THE SINGING SCULPTURE
The Lyceum, London

1969
TELLING A STORY
The Lyceum, London

1969
THE SINGING SCULPTURE
National Jazz and Blues Festival, Plumpton

1969
A LIVING SCULPTURE
At the opening of 'When Attitudes become Form', ICA, London

1969
UNDERNEATH THE ARCHES
Cable Street, London

1970
POSING ON STAIRS
Stedelijk Museum, Amsterdam

1970
3 LIVING PIECES
BBC Studios, Bristol

1970
LECTURE SCULPTURE
Museum of Modern Art, Oxford

1970
LECTURE SCULPTURE
Leeds Polytechnic, Leeds

1970
UNDERNEATH THE ARCHES
Kunsthalle Düsseldorf

1970
UNDERNEATH THE ARCHES
Block Gallery Forum Theatre, Berlin

1970
POSING PIECE
Art & Project, Amsterdam

1970
POSING PIECE
Konrad Fischer Gallery, Düsseldorf

1970
UNDERNEATH THE ARCHES
Kunstverein, Recklinghausen

1970
UNDERNEATH THE ARCHES
Heiner Friedrich Gallery, Munich

1970
UNDERNEATH THE ARCHES
Kunstverein, Nuremberg

1970
UNDERNEATH THE ARCHES
Württembergischer Kunstverein, Stuttgart

1970
UNDERNEATH THE ARCHES
Galleria Civica d'Arte Moderna, Turin

1970
UNDERNEATH THE ARCHES
Sonja Henie Niels Onstad Foundation, Oslo

1970
UNDERNEATH THE ARCHES
Stadsbiblioteket Lyngby, Copenhagen

1970
STANDING SCULPTURE
Folker Skulima Gallery, Berlin

1970
UNDERNEATH THE ARCHES
Gegenverkehr, Aachen

1970
UNDERNEATH THE ARCHES
Heiner Friedrich Gallery, Cologne

1970
UNDERNEATH THE ARCHES
Kunstverein, Krefeld

1970
UNDERNEATH THE ARCHES
Nigel Greenwood Gallery, London

1971
UNDERNEATH THE ARCHES
Show Room du Jardin Stores Louise, Brussels

1971
UNDERNEATH THE ARCHES
BBC play, *The Cowshed*, London

1971
UNDERNEATH THE ARCHES
Sonnabend Gallery, New York

1972
UNDERNEATH THE ARCHES
Kunstmuseum, Luzern, Lucerne

1972
UNDERNEATH THE ARCHES
L'Attico Gallery, Rome

1973
UNDERNEATH THE ARCHES
National Gallery of New South Wales, John Kaldor Project, Sydney

SCULPTURES, FILMS AND EDITIONS

1973
UNDERNEATH
THE ARCHES
National Gallery of
Victoria, John Kaldor
Project, Melbourne

1975
SHAO LIN
MARTIAL ARTS
(Film Presentation)
Collegiate Theatre,
London

1975
THE RED
SCULPTURE
Art Agency, Tokyo

1976
THE RED
SCULPTURE
Sonnabend Gallery,
New York

1976
THE RED
SCULPTURE
Konrad Fischer
Gallery, Düsseldorf

1976
THE RED
SCULPTURE
Lucio Amelio Gallery,
Naples

1977
THE RED
SCULPTURE
Sperone Gallery,
Rome

1977
THE RED
SCULPTURE
Robert Self Gallery,
London

1977
THE RED
SCULPTURE
Art Fair, Sperone/
Fischer, Basel

1977
THE RED
SCULPTURE
MTL Gallery, Brussels

1977
THE RED
SCULPTURE
Museum van
Hedendaagse Kunst,
Ghent

1977
THE RED
SCULPTURE
Stedelijk Museum,
Amsterdam

1991
THE SINGING
SCULPTURE
(20TH ANNIVERSARY)
Sonnabend Gallery,
New York

1995
THE SINGING
SCULPTURE
CAPC Musée d'Art
Contemporain,
Bordeaux

**Film and Video by
Gilbert & George**

1970
THE NATURE OF
OUR LOOKING
Edition 4

1972
GORDON'S MAKES
US DRUNK
Edition 25

1972
IN THE BUSH
Edition 25

1972
PORTRAIT OF
THE ARTISTS
AS YOUNG MEN
Edition 25

1981
THE WORLD OF
GILBERT & GEORGE,
Produced by Philip
Haas for the Arts
Council of Great
Britain (70 mins)

Editions

1970
THE WORDS OF
THE SCULPTORS
Edition 35

1970
WALKING VIEWING
RELAXING
Edition 13

1970
TO BE WITH ART
IS ALL WE ASK
Edition 9

1970
TWO TEXT PAGES
DESCRIBING
OUR POSITION
Edition 19

1971
THE TEN SPEECHES
Edition 10

1971
THE EIGHT
LIMERICKS
Edition 25

1972
MORNING LIGHT
ON ART FOR ALL
Edition 12

1972
GREAT
EXPECTATIONS
Edition 12

1972
AS USED BY
THE SCULPTORS
Edition 30

1973
RECLINING DRUNK
Edition 200

1976
THE RED
SCULPTURE ALBUM
Edition 100

1979
FIRST BLOSSOM
Edition 50

1987
NINETEEN EIGHTY
SEVEN
Edition 200

1988
NINETEEN EIGHTY
EIGHT
Edition 6

1993
THE SINGING
SCULPTURE
1969–1991
Edition 20

2003
GINKGO WINKGO
Edition 50

2006
LONDON PLANE
Edition 100

2006
GOTHIC QUERY
Edition 100

2006
STRAIGHT
QUESTION
Edition 100

**Television, Radio
Broadcasts, and
Films about Gilbert
& George**

1981
GILBERT & GEORGE
TALK WITH EDWARD
LUCIE-SMITH
BBC Radio 3, London

1986
GILBERT & GEORGE
with Ben Elton, South
of Watford, ITV

1986
RENCONTRE
A LONDRES
A film by Michel
Burcel, Vidéo
Londres, France

1991
GILBERT & GEORGE
La Estacion de
Perpinan, TVE, Spain

1992
THE RED
SCULPTURE
Sonnabend/ Castelli,
New York

1992
GILBERT & GEORGE:
DAYTRIPPING
Produced and
directed by Ian
Macdonald, Anglia
TV, Norwich

1993
NORMAL
CONSERVATIVE
REBELS: GILBERT &
GEORGE IN CHINA
(VHS)
A film by David Zilka

1997
THE SINGING
SCULPTURE BY
GILBERT AND
GEORGE
Produced and
directed by Philip
Haas, Sonnabend/
Methodact, New York

1998
PRIVATE VIEW
Presented by
Nicholas Ward
Jackson, BBC
Radio 3, London

1998
THE FUNDAMENTAL
GILBERT AND
GEORGE
(VHS)
Produced and
directed by
Gerry Fox, Phaidon
Video, London

2000
THE SECRET FILES
OF GILBERT &
GEORGE (VHS)
A film by Hans Ulrich
Obrist
The Visual Arts
Foundation/bdv, Paris

2002
GILBERT & GEORGE
(VHS)
Illuminations, London

1970
THE PENCIL ON
PAPER DESCRIPTIVE
WORKS
Gilbert & George,
London, edition 500

1970
ART NOTES AND
THOUGHTS
Gilbert & George,
London

1970
TO BE WITH ART
IS ALL WE ASK
Gilbert & George,
London, edition 300

1970
A GUIDE TO
THE SINGING
SCULPTURE
Gilbert & George,
London

1971
THE PAINTINGS
Exh. cat., Kunstverein,
Düsseldorf

1971
SIDE BY SIDE
Cologne, edition 600

1971
A DAY IN
THE LIFE OF
GILBERT & GEORGE
Gilbert & George,
London, edition 1000

1972
OH, THE GRAND
OLD DUKE OF YORK
Kunstmuseum
Luzern, Lucerne

1973
CATALOGUE
FOR THEIR
AUSTRALIAN VISIT
Exh. cat., John Kaldor,
Sydney

1976
DARK SHADOW
Exh. cat.,
Nigel Greenwood
Gallery, London
Edition 2000

1977
GILBERT & GEORGE
Exh. cat.,Taxipalais
Gallery, Innsbruck

1980
GILBERT & GEORGE
1968 TO 1980
Carter Ratcliff
(introd.), exh. cat.,
Stedelijk Van
Abbemuseum,
Eindhoven

1984
GILBERT & GEORGE
Brenda Richardson
(text), exh. cat.,
Baltimore Museum of
Art, Baltimore

1985
DEATH HOPE
LIFE FEAR
Rudi Fuchs (introd.),
exh. cat., Castello di
Rivoli,Turin

1986
THE CHARCOAL ON
PAPER SCULPTURES
1970–1974
Demosthenes
Davvetas and Carter
Ratcliff (texts), exh.
cat., CAPC, Musée
d'Art Contemporain,
Bordeaux

1986
THE PAINTINGS 1971
Wolf Jahn (introd.),
exh. cat.
Fruitmarket Gallery,
Edinburgh

1986
GILBERT & GEORGE.
THE COMPLETE
PICTURES 1971–1985
Carter Ratcliff (text),
London

1988
GILBERT & GEORGE
Werner Buttner, Diego
Cortez and Wolf Jahn
(texts), exh. cat.,
Ascan Crone Gallery,
Hamburg

1989
FOR AIDS
EXHIBITION
Gilbert & George
(introd.), exh. cat.,
Anthony d'Offay
Gallery, London

1989
THE ART OF
GILBERT & GEORGE,
OR AN AESTHETIC
OF EXISTENCE
Wolf Jahn, London

1990
THE MOSCOW
CATALOGUE
Brenda Richardson
and Sergei Klokov
(texts), exh. cat.,
Gilbert & George and
Anthony d'Offay
Gallery, London

1990
TWENTY-FIVE
WORLDS AND
WINDOWS BY
GILBERT & GEORGE
Robert Rosenblum
(texts), exh. cat.,
Robert Miller Gallery,
New York

1990
WORLDS AND
WINDOWS
Robert Rosenblum
(text), exh. cat.,
Anthony d'Offay
Gallery/ Robert Miller
Gallery, London/ New
York

1990
ELEVEN WORLDS BY
GILBERT & GEORGE
AND ANTIQUE
CLOCKS
Remo Guidieri
(introd.), exh. cat.,
Desire Feurele
Gallery, Cologne

1990
GILBERT & GEORGE
POSTCARD
SCULPTURES AND
EPHEMERA,
1969–1981
Carter Ratcliff
(introd.), exh. cat.,
Hirschl & Adler, New
York

1991
MONARCHY AS
DEMOCRACY
Wolf Jahn (text), exh.
cat., Anthony d'Offay
Gallery, London

1991
WITH
GILBERT & GEORGE
IN MOSCOW
Daniel Farson,
London

1991
THE COSMOLOGICAL
PICTURES
Rudi Fuchs and
Wojciech Markowski
(introd.), exh. cat.,
Haags
Gemeentemuseum,
The Hague

1992
NEW DEMOCRATIC
PICTURES
Anders Kold, Andrew
Wilson and Lars
Morell (texts),
exh. cat., Aarhus
Kunstmuseum,
Aarhus

1993
THE SINGING
SCULPTURE
Carter Ratcliff and
Robert Rosenblum,
London

1993
GILBERT & GEORGE,
CHINA EXHIBITION
Wojciech Markowski,
Norman Rosenthal,
and others (texts),
Andrew Wilson
(interview), exh. cat.,
Shanghai Art
Museum, Shanghai

1994
GILBERT & GEORGE:
RECENT WORKS
Exh. cat., Robert
Miller Gallery, New
York

1994
GILBERT & GEORGE
Wolf Jahn, (text), exh.
cat., Museo d'Arte
Moderna, Lugano

1994
THE NAKED SHIT
PICTURES
Wolf Jahn (text), exh.
cat., Galerie Rafael
Jablonka, Cologne

1994
SHITTY NAKED
HUMAN WORLD
Gilbert & George,
exh. cat.,
Wolfsburg
Kunstmusem,
Wolfsburg

1995
THE NAKED SHIT
PICTURES
Wolf Jahn (introd.),
exh. cat., South
London Gallery,
London

1996
GILBERT & GEORGE
Danilo Eccher (text),
exh. cat., Galleria
d'Arte Moderna,
Bologna

1996
OH, THE GRAND
OLD DUKE OF YORK
(FLICK BOOK)
Gilbert & George,
Cologne

1997
LOST DAY
(FLICK BOOK)
Gilbert & George,
Cologne

1997
THE FUNDAMENTAL
PICTURES
Robert Rosenblum
(text), London

1997
ART FOR ALL
1971–1996
Robert Rosenblum
and Fumihiro
Nomomura (texts),
exh. cat., Sezon
Museum of Art, Tokyo

1997
GILBERT & GEORGE-
KONST
Hans Ulrich Obrist
(interview), exh. cat.,
Magasin 3, Stockholm

1997
GILBERT & GEORGE
Gilbert & George,
Martin Gayford
(interview) and
Bernard Marcadé
(text), exh. cat.,
Musee d'Art Moderne
de la Ville de Paris,
Paris

1997
THE WORDS OF
GILBERT & GEORGE
WITH PORTRAITS OF
THE ARTISTS FROM
1968–1997
Gilbert & George
Robert Violette and
Hans Ulrich Obrist
(eds.), London

1998
NEW TESTAMENTAL
PICTURES
Demosthenes
Davvetas (introd.),
exh. cat., Galerie
Thaddaeus Ropac,
Paris

1998
NEW TESTAMENTAL
PICTURES
Achille Bonito Oliva,
Mario Codognato and
Angela Tecce (texts),
exh. cat., Museo di
Capodimonte, Naples

PUBLICATIONS

1999
GILBERT & GEORGE
(1986–1997)
José Miguel G.
Cortés, Vicente
Molina Foix (texts),
and Wolf Jahn
(interview), exh. cat.,
Drassanes Valencia,
Valencia

1999
GILBERT & GEORGE
1970–1997
Exh. cat., Astrup
Fearnley Museet for
Moderne Kunst, Oslo

1999
THE RUDIMENTARY
PICTURES
David Sylvester
(interview) and
Michael Bracewell
(text), exh. cat.,
Milton Keynes Gallery,
Milton Keynes

1999
GILBERT & GEORGE:
A PORTRAIT
Daniel Farson,
London

2000
ZIG-ZAG PICTURES
2000
Exh. cat., FIAC 2000/
Galerie Thaddaeus
Ropac, Paris

2001
NEW HORNY
PICTURES
Exh. cat., White
Cube 2, London

2001
GILBERT & GEORGE
Hans Ulrich Obrist
(interview) and Wolf
Jahn (text), exh. cat.,
Fondation pour l'Art
Contemporain
Claudine et Jean-
Marc Salomon
Chateau d'Arenthon,
Alex (Annecy)

2001
THE ART OF
GILBERT AND
GEORGE
Kyrillos Sarris (text),
exh. cat., Athens
School of Art, Athens

2001
THE WORLD OF
GILBERT & GEORGE:
THE STORYBOARD
Marco Livingstone
(introd.), Gilbert &
George (preface),
London

2002
SOMERSET HOUSE
1971 (FLICK BOOK)
Gilbert & George,
Cologne

2002
GILBERT & GEORGE.
AN EXHIBITION
Exh. cat., Kunsthaus
Bregenz

2002
THE DIRTY WORDS
PICTURES
Michael Bracewell
and Lisa G. Corrin
(texts), exh. cat.,
Serpentine Gallery,
London

2002
NINE DARK
PICTURES
Michael Bracewell
and Wolf Jahn (texts),
exh. cat.,
Portikus, Frankfurt

2002
A ARTE DE
GILBERT & GEORGE
Exh. cat., Centro
Cultural de Belém,
Lisbon

2004
20 LONDON E1
PICTURES
Anne Prenzler, Eric
Troncy and Lorand
Hegyi (texts), exh.
cat., Galerie
Thaddaeus
Ropac, Paris

2004
THIRTEEN
HOOLIGANS
PICTURES
Michael Bracewell
(text), exh. cat.,
Gallery Bernier/
Eliades, Athens

2004
PERVERSIVE
PICTURES 2004
Michael Bracewell
(text), exh. cat.,
Sonnabend Gallery
and Lehmann
Maupin, New York

2004
INTRODUCING
GILBERT & GEORGE
Robert Rosenblum,
London

2004
GILBERT & GEORGE:
OBSESSIONS &
COMPULSIONS
Robin Dutt, London

2005
GILBERT & GEORGE
E1
Isabelle Baudino and
Marie Gautheron
(texts), Musee d'Art
Moderne de Saint-
Etienne Metropole,
Saint-Etienne and
Paris

2005
THE GENERAL
JUNGLE OR
CARRYING ON
SCULPTING
Mario Kramer (text)
and Andrew Wilson
(interview), exh. cat.,
MAXXI- Museo
Nazionale delle arti
del XXI Secolo, Rome

2005
GINKGO PICTURES,
VENICE BIENNALE
2005
Daniel Birnbaum and
Michael Bracewell
(texts), exh. cat.,
Venice Biennale/
British Council,
London

2005
INTIMATE
CONVERSATIONS
WITH FRANÇOIS
JONQUET
François Jonquet,
London

2006
SONOFAGOD
PICTURES:
WAS JESUS
HETEROSEXUAL?
Michael Bracewell
(text), exh. cat., White
Cube, London

2007
GILBERT & GEORGE:
THE COMPLETE
PICTURES
Rudi Fuchs (introd.),
London

Compiled from London and Munich exhibitions. Unless otherwise stated the medium is 'mixed media'.

ALL MY LIFE I GIVE YOU NOTHING AND STILL YOU ASK FOR MORE
1970
A charcoal on paper sculpture
In two parts, each
193 x 75 cm
Private collection, courtesy MaxmArt, Mendrisio
[pl.1]

GEORGE THE CUNT AND GILBERT THE SHIT
1969
A magazine sculpture
38 x 64 cm
Private collection
[fig.6]

THE NATURE OF OUR LOOKING
1970
A five-part charcoal on paper sculpture
348 x 236 cm;
263 x 118 cm;
278 x 362 cm;
263 x 90cm;
385 x 270 cm
Tate, London
Purchased 1982
[pl.3]

THERE WERE TWO YOUNG MEN
1971
A six-part charcoal on paper sculpture
240 x 240 cm;
240 x 240 cm;
270 x 200 cm;
270 x 200 cm;
240 x 400 cm;
240 x 400 cm
Collection Gian Enzo Sperone, New York
Courtesy Sperone Westwater, New York
[pls.4–9]

THE GENERAL JUNGLE or CARRYING ON SCULPTING
1971
A twenty-three-sheet descriptive work
Each part
280 cm high; various widths
One part: Museo nazionale delle arti del XXI Secolo, Rome
Eleven parts: private collection, courtesy Sonnabend Gallery
Ten parts: private collection, courtesy MaxmArt, Mendriso
One part: Collection Heide Duerr, Berlin, courtesy Ralph Wernicke, Berlin
[pl.10]

PHOTO-PIECE
1971
159 x 143 cm
Collection S.M.A.K., Museum of Contemporary Art, Ghent, Belgium
[pl.11]

PHOTO-PIECE
1971
130 x 180 cm
Agnes and Frits Becht Collection, Naarden, The Netherlands
[pl.12]

THE BAR NO.2
1972
A nine-part charcoal on paper sculpture
Each part
260 cm high; various widths
Private collection, courtesy Sonnabend Gallery, New York
[pl.2]

BALLS or THE EVENING BEFORE THE MORNING AFTER
1972
211 x 437 cm
Tate, London.
Purchased 1972
[pl.13]

AXE BAR
1973
129 x 109 cm
Private collection
[pl.21]

THE EFFECT formerly known as A DRINKING PIECE
1973
173 x 82 cm
Francesca and Massimo Valsecchi
[pl.14]

GIN AND TONIC
1973
71 x 42 cm
Private collection, courtesy Sonnabend Gallery, New York
[pl.22]

THE GLASS 2
1973
130 x 85 cm
Private collection, London
[pl.16]

HEAD OVER HEELS
1973
277 x 64 cm
Collection of Samuel and Ronnie Heyman
[pl.18]

RATHER SPORTY
1973
15 x 96 cm
Private collection, courtesy Sonnabend Gallery, New York
[pl.20]

'TO HER MAJESTY'
1973
145 x 350 cm
Collection Max de Jong, France
[pl.19]

TWO A.M.
1973
122 x 89 cm
Collection Herbert
[pl.15]

INCA PISCO A
1974
Collection Herbert
353 x 426 cm
[pl.23]

INCA PISCO B
1974
305 x 410 cm
Collection Herbert
[pl.24]

HUMAN BONDAGE NO.5
1974
175 x 175 cm
Private collection, London
[pl.25]

DARK SHADOW NO.4
1974
211 x 156 cm
Museum Boijmans Van Beuningen, Rotterdam
[pl.26]

DARK SHADOW NO.6
1974
151 x 206 cm
Private collection, London
[pl.27]

DARK SHADOW NO.8
1974
151 x 206 cm
Van Abbemuseum Collection, Eindhoven
[pl.28]

CHERRY BLOSSOM NO.1
1974
251 x 211 cm
Private collection, courtesy MaxmArt, Mendrisio
[pl.29]

CHERRY BLOSSOM NO.2
1974
251 x 211 cm
Private collection, courtesy Sonnabend Gallery, New York
[pl.39]

CHERRY BLOSSOM NO.5
1974
251 x 211 cm
Private collection, courtesy Sonnabend Gallery, New York
[pl.32]

CHERRY BLOSSOM NO.7
1974
251 x 211 cm
Collection of Samuel and Ronnie Heyman
[pl.33]

CHERRY BLOSSOM NO.11
1974
187 x 157 cm
Private collection, London
[pl.30]

COMING
1975
187 x 157 cm
Dimitris Daskalopoulos Collection, Greece
[pl.34]

BLOODY LIFE NO.1
1975
251 x 211 cm
Statens Museum for Kunst, Copenhagen
[pl.36]

BLOODY LIFE NO.3
1975
251 x 211 cm
Private collection, courtesy MaxmArt, Mendrisio
[pl.31]

BLOODY LIFE NO.4
1975
251 x 211 cm
Private collection, courtesy MaxmArt, Mendrisio
[pl.40]

BLOODY LIFE NO.7
1975
187 x 157 cm
Private collection, courtesy MaxmArt, Mendrisio
[pl.37]

BLOODY LIFE NO.16
1975
251 x 211 cm
Francesca and Massimo Valsecchi
[pl.38]

BAD THOUGHTS NO.7
1975
251 x 211 cm
Private collection
[pl.35]

DUSTY CORNERS NO.2
1975
187 x 157 cm
Private collection, London
[pl.45]

DUSTY CORNERS NO.6
1975
124 x 104 cm
Melissa and Robert Soros
[pl.41]

DUSTY CORNERS NO.13
1975
251 x 211 cm
Private collection, courtesy MaxmArt, Mendrisio
[pl.46]

DUSTY CORNERS NO.15
1975
124 x 104 cm
Private collection, London
[pl.42]

DUSTY CORNERS NO.16
1975
124 x 104 cm
Private collection, Arkansas
[pl.43]

DUSTY CORNERS NO.21
1975
124 x 104 cm
Private collection, London
[pl.44]

DEAD BOARDS NO.7
1976
251 x 211 cm
Francesca and Massimo Valsecchi
[pl.51]

DEAD BOARDS NO.9
1976
251 x 211 cm
Jedermann Collection, N.A.
[pl.52]

DEAD BOARDS NO.16
1976
124 x 104 cm
Private collection, courtesy Massimo Valsecchi
[pl.49]

DEAD BOARDS NO.17
1976
124 x 104 cm
Private collection, Italy, courtesy Massimo Valsecchi
[pl.50]

MENTAL NO.2
1976
314 x 264 cm
Kröller-Müller Museum, Otterlo, The Netherlands
[pl.54]

MENTAL NO.3
1976
314 x 264 cm
Collection of the Modern Art Museum of Fort Worth, museum purchase by The Burnett Foundation
[pl.53]

MENTAL NO.4
1976
251 x 211 cm
Private collection, courtesy Sonnabend Gallery, New York
[pl.59]

MENTAL NO.10
1976
187 x 157 cm
Private collection, London
[pl.55]

MENTAL NO.11
1976
124 x 104 cm
Melissa and Robert Soros
[pl.58]

MENTAL NO.12
1976
124 x 104 cm
Private collection, courtesy MaxmArt, Mendrisio
[pl.60]

RED MORNING: DIRT
1977
181 x 151 cm
Graphische Sammlung Staatsgalerie Stuttgart, Dr Rolf H. Krauss Collection
[pl.61]

RED MORNING: HATE
1977
242 x 202 cm
Yageo Foundation
[pl.63]

EXHIBITED PICTURES AND SCULPTURES

RED MORNING:
TROUBLE
1977
301 x 251 cm
Tate, London.
Presented by Janet
Wolfson de Botton 1996
[pl.64]

RED MORNING:
VIOLENCE
1977
242 x 202 cm
Lhoist Group
Collection
[pl.62]

ANGRY
1977
302 x 252 cm
Kröller-Müller
Museum, Otterlo, The
Netherlands. Formerly
in the Visser Collection
[pl.70]

ARE YOU ANGRY OR
ARE YOU BORING?
1977
242 x 202 cm
Van Abbemuseum
Collection, Eindhoven
[pl.66]

COMMUNISM
1977
302 x 252 cm
Collection Herbert
[pl.71]

CUNT
1977
242 x 202 cm
Musée d'Art Moderne
de la Ville de Paris,
Paris
[pl.67]

FUCK
1977
242 x 202 cm
Kunstmuseum
Wolfsburg
[pl.68]

LICK
1977
242 x 202 cm
Private collection
[pl.65]

QUEER
1977
302 x 252 cm
Museum Boijmans Van
Beuningen, Rotterdam
[pl.69]

THE ALCOHOLIC
1978
242 x 202 cm
The Art Institute of
Chicago, Twentieth-
Century Purchase
Fund
[pl.75]

THE BRANCH
1978
242 x 202 cm
Mr and Mrs Ealan
Wingate
[pl.74]

MORNING
1978
151 x 121 cm
Sheffield Galleries &
Museums Trust
[pl.73]

THE PENIS
1978
242 x 202 cm
Private collection,
courtesy Marc Jancou
Fine Arts, New York
[pl.76]

THE QUEUE
1978
242 x 202 cm
Private collection,
courtesy MaxmArt,
Mendrisio
[pl.72]

ANTICHRIST
1980
181 x 151 cm
Private collection,
London
[pl.85]

BLACK CHURCH
FACE
1980
242 x 202 cm
Private collection,
courtesy Sonnabend
Gallery, New York
[pl.87]

BLACK CROSS
1980
242 x 202 cm
Ivor Braka Ltd.,
London
[pl.88]

BLACK JESUS
1980
181 x 252 cm
Private collection,
courtesy MaxmArt,
Mendrisio
[pl.77]

BUNHILL KNIGHT
1980
181 x 202 cm
André Simoens,
Knokke, Belgium
[Not illustrated]

DEATH MARCH
1980
242 x 202 cm
Private collection,
courtesy Ivor Braka
Ltd.
[pl.84]

ENGLAND
1980
302 x 303 cm
Tate, London.
Purchased 1981
[pl.91]

FOUR KNIGHTS
1980
242 x 202 cm
Southampton City Art
Gallery
[pl.89]

FOURNIER STREET
1980
181 x 252 cm
Hamburger
Kunsthalle, Collection
Elisabeth and
Gerhard Sohst
[pl.78]

HELLISH
1980
242 x 303 cm
Baltimore Museum
of Art. Nelson and
Juanita Greif Gutman
Collection, 1980.127
[pl.83]

LIVING WITH FEAR
1980
242 x 202 cm
Collection of Samuel
and Ronnie Heyman
[pl.86]

MAD
1980
242 x 202 cm
Private collection,
Germany, courtesy
Galerie Daniel
Varenne, Geneva
[pl.79]

MULLAH
1980
242 x 202 cm
Francesca and
Massimo Valsecchi
[pl.80]

PATRIOTS
1980
181 x 303 cm
David and Diane
Waldman, Rancho
Mirage, California,
USA
[pl.82]

ROSE HOLE
1980
181 x 303 cm
Collection Sanders,
Amsterdam
[pl.90]

STREAM
1980
242 x 202 cm
Private collection,
courtesy Galerie Piece
Unique, Paris
[pl.81]

COLOURED SKINS
1981
181 x 202 cm
Private collection
[pl.92]

ARMED FAITH
1982
302 x 303 cm
Francesca and
Massimo Valsecchi
[pl.98]

COLOURED ENEMIES
1982
242 x 202 cm
Pamela and James
Heller, New York
[pl.106]

FAITH CURSE
1982
242 x 252 cm
Private collection
[Not illustrated]

DEATHO KNOCKO
1982
423 x 404 cm
Tate, London.
Presented by Janet
Wolfson de Botton
1996
[pl.99]

FINDING GOD
1982
423 x 606 cm
The Rubell Family
Collection, Miami
[pl.104]

FORGIVENESS
1982
242 x 202 cm
Collection Marco and
Simona Voena
[pl.105]

HUNGER
1982
242 x 202 cm
Private collection
[pl.94]

LIFE WITHOUT END
1982
423 x 1111 cm
Williams College
Museum of Art,
Williamstown,
Massachusetts,
museum purchase,
Kathryn Hurd Fund
[pl.103]

NAKED LOVE
1982
302 x 303 cm
Collection Attilio
Codognato, Venice
[pl.97]

REAMING
1982
302 x 303 cm
Collection of Art
Gallery of New South
Wales, purchased with
funds provided by the
Art Gallery Society of
New South Wales,
2000
[pl.108]

SPERM EATERS
1982
242 x 202 cm
Private collection,
London
[pl.95]

THIRST
1982
242 x 202 cm
Private collection
[pl.93]

WINTER FLOWERS
1982
242 x 252 cm
The Carol and Arthur
Goldberg Collection
[pl.102]

WINTER TONGUE
FUCK
1982
242 x 202 cm
Thea Westreich and
Ethan Wagner
[pl.96]

YOUTH ATTACK
1982
302 x 606 cm
Private collection,
courtesy MaxmArt,
Mendrisio
[pl.109]

YOUTH FAITH
1982
302 x 303 cm
Private collection,
courtesy MaxmArt,
Mendrisio
[pl.100]

BLACK GOD
1983
242 x 151 cm
Private collection,
courtesy MaxmArt,
Mendrisio
[pl.110]

BLOODED
1983
302 x 252 cm
Musée de Grenoble
[pl.116]

FLIGHT
1983
242 x 303 cm
Hess Collection, Bern
and Napa
[pl.117]

GOOD
1983
242 x 151 cm
Wolverhampton Arts
and Museums.
Presented by the
Contemporary Art
Society, 1986
[pl.111]

INSIDE
1983
302 x 303 cm
Janet de Botton,
London
[pl.115]

SHITTED
1983
242 x 202 cm
Collection Norman
and Norah Stone, San
Francisco; courtesy
Thea Westreich Art
Advisory Services
[pl.112]

WE
1983
242 x 202 cm
Private collection
[pl.113]

WORLD
1983
242 x 303 cm
Baltimore Museum of
Art. Gift of the artists,
London, 1984.24
[pl.114]

DEATH HOPE
LIFE FEAR
1984
A quadripartite picture
Two parts
423 x 252 cm;
two parts
423 x 656 cm
Tate, London.
Purchased 1990
[pl.119]

EXISTERS
1984
242 x 353 cm
Private collection
[pl.118]

SPORE
1986
242 x 505 cm
Private collection,
courtesy MaxmArt,
Mendrisio
[pl.121]

THE WALL
1986
242 x 353 cm
Private collection
[pl.120]

A.D.
1987
302 x 252 cm
Janet de Botton,
London
[pl.124]

HERE
1987
302 x 353 cm
Lent by The
Metropolitan Museum
of Art, New York.
Anonymous Gift, 1991
[pl.122]

THERE
1987
302 x 252 cm
Private collection
[pl.123]

TEARS
1987
242 x 202 cm
Private collection
[pl.125]

BLEEDING
1988
226 x 254 cm
Private collection,
courtesy MaxmArt,
Mendrisio
[pl.130]

THE EDGE
1988
242 x 202 cm
Private collection,
courtesy White Cube,
London
[pl.127]

FLOW
1988
253 x 284 cm
Astrup Fearnley
Collection,
Oslo, Norway
[pl.129]

FRUITION
1988
302 x 254 cm
Collection of Samuel
and Ronnie Heyman
[pl.126]

LIFE ON DEATH
1988
169 x 142 cm
Jacqueline
and Marc Leland
[pl.131]

POWER
1988
169 x 142 cm
Private collection
[pl.132]

WRONG
1988
253 x 213 cm
Private collection
[pl.128]

ALL
1989
226 x 381 cm
Collection Martin
Hatebur, Switzerland
[pl.142]

BLOOD HEADS
1989
226 x 381 cm
Francesca and
Massimo Valsecchi
[pl.140]

BOOT
1989
226 x 317 cm
Bing and Migs Wright
[pl.136]

DEAD HEAD
1989
226 x 508 cm
Private collection,
courtesy MaxmArt,
Mendrisio
[pl.141]

DEATH OVER LIFE
1989
226 x 254 cm
The Philip & Faith
Geier Collection
[pl.137]

DOWN TO EARTH
1989
226 x 317 cm
Museum of Modern
Art, New York. Gift of
Werner and Elaine
Dannheisser, 1996
[pl.139]

HOLED
1989
169 x 142 cm
Collection of Nicki and
J. Ira Harris
[pl.134]

LOOK
1989
169 x 142 cm
James Birch
[pl.133]

MY WORLD
1989
226 x 190 cm
Private collection
[pl.135]

SEEN
1989
226 x 254 cm
Private collection,
courtesy MaxmArt,
Mendrisio
[pl.138]

CITY FAIRIES
1991
253 x 426 cm
Robert Tibbles
Collection
[pl.143]

COLD STREET
1991
253 x 639 cm
Private collection,
London
[pl.149]

FAITH DROP
1991
253 x 355 cm
Private collection
[pl.146]

FLAT MAN
1991
253 x 497 cm
Private collection,
London
[pl.150]

HEADY
1991
253 x 426 cm
McMaster Museum
of Art. Gift of Herman
Levy, Esq. OBE
[pl.144]

HEADACHE
1991
253 x 497 cm
Private collection,
London
[pl.148]

LIGHT HEADED
1991
253 x 355 cm
Private collection
[pl.145]

STREET BEACHED
1991
253 x 426 cm
Collection Antoine de
Galbert, Paris,
courtesy Galleries
Thaddeus Ropac,
Paris/ Salzburg
[pl.147]

CHRISTS
1992
253 x 426 cm
Private collection,
courtesy MaxmArt,
Mendrisio
[pl.151]

YELL
1992
253 x 213 cm
Astrup Fearnley
Collection, Oslo,
Norway
[pl.152]

SHITTY NAKED
HUMAN WORLD
1994
A quadripartite picture
Each part
338 x 639 cm
Stedelijk Museum,
Amsterdam
[pl.153]

BLOOD TEARS
SPUNK PISS
1996
338 x 1207 cm
ARTIS Collection
[pl.154]

BLOODY MOONING
1996
338 x 568 cm
Vanhaerents Art
Collection, Brussels,
Belgium
[pl.156]

SPUNK BLOOD
PISS SHIT SPIT
1996
338 x 426 cm
Collection Attilio
Codognato, Venice
[pl.155]

OUR SPUNK
1997
254 x 604 cm
Galerie Thaddaeus
Ropac, Paris/ Salzburg
[pl.158]

SPIT LAW
1997
254 x 528 cm
Galerie Thaddaeus
Ropac, Paris/ Salzburg
[pl.157]

GUM CITY
1998
338 x 284 cm
Collection of Richard
B. Sachs
[pl.159]

NINETEEN
NINETY NINE
1999
A quadripartite picture
Two parts
355 x 507 cm;
two parts
355 x 676 cm
Museum Moderner
Kunst Stiftung
Ludwig Wien, Vienna
[pl.160]

ZIG-ZAG KISMET
2000
284 x 845 cm
Private collection,
courtesy BFAS –
Blondeau Fine Art
Services, Geneva
[pl.161]

ANIMOSITY
2001
190 x 302 cm
Collection
Camille O. Hoffmann
[pl.163]

CHAINED UP
2001
254 x 528 cm
Bernier-Eliades
Gallery Collection,
Athens
[pl.167]

JESUS SAID
2001
226 x 254 cm
Private collection
[pl.166]

LOCKED
2001
190 x 226 cm
Collection Musée des
Arts Contemporains
de la Communauté
française au Grand-
Hornu, Propriété de la
Communauté
française de Belgique
[pl.165]

NAMED
2001
355 x 1521 cm
Tate, London.
Presented by
Tate Members, 2004
[pl.168]

NURUL
2001
127 x 151 cm
Private collection
[pl.162]

ONE WAY
2001
190 x 302 cm
Private collection,
Belgium
[pl.164]

THIRTY-FOUR
STREETS
2003
355 x 591 cm
Private collection,
Los Angeles. Courtesy
Galerie Thaddaeus
Ropac, Paris/ Salzburg
[pl.170]

THREE DOZEN
STREETS
2003
355 x 760 cm
Private collection,
courtesy Faggionato
Fine Art, London
[pl.169]

TWENTY-EIGHT
STREETS
2003
355 x 676 cm
Collection MUDAM,
Luxemburg
[pl.171]

APOSTASIA
2004
284 x 760 cm
The Rubell Family
Collection, Miami
[pl.184]

CHICHIMAN
2004
284 x 338 cm
Collection of
Elisabeth Wingate
and Ronald Kawitzky
[pl.181]

CLEAN ME
2004
190 x 302 cm
Private collection,
courtesy Sonnabend
Gallery, New York
[pl.178]

DEVOUT
2004
190 x 302 cm
BES art – Collection
Banco Espírito Santo
[pl.177]

DOOR
2004
226 x 381 cm
Private collection,
courtesy Sonnabend
Gallery, New York
[pl.180]

FINGLE-FANGLE
2004
284 x 507 cm
Private collection,
Brussels
[pl.182]

HANDS
2004
142 x 169 cm
Private collection,
courtesy Faggionato
Fine Art, London
[pl.174]

HARAM
2004
190 x 226 cm
James B. Tananbaum
and Dana
S.Tananbaum Family
Trust
[pl.173]

HEART
2004
190 x 226 cm
Private collection,
Switzerland
[pl.172]

ISHMAEL
2004
284 x 591 cm
ARTIS Collection
[pl.183]

LUCK
2004
190 x 302 cm
The Essl Collection,
Klosterneuburg/
Vienna
[pl.179]

SALUTE
2004
142 x 169 cm
Private collection,
courtesy Sonnabend
Gallery, New York
[pl.175]

TAG DAY
2004
254 x 377 cm
Private collection
[pl.176]

COWLS
2005
338 x 355 cm
Private collection
[pl.188]

DIVIDERS
2005
226 x 190 cm
Private collection,
London
[pl.189]

FATES
2005
426 x 760 cm
Tate, London.
Purchased with
assistance from
Tate Members 2006
[pl.186]

GINK
2005
284 x 422 cm
Collection Maja
Hoffmann
[pl.187]

HOODED
2005
284 x 507 cm
Private collection,
London
[pl.185]

MASS
2005
226 x 254 cm
Private collection,
courtesy White Cube,
London
[pl.192]

MUFTI
2005
254 x 377 cm
Collection of James
Chanos, New York and
London
[pl.191]

PIXIE HILL
2005
302 x 381 cm
Collection David
Roberts
[pl.190]

WAS JESUS
HETEROSEXUAL?
2005
381 x 604 cm
Astrup Fearnley
Collection,
Oslo, Norway
[pl.193]

BOMB
2006
A triptych picture
Two parts
336 x 352 cm;
one part
336 x 705 cm
Courtesy Jay Jopling/
White Cube, London
[pl.199]

BOMBER
2006
352 x 504 cm
Courtesy Jay Jopling/
White Cube, London
[pl.196]

BOMBERS
2006
336 x 493 cm
Courtesy Jay Jopling/
White Cube, London
[pl.198]

BOMBING
2006
336 x 423 cm
Courtesy Jay Jopling/
White Cube, London
[pl.195]

BOMBS
2006
336 x 493 cm
Courtesy Jay Jopling/
White Cube, London
[pl.197]

TERROR
2006
336 x 775 cm
Courtesy Jay Jopling/
White Cube, London
[pl.194]

*PP. 198–208,
compiled and edited
by Sarah Turner*

INDEX TO
PICTURE TITLES